ES

The Memoirs of Leonid Pasternak

The Memoirs of
LEONID
PASTERNAK

Translated by Jennifer Bradshaw

With an Introduction by
JOSEPHINE PASTERNAK

QUARTET BOOKS
LONDON MELBOURNE NEW YORK

First published in Great Britain by Quartet Books Limited 1982
A member of the Namara Group
27/29 Goodge Street, London W1P 1FD

British Library Cataloguing in Publication Data

Pasternak, Leonid
 The memoirs of Leonid Pasternak.
 1. Pasternak, Leonid
 2. Painters–Soviet Union–Biography
 I. Title
 759.7 ND699.P/

ISBN 0-7043-2343-5

Typeset by MC Typeset, Rochester, Kent
Printed in Great Britain by Mackays of Chatham Limited

Contents

Acknowledgements

I am grateful to Mrs Ludmila Kushev who read the Russian edition of the Memoirs (*Zapisi Raznykh Let*) and suggested editorial changes, and to Dr Anne Smith who read the manuscript in translation. I am also indebted to Mr Roger Keys for his valuable assistance with parts of the translation and to Dr Christopher Barnes who collaborated on an earlier draft of the Tolstoy chapter. The Scottish Arts Council was generous enough to award me a bursary in its 'Writers on the Arts' scheme. My greatest debt is to Mrs Josephine Pasternak, whose tireless devotion to her father's work made her a source of continual encouragement and practical advice. Finally, I thank my husband and children for loving patience and support.

J.B.

Illustrations

Colour

Double Portrait of the Artist and his Wife
Lydia with Skis
The Artist's Grandchildren at a Table
Boris and Alexander
The Sisters on the Verandah in Molodi
Artist's Wife with Boris as a Child
The Artist's Mother
Apples and Violets
Bowl of Fruit
Lady with Two Children in a Boat
Two Women on a Beach by the Black Sea
Autumnal Orchard near Moscow
Yellow Tree in a Garden at Sunset
Landscape: Lake in the Bavarian Alps
Pink Gasometer in a Berlin Street
Winter Morning, Moscow
Street in Jerusalem
Going for a Drive in the Country, near Moscow
Hercules and Omphale

Foreword

L.O. Pasternak kept no diary, nor did he leave any regular entries about his life and work. And yet he left sufficient memoir material. Apart from notebooks and albums he put down his reminiscences, thoughts and remarks in various copy-books, and even on bits of writing-paper, or old envelopes. Most are undated, but following up the texts, it is not too difficult to relate them to one or the other period.

According to the time of their origin, and the manner of exposition, Pasternak's notes can be divided into three groups.

1) The notes of the Moscow period (approximately, 1910–20) are remarkable as if being written under the direct impact of events in the sphere of art; they reflect the author's views on this or that question, his opinions about what happened around him in the domains of art, artistic tuition, art criticism, and so on.

2) The Berlin memoirs (the twenties, and the early thirties), part of which were meant for publication in his Berlin Monograph, are less impulsive – one can feel that he wrote them while thinking of the past, comparing it with the present, summing up.

3) The Oxford reminiscences (late thirties, and, mainly, early forties), owe their realization to the insistence of his daughters. No less emotional, the notes of this period are distinguished by the mellowness of old age, of experience, and of the wisdom of a man who, now with a smile, now with sadness, looks back on life's journey. Much of what appears in the fluent Oxford Notes, might have been mentioned before, in Moscow, or Berlin in a more compressed, schematic way. On the other hand, some of the

problems discussed in the early period, are only briefly referred to in the later interpretation.

In his notes the painter quite often jots down remarks such as 'I am in a hurry', or 'next time', and the like. The reason is that – in his youth – he was engrossed in his work, creative, artistic, pedagogical; in the last years of his life he is 'in a hurry to write down', afraid that time is short, and that 'the end is near'. Having hardly finished something he hurries on to some different recollection, unrelated to the former, especially so since there occurred long breaks in his writing. Pasternak was aware of that, and among his texts we come across remarks and exclamations such as 'I think I've mentioned it somewhere already', 'Check!', 'Connect the texts' . . . To avoid repetitions, interruptions, and occasional vagueness, the compiler's main task in shaping the Russian edition of the book was the regrouping of certain texts; the joining up in corresponding chapters of fragments relating to the same subject; and observing as far as possible both chronological and thematic consistency. At the same time, in spite of the regrouping of some texts, *the wording of the entries remained unchanged,* a guarantee of the *inviolability* of the author's mode of expression.

A further regrouping took place by the Russian publishers, and some cuts in the English presentation. The Fourth Part has not been included in the English version of the book.

Much of L. Pasternak's work has remained in his native Russia. There his works are to be found in the State Tretyakov Gallery, the State Literary Museum, the State Museum Fund, the State Pushkin Museum of Fine Arts, the State Tolstoy Museums (Moscow and Leningrad), the Theatrical Museum, Leningrad, the Lenin State Library (Moscow), the Theatrical Museum, Moscow, the Historical Museum, the Gorky Museum, the Skriabin Collection, the Brodsky Museum (Leningrad), in over forty provincial Museums and Galleries, such as Odessa, Smolensk, Vladimir, and so on. Also, of course in private collections in various Russian towns.

London, New York, Dallas, Paris, Berlin, Munich, Florence, Bristol, Sheffield, etc., have numerous important examples in public and private collections. It has not been possible yet to compile a comprehensive catalogue of Pasternak's work but it is known to be in most European countries, in the United States, in Egypt, Palestine, Israel, and in Australia.

The main difficulty in ascertaining the whereabouts of the painter's works is that owing to wars and revolutions many of his pictures have changed hands, and their present location is not known. It is up to the future art historian to investigate the question, in order to be able to put together a *catalogue raisonné.*

The Memoirs of Leonid Pasternak

Introduction

by Josephine Pasternak

Moscow and Petersburg

Leonid Pasternak's life and work are so closely connected with the development of Russian art at the end of the nineteenth century and the first decades of the twentieth that the latter cannot be fully comprehended without reference to his and his colleagues' influence. In Pasternak's notes, which are too extensive to have been included in their entirety in the present volume, we find useful information about the transition of Russian art from the late nineteenth century, with its dated art ideals (the 'Wanderers'), to the new approach to art inspired by the Polenov circle in Moscow, to which Pasternak himself belonged.

What would have been the fate of Russian art if at the outset of our century a certain group of Petersburg aesthetes had not usurped the right of representing Russian art abroad? Such 'representation' became one of the saddest misunderstandings in the history of modern art. It was responsible for the distorted vision of Russian art which even now prevails in the West: firebirds, and *petroushkas;* ballerinas, *boyars,* and samovars; nymphs and enchanted lakes – could all these really have been given the task of introducing Russian art to its Western neighbours? True, while various kinds of decorative art based on folklore, crafts, and home-industry might be valuable for the assessment of certain cultural aspects of a country, in no way can they replace the source of their origin, art as such. Likewise, theatre sets and costume designs might be beautiful and alluring but they too are of a derivative value only.

It is an unpleasant but vital task for the art historian to try to

show why a completely distorted image of Russian art has been tolerated undisputed for more than fifty years. He will have to cut through a web of misunderstandings which, from neglect, ill will, and indolence have been allowed to become the basis for uncritical pronouncements. Pasternak himself was aware of this, as his journals show. He wrote hopefully, 'the future historian will vindicate the position'.

In a way, the painter Prince Sergei Shcherbatov★ is one of the historians 'vindicating the position'. Writing of Diaghilev's *Mir Iskusstva* (M.I.; World of Art), Shcherbatov, while admitting that some of the artists belonging to that movement arouse his interest and even his sympathy, remarks that he could not help feeling a certain 'remoteness' from them, something that had never occurred in his relations with Moscow painters. He goes on to explain the reason for this:

> Instinctively, in the heart of hearts, a line was being drawn between the indubitably high quality of things *authentic,* spiritually significant and precious in the highest sense of the word, and therefore simple, on one side, and something else on the other – the clever work of gifted men, refined and curious perhaps, and sometimes attractive yet as if having a different *specific weight, a different hallmark.*
>
> The Petersburg snobs, and their often biased judgements and criticisms brought an unpleasant note into the relations of the artistic groups of the two capitals . . . There were no men of genius in this Petersburg group of refined, cultured and, of course, gifted artists . . . The French seventeenth century, and its reflection, the Russian eighteenth, became a cult . . . Style . . . the aestheticism of an exquisitely relaxed epoch . . . with its heady delicate fragrance, its customs of court gallantry, and rich finery – cast an ever increasing spell upon our Petersburg aesthetes, eclectics and collectors of old drawings, prints . . . figurines, bead embroideries and various knick-knacks . . . Hence the cult of Versailles, clipped parks, piquante marquises with wigs and beauty spots – all of which time and again had been glorified in his pictures by Alexander Benoit, the ardent imitator of his adored eighteenth century who drew his inspiration . . . both from his beloved Versailles, and from Paris libraries and museums.

There is nothing wrong with an artist drawing part of his inspiration from old French prints and parks, but the situation

★Prince S. Shcherbatoir, *The Artist in Russia in the Past,* Chekhov Public House, NY, 1955

becomes preposterous when this same artist thinks of himself as a protagonist, abroad, of contemporary Russian art. Shcherbatov concludes:

> In its way it was a disease which contaminated talented people around Benoit . . . It was the taint of the M.I. . . . its organic defeat – the peril of decadent aesthetics . . . M.I. never did reach the standards of great painting, and its creative tasks. Aestheticism and eclecticism were lowering elements in this association, with its *pretension* of representing a progressive movement.

This assessment of the M.I. is the more revealing since Shcherbatov was on good terms with its members, and used to work with Benoit and some of the others in certain fields of applied arts. While he does not underestimate their value in the sphere of decorative arts, he states very clearly that they could not be regarded as representatives of serious Russian art.

Moreover, and this to me seems the most important point, he blames M.I. for 'having deflected a whole galaxy of our best painters towards the activities of scene designers'. True, Diaghilev had raised the theatrical art to unknown heights – yet there was a reverse side to the medal. I quote:

> You cannot serve two masters . . . We must keep in mind that art for the theatre in a way is an art of compromise, based on . . . devices and effects of a special technique . . . If I have dwelt on the subject . . . which had worried me, it is because this question cannot be divorced from the problem of the history and the fate of our art.

Shcherbatov is right indeed. As mentioned in the beginning, the export to Paris, and hence to the rest of Europe, of 'art goods' of a derivative nature could not but prevent a true appreciation of genuine Russian art in the West.

How had it been possible? Pasternak's notes reveal at least some of the reasons.

'Instead of monopolizing the Seat of judgement, journalism should be apologizing in the dock.' Oscar Wilde

On the whole Pasternak thought it unworthy of a painter to enter into polemics about art. But it would be inhuman if a man devoted to art as unreservedly as he was had not reacted in one way or another to what happened in his time in his own sphere.

Considering that Benoit was a gifted painter himself, and that he was the most erudite, significant and influential of all contemporary critics, Pasternak – like Shcherbatov some forty years later – blames him for many of the abuses of art criticism and journalism, and it is Benoit to whom he addresses his strongest argument: 'If the artist Benoit was asked, whether as an artist, he attaches any importance to journalistic art critiques – assuming that he would speak quite frankly – his answer, no doubt would have been: "None whatever".'

In another context Pasternak says:

> . . . P.S. I am surprised, dear Alexander Nikolaevitch, at your wistful mood: you deplore the coldness of the public, their lack of respect for the artist. But who is at the root of this evil? Who for the last ten years systematically belittled his fellow-painters in a most disparaging manner, and in his History of Russian Art mocked at our greatest artists, vilifying honoured names – the better to shine on the darkened background?

What are the reasons for Benoit's journalistic activities? Pecuniary, no doubt. But also power. I quote: '. . . The knowledge that while writing about his fellow-painters he held their destinies in his hands, and they are kept in awe . . . Don't we all know what shy, mute and patient people our Russian painters are. A fool only will fail to take advantage of them, to use them for his own purposes.'

There is a third reason, perhaps the most potent of all, which explains why an artist takes to journalism: to gain publicity of this kind for oneself and one's closest friends is the quickest and easiest way to fame.

It is impossible of course within the limits of this *aperçu* to do justice to Pasternak's views on the matter. I can only refer to some of his points. In various contexts he mentions the name of Meyer-Graefe, 'one of the most brilliant and at the same time most injurious "chatterers" '. To him we owe, in Pasternak's view, the

vicious practice in art criticism, of what is expressed by the phrase: *'Calomniez, calomniez, il en restera quelque chose'*. He applied it, for instance, in trying to dethrone Velasquez. As to the artists themselves, Pasternak says that 'the greater the artist, the more cautious he is in his assessments of other people's work'.

None the less Pasternak assumes that there must be serious, art-loving people among critics and historians, who could advance the cause of art. Their work, he maintains, should not consist in constructing theories, but in collecting authentic material about artists, their letters and notes, and records by eye-witnesses and disciples. Pasternak was deeply interested in everything of documentary value, and he assigned to art writers the noble task of searching in libraries, archives, and so on, for material pertaining to the methods and techniques of art. He says:

> They would render an inestimable service to us if they could retrace and make known the old masters' 'recipes', their technical devices almost entirely lost to posterity. They would certainly enrich human knowledge if instead of inventing futile theories they would conscientiously reproduce the painters' authentic views, and let us know all they could get hold of in the way of biographies, letters, and reminiscences of masters new and old, in the cause of perpetuating this invaluable knowledge.

One of the most comprehensive fragments from Pasternak's comments on the subject of art criticism is entitled 'The Unbidden in Art'. He compares art with a fenceless garden unprotected from trespassers. Wistfully he looks back to the Renaissance unhampered by extraneous issues such as those of 'aesthetics', and other intrusions. True, Pasternak says, even then there was an Aretino, but at least, he remarks, he was witty and amusing, and the painters were not bothered by him unduly. But the critics of today: '. . . should leave well alone the garden which they have invaded in such numbers. If however they wish to remain therein, to enjoy its florescence, to partake of the fruit of the artists' work – they should refrain from ordering it about as if the territory belonged to them or – worse still – from polluting its grounds . . .'

Pasternak could forgive a personal injury, but the slighting of art was unbearable to him. He mentions some of the omnipotent Russian critics, and points to the damaging effect of their homilies, of the parochialism of their followers, of fostering what Pasternak calls the development of 'Anti-Art'. He says: 'I am not alone. Many are the artists in different spheres of creative manifestation who have voiced the same views.' He quotes painters, and writers

such as Pushkin, Dostoyevsky and others to support this. Like Tolstoy, he held that 'each art has its own specific language . . . It is impossible to express its essence in words.' But in literature the evil at least can be met and checked with the same weapon in hand: writer and critic speak the same language, they have the means of expression in common. Painting, on the other hand, is the most vulnerable of all arts.

A considerable part of Pasternak's notes is dedicated to the discussion of the inevitable clash between the flashy 'movements' and art tuition. Painters who could still give of their best to the younger generation of artists are discouraged by the onslaught of theorizing art writers, at war with each other and the rest of the world.

As to the quick change of art movements in Russia, Pasternak remarks that the wave of Futurism and Cubism from Italy and France was followed by '. . . our home-grown *Rayonnisme*, Constructivism, Suprematism, and the like, with their gaudy proclamations and the glorification of rowdy methods of propaganda which sent reeling even the former maestros of "modern" journalism'.

Of course, new movements are vital, and relevant to the progress of art, but the trends of last years dissociated themselves from the principle of continuity: there is a much closer connection between psychological research, public relations, trade and so on and modern art than there is between art past and present. Why do its representatives so stubbornly stick to the name of art while at the same time refuting all art principles prior to their present rule? They would only gain if they would invent a new designation for their activities, more in keeping with their aims, which would convey their glory undiminished by comparison with what used to be understood by the term.

We must not be misled into believing that Pasternak's attitude towards art criticism was one of unquestioning condemnation. He did not shun criticism even if it was unfavourable, provided that it was constructive – and by a serious, and unbiased critic. Thus time and again he mentions the articles of an art critic in the *Petersburg Herald* who signed himself with the letter 'P', and whose real name Pasternak and his friends in the Polenov circle did not succeed in identifying. I quote: '. . . This indeed was art criticism at its best. How grateful we painters were to this man who approached us with understanding, whose conscientiousness made him quite different from the usual run of critics in their world of intrigues and arbitrary accusations.'

When in the twenties Pasternak temporarily settled in Berlin, he paid tribute to the impartiality of German critics. A fellow-painter

of his even calls them kinder. This pronouncement about the 'kinder' German critics involuntarily recalls an entry which Pasternak made in his journals some ten years earlier in Moscow. The subject covers almost a whole chapter, I will quote a few lines only:

> . . . A fortnight ago some of my colleagues and I received from Petersburg a printed questionnaire to be filled in by us – painters. The questions alone tell their own tale: 'Is art criticism – generally speaking – necessary?' and similar queries. While reading on I was shaken by the following column: 'Point out an instance of injury, blackmail, death.' I could not believe my eyes . . . That some confusion not to say a kind of persecution tendency the details of which unfortunately are not fully known to me – is going on in this domain – is certain. Quite certain indeed since the other day I learnt of the tragic death of one of our prominent painters, K. Kryzhitsky. I am not acquainted with the circumstances of his death but in the papers which I happened to see, it was referred to as 'the result of abuses', and even 'baiting' and 'hunting down' of the artist by reviewers and critics.

One is reminded of Oscar Wilde's pronouncement.

The Union of Russian Artists

In the last two decades of the nineteenth century young painters around V.D. Polenov in Moscow formed the nucleus of what might be called the avant-garde of that time. They tried to replace the 'what' (tendentiousness of subject-matter) with the 'how' of art (influenced no doubt by the French Impressionists). But at the time the Moscow circle had no leader, and Polenov, being a member of the Wanderers, did not want to become disloyal to them. It was not until 1903 that the U.R.A. (Union of Russian Artists) was founded. Even judged by western standards, the impartiality and seriousness of the objectives of the U.R.A. stamped it as the most progressive artistic movement of its time. The membership of the U.R.A. was made up of artists concerned like Pasternak himself with their work only, and in contrast to the Wanderers and M.I. they had no writers or 'heralds' among them to advertise their work. Their antagonists took full advantage of this. As a result, the accounts of art writers engaged mainly in the glorification of their

personal friends formed a completely distorted picture of modern Russian art in general, and of U.R.A. in particular.

As a co-founder and active member of U.R.A. Pasternak thought it his duty to restore the truth:

> I would like to give a sketch of the U.R.A. The history of its origin, its past, the way it went, its aims and its tasks – all this is an important page in the history of our art. Together with my colleagues having contributed to its formation, having had at heart its fate, having lived through its adversities, and having witnessed its progress – I would like to capture the memories before, with the passage of time, the traits become effaced . . . I would like to commit them to paper, for one day they might be useful for those looking for authentic material, interesting from an historical point of view . . . I am dwelling on the question because, to my deep regret, the future student of Russian art will find . . . material left in the opposed camps, and as to the unbroken silence of U.R.A. . . . it will not, I am afraid, be interpreted as the modesty of serious reserved artists.

Restraint, disgust with party politics, undivided loyalty to the cause of art – this is what above all distinguished the members of the U.R.A.

In the eighties and in the middle nineties the Moscow house of the Polenovs became the centre of genuine artistic fervour. Pasternak tells us: '. . . There we assembled, there we discussed our needs, our wishes, our hopes . . . Polenov and his sister, conversant in many languages, introduced us to the leading English "Studio", to the "Pan", the "Secession" etc. The new ideas could not fail to influence us. They fell on propitious ground . . .'

It is here that Diaghilev steps on to the scene. And Pasternak, though remarking that Diaghilev 'reaped the fruit of our labour', bore him no grudge – indeed he praised him for his gift of organizing, for his flair, and so on, and he remarks: 'The talented Diaghilev rightly guessed, and took advantage of, the young painters' moods and sentiments which were in the air, and formed his new society, "Mir Iskusstva" in Petersburg.'

Pasternak and some of his colleagues used to show their work at the exhibitions of the M.I: Diaghilev himself was well disposed towards the Moscow group, some of the others of the M.I. were not, as Pasternak tells us: '. . . the dictatorial behaviour there became intolerable, and necessitated our separation – it led to the foundation, in Moscow, first of the "36", and subsequently, in 1903, of the U.R.A.'

The ascendancy of M.I. was of short duration. In 1903 it stopped its activities, and the majority of its former members, among them Benoit, joined the U.R.A.

Although Pasternak never says so explicitly, viewing the situation in retrospect, one has good reason to believe that Benoit joined the U.R.A. with the hidden desire, subconscious perhaps, of manoeuvring himself into a leading position. In this he failed. Pasternak writes:

> The fundamental principles uniting the '36' on collective lines had been in the first place, the absence of a jury, or hanging committee – a complete freedom of creative work and self-determination for all those taking part in the exhibitions. These principles were quite unknown to the organizations of the Wanderers and the M.I. . . . As a striking example, I might take the case of the late M.A. Vrubel who, as the founder-members will remember, simply thirsted for the liberation from the tutorial spirit, for tastes – often mere whims – of this or that judge. Each participant of an exhibition (every member of the U.R.A.) is his own supreme judge.

This mention of Vrubel is not a superficial detail. Indeed so unbiased were the founders of the '36' and later of the U.R.A., so full of respect for one another, and so tolerant, that a man as original in his artistic conceptions as Vrubel could coexist there with one of the pillars of the Wanderers, the famous Surikov who had left the latter, and joined the U.R.A.

The case of Benoit does not weaken our image of the U.R.A.'s tolerance. After a few years of his slighting his own fellow-members of the U.R.A. in the press, they very politely explained to him that it is against both comradely relations and the standards of ethics to belong to a society and at the same time to poke fun at it. Benoit chose to leave the U.R.A. and continued to provoke controversy from outside.

Pasternak tells us that: 'The significance of the U.R.A. becomes apparent if we consider that it grew, and became firmly established in the throes of constant struggles, invisible to the outsider, precisely at the time when almost yearly there was a change of views, tastes, and art movements; when incessantly new ventures, groups, and exhibitions arose and collapsed.'

V.P. Lapshin confirms this in his book on the U.R.A., *Soyouz Russkikh Khudojnikov* (published by *The Artist* in Leningrad, 1974), in which he describes its growing success to the point at which, through its annual exhibitions, it became the focal point of Russian art.

Pasternak's view of the artist's role is clear:

> It is our mission to pass on our knowledge to the following generations, and to perpetuate artistic culture . . . All the young engaged in 'new' art activities have absorbed our life-blood, they are our pupils, both literally, and figuratively . . . Extremist tendencies now seem to be dominating the scene. However . . . I am confident that . . . eccentricities will fall away, and that of all that was proclaimed as new achievements only those trends will remain which will stand the test of time and will prove deserving to survive in the continuity of real art.

It is difficult to define what 'real' or 'pure' or 'genuine' art is. It seems that to Pasternak it meant spiritual communication between the artist and his fellow-beings. The channels of its influence, the means of expression, are of a purely pictorial character. And this language of paints governed by the laws of draughtsmanship sets the limits to the scope of its message.

Unfortunately, aestheticians are mostly out of contact with the specific language of different arts, such as music, painting, poetry. Irrespective of their basic forms of expression, they are all thrown into one cauldron, and cooked up together under one overall name, such as 'symbolism', 'realism', 'romanticism', or whatever. Accordingly, art epochs are labelled with fancy names. If these were only simple labels such as 'Ming Era', or 'Crete Epoch', or 'Dutch School', or 'Barbizon Circle', all would be well, for they would only indicate a certain national or artistic grouping, a stage in the development of art in a certain time. But the innumerable 'isms' of the aestheticians have a para-philosophical flavour detrimental to the essence of art.

To wind up Pasternak's assessment of the achievements of the U.R.A., I would like to quote an optimistic statement of his:

> By the series of its exhibitions the U.R.A. has shown its tolerant and broad approach to the tasks of art . . . It has acknowledged and supported all that was best in it, and has given the young the possibility of expressing themselves freely, uninhibited by imposed tastes or personal dominations. With all that it has remained true to its original self in spite of the adversities it had to encounter, in spite of hostile attacks . . . We have paved the way for the young who are our successors, and whom we have spared the exhausting struggle. The part which the U.R.A. has been and still is, playing in the development of Russian art will be revealed and acknowledged by future writers. Art is eternal. Unscathed by

perils which in the past have threatened its progress, we have helped to preserve its integrity, and to pass on to coming generations its pure and noble voice.

Postscript

I tried to draw the reader's attention to some negative aspects which saddened the life of a Russian artist at a certain time of his career. Having finished with them, I am glad to say that on the whole Pasternak's life was a happy one; that he devoted himself with never-flagging inspiration and joyful ardour to the cause of his beloved art; that his wife, an eminent pianist, made him acquainted with music and musicians; that all through his life he had many friends; that many outstanding people of his time were immortalized in his portraits; that he never ceased to learn, to experiment, to perfect his means of expression, to try to raise to mastery his innate abilities; that he worked with the same enthusiasm in his last days in Oxford as he did in his young manhood in Odessa.

From the Past

I have been asked to add a few personal notes. This is a difficult task. A few lines only? The result would be one of coldness and remoteness. Indulge in reminiscences? I might catch myself telling a family story which does not belong here. Besides, whatever there is of biographical interest, my father has mentioned – more vividly than I could ever have achieved – in the pages of this book. Whatever I might jot down could be only a few flashes from the past – unconnected in space or time, or in any other kind of logical association.

As a child I probably did not attach too much significance to what my parents were or to what they did. I knew that my father was 'a famous painter', that my mother's music was 'something heavenly', but that for the sake of her family, for our sake (if we were ill; if she had to help Father), she would forget everything

concerning her own self and give us her wholehearted attention.

When I was already grown-up, I remember that in an angry mood I said to a friend: 'My parents . . . you know . . . even they are not absolutely faultless . . .' She looked at me in surprise: 'What do you mean? Did you think that your parents are the incarnation of perfection?' That, I suppose, was just what I thought, and cannot help thinking to this day. Of course they had their weaknesses or else they would not have been human, but even these weaknesses made them lovable to us as marks of their characters. And like most families, we did not always agree as to our views on this or that – but that was never a reason for blaming them.

I remember how just after the war a question was being discussed on the B.B.C. radio by the then most popular 'Brains Trust': supposing an incendiary bomb fell on a museum containing treasures of art, what would your first impulse be – to save a work of art, or the attendant in the building? Art or Life? I thought: what would my parents have answered, they to whom art meant so much? 'Life', they indubitably would have answered. For they believed in the priority of God-given life.

My mother, with her passionate disposition, could not obey two masters: her music, and her husband and children. She had, she thought, to sacrifice the former. Her subconscious, however, avenged itself, wounded as it was by this terrible self-abnegation: she suffered from an acute heart-neurosis. As she grew older her illness, some of the time, became subdued, but it never really left her. And Father? He too would drop work, and sit on Mother's bed holding her hand when she was suffering from one of her heart attacks.

I cannot remember my father without a brush, or chalks, or a pencil in his hand. In his studio, in the nursery, he would draw and sketch. He would never leave home without his little sketch-book – the smaller it was, the better – so that he could make his quick drawings unobtrusively, in the hollow of his hat when sitting in a concert hall, or attending a public lecture. But even in the street he would sketch – now a horse, now a group of gesticulating people. Thus, next to his famous sitters, there are among his portraits those of ordinary mortals, pictures of chance meetings, and so on. Somebody had called my father 'the Poet of Everyday Life'. This is quite true; he knew how to instil into domestic scenes, into humble manifestations of life a tenderness, a poetical note all his own. And even his major works, still life, landscapes, interiors bear that signature of poetical interpretation. His sketch-books are with my brother and my nephew, in Moscow. The pictorial entries, like entries in a diary, could help to

reconstruct the story of his life, and that of others around him.

My mother's emotionality had to be counterbalanced by father's 'strictness'. It was no more than a pretence (thought useful by our parents) which would guarantee the children's obedience. There was no need for it. Like most of the children of that time we were obedient, and never had to suffer from Father's assumed 'strictness'. In later life I came to realize that in fact he was exceptionally gentle. When I was a twelve-year-old girl I was fascinated by my brother Boris, the poet. When, however, in the twenties my sister and I temporarily stayed in Berlin with our parents and when the setting called for a closer relationship, a kind of spiritual reorientation took place. Then only – not automatically as in our childhood – did we begin to understand and value our parents' exclusiveness blended with an astonishing modesty.

We spent the summer of 1931 as paying guests in a country house situated in a big garden, on a mountain slope over Schliersee, a Bavarian lake. As usual, my father worked enthusiastically: the beautiful lake, its surroundings, *plein-air* scenes, portraits. In the evenings one had music. And then my mother was asked to play. Nobody, of course, was aware that this woman who looked so unpretentious and motherly was no other than the spirit of music. When later in the evening we were back in our rooms upstairs, in a voice of pure admiration Father said to her: 'I now realize that I ought not to have married you. It was my fault. You have sacrificed your genius to me and the family. Of us two you are the greater artist.'

A week before the Second World War, on 23 August, Mother died after a severe stroke. The sudden death of his wife, six months after the celebration of their golden wedding, in London, to my father was a blow from which he could never recover. He behaved as wise men do: without complaining, without parading his distress. In Oxford, in the home of my sister, who was married to the psychiatrist Dr E. Slater, Father tried to fall in with the new life without the friend, the companion, the soul of all his life. The presence of his daughters, his grandchildren and his friends, to a certain extent helped him to overcome his loneliness. Gradually he took up his work, he started to write his reminiscences dedicated to the memory of his wife. He was horrified by the atrocities of the war. 'Thousands of years will pass before "the Kindgom of God" will triumph on earth', and he was glad that 'Tolstoy was spared the experience of this war, the inhuman carnage'.

Owing to the war, to his old age, and his poor health he led a very retiring life. Apart from his work, and the hours spent with us and our children, his greatest pleasure was visiting the Ashmolean.

He was now often in a pensive mood. The scarcity of news from his sons and relations in Russia distressed him profoundly.

Used to his sense of reality, his religious firmness, and his somewhat ironical attitude towards philosophizing, it was with a stab of pain that one day I heard him say: 'What is the meaning of life?' He must have looked into an abyss of suffering if he could have asked this question with such pathetic submissiveness. I answered as best I could, pointing out that he should be the last man to ask such a question, as his life had been one of giving and receiving love. But sadly he shook his head. My answer had obviously not satisfied him.

During the war years the house in Park Town Oxford where Father lived became a sanctuary. My sister felt she could not refuse anyone, and it teemed with European refugees, London evacuees, and other people who had lost their homes. With bewilderment, yet sometimes with a twinkle, Father used to look at this motley crowd who sometimes behaved very oddly indeed.

He was one of the very few who even in the darkest hours of the war retained a sense of proportion and did not lose courage. Chance visitors who happened to call at Park Town would be reassured, and would regain hope after a talk with Father. He admired Churchill: 'Oh, how wise this man is. Don't you worry: he will see this country through to final victory.' He spoke of peace, of progress. What a blessing that he was spared the news of the Hiroshima crime. He died on 31 May 1945.

In a way, my parents' life was a puritanical one. Strange? They were artists. And artists are supposed to be anything but puritans. Purity would be perhaps the more appropriate expression? Yet we must not associate with it a lack of enjoyment of beauty, of occasional gaiety, of innocent pleasures, of the deep bliss of aesthetic revelations. Mother sparkled with vitality, Father had a subtle sense of humour which often delighted us his children and his friends, and which, as often as not, helped him to overcome unpleasant experiences.

In life and in art they did not glance to the right or to the left. They did not stray from the arduous path of creative progress which is a straight one.

When Mother died it was as if harmony had abandoned the world. When Father died it seemed that truth had left it.

My Life

Early Childhood

Odessa

My early childhood is divided into a 'fairy-tale' period and a real
one. Our old courtyard, for instance, seems like a legend to me
now. It was really quite enormous in its proportions. At the main
festivals (Christmas and Easter) the courtyard would be com-
pletely empty, since the peasants, or *chumaks* as they were known
in Ukrainian, would have left this 'inn with rooms', as the big sign
on the gate said, and gone home with their carts and oxen and
horses – and the whole place would become a little eerie.

At the end of the courtyard, opposite the gate and between two
stables, there was the most interesting 'fairy-tale' of all – a wooden
hut, or something on those lines. When you opened the door to
enter, hens would rush out in agitation from right under the
Russian stove, and cockerels would flutter down from the top of it,
infected by the hens' hysteria. But weirder and more legendary
than anything else were the two half-mad, half-drunk brothers
who lived in the adjacent rooms and who were said to have been
the former owners of this 'inn with rooms'. Whether they were
crazy or simply unhappy remained a mystery. Their past was an
enigma, their present – an even greater one. How did they live and
what did they live on? They never cooked anything, but only
drank, and hardly ever left their den. For us children, there was
something terrifying about these mysterious individuals who were
more dead than alive. In actual fact, they themselves were afraid of
any stranger and used to hide away from people. In all probability
the new owner of the house, a prominent official who bought it

very cheaply, allowed the brothers to live out their days in that hen-coop.

My father used to rent the house, or rather, not so much the house as 'the courtyard with corner wing' consisting of eight separate numbered rooms for petty landowners who would arrive in their huge, unwieldy carriages and tarantasses straight out of Gogol.

When the yard had enough manure in it, this future fuel (or *kizyak* as it was known locally) would be cut up into square briquettes and stacked in pyramid-shaped heaps to dry. And there, surrounded by these heaps, we would play. These pyramids were of enormous interest to us children, and we carried on playing and hiding behind them even later, when we had already begun to read Mayne Reid and Fenimore Cooper. With their cone-shaped silhouettes resembling Red-Indian wigwams, we would hide behind them and attack the pale-faces – what marvellous scope for children's imaginations!

'Dearest sister, Asya.[1] You are the only member of our large family still alive. You alone, my companion and faithful friend, you alone remember the strange things which happened while I was still in my cradle.

'I can almost see the scene now! A tall, emaciated woman, worn out with work and care, runs out of a semi-basement into the tiny courtyard of a house filled with poor inhabitants. It is our mother, groaning and wringing her hands in despair. With a heart-rending cry she begins to appeal to people to help save her dying baby. The neighbours who happen to be around surge into the tiny room with their children and see the two-week-old infant convulsed in its cradle, obviously dissatisfied with this world and about to leave it for the next. The room quickly begins to fill up with noisy, sympathetic onlookers, but of all the people clustering around my cradle and shouting, each after his own fashion, only one, a little tailor, knew what had to be done. "Hurry up! Give me the biggest jug you have, quickly! Make way, the rest of you!" And raising the empty jug high over my head, he hurls it to the ground. There is a deafening crash as the crock smashes into smithereens. It seemed as if the evil spirits which had been torturing me and dragging me off to the next world took such fright that they straight away flew out of my body. Suddenly I came back to life and turned quite pink.

'Our dear mother and elder sisters often used to tell us about this when we were children, which is why the story made such a vivid impression on our childish imaginations.

'One of my first real memories as opposed to the "fairy-tale"

ones which preceded it, is of one New Year's Eve when I was three or four years old. I really can remember this event very well.

'A peaceful winter's day gave way to the profound dark and quiet of a winter's night. The last peasant lodgers had left our enormous courtyard. The rooms and the stables were empty. There was not a sound to be heard. It was peaceful, eerily peaceful. Two figures left through the glass door of our flat and emerged into the mysterious blackness of the starlit night. The larger one, dressed in smart clothes, clasped with one hand a large, round dish, wrapped in a red kerchief; in the other he held the tiny hand of a boy, warmly wrapped up in winter clothes. It was my father and I. This was the first time I had left the house at night. I can well remember the dark, starry sky. The thick black night stared down at me and filled me with inexplicable terror. I shall never forget the bright, glittering stars twinkling overhead, the mysterious silence of the streets and our strange, noiseless, ceremonious, almost sacrificial progress.

'We said not a word, the two of us, but moved through dark, empty streets which seemed endless to me. But finally a lighted window appeared as we turned a corner. Something brightly coloured was shining in it. We approached our goal – Duryan's famous confectionery shop at the corner of Preobrazhensky Street, opposite the city gardens. The illuminated windows were filled with something quite unprecedented, the many colours of which shone out yet more brightly against the darkness all around. Suddenly I saw pies in the window, cream cakes, pastries, filled-rolls, and open boxes with sweets I had never seen before – the meagre fare of our everyday existence contained none of this, it was inaccessible, marvellous – and all the more fascinating and thrilling for that.

'We entered the shop. It was a magical world and quite unique. Behind the clean, glittering counters, shop-assistants removed brightly wrapped objects from the shelves. Customers waited, like us, and then went off with cream cakes and sweets. I shall never forget this sparkling room with its biscuits and sweets of all shapes and colours glittering beyond my reach like the stars that had accompanied us on our journey!

'My eyes lit up at the sight of this abundance of good things I had never seen before. I stood there clutching my father's hand and filled with joy. Mr Duryan was a good-natured man and understood everything from the expression on my face. He turned to the counter, chose an almond cake and pressed it into my hand. My father thanked him on my behalf. Finally, Father collected the cake he had ordered, placed it on the plate and began to wrap it up carefully in the dark red kerchief which he had brought with him.

17

'We went out onto the street. The same dark, starry night greeted us, the same empty, unfamiliar streets, the same silhouettes of unlighted houses. It seemed solemn, eerie. I clung close to my father, filled with impressions.

'At home, when the ends of the kerchief had been untied, the whole family gathered to examine the cake. We couldn't take our eyes off it. Like some sacred object, which we children could look at only from a distance, it spent the night in our house, as I later discovered, our father took it to our landlord, the government official Untilov, who was a very important person in our eyes. Father gave him this cake – an act filled with some sort of significance – and wished him and his family a Happy New Year.

'And do you remember the courtyard where the gypsies whom we so feared set up a proper camp? In the courtyard every evening convoys of unwieldy carts and creaking wagons would assemble for the night. These were accompanied by the obligatory pack of sullen dogs, and drawn by oxen in harness, marvellous creatures with intelligent eyes and large horns. Only in Umbria did I ever again see animals like them. Ukrainian peasants with their straw hats and grey canvas shirts bespattered with tar, their wide trousers and boots, mingled higgledy-piggledy with landowners' coachmen soothing their neighing horses. Those enormous and peculiar baggage-wagons drawn up in fours! Those phaetons, gigs, *britschkis* and buggies! Those old-fashioned carriages which used to seat old-world landowners, surrounded by their belongings, and straight out of Gogol, petty landowners with their families and children who used to put up at our so-called hotel! What strange characters we saw amongst those former owners of live and dead souls (for serfdom had been abolished only a few years earlier and its spirit still lived on in these people). But that is a special chapter in the history of Russian culture.

'I can see them now, that unique and extraordinary collection of characters, all of whom have slipped away into the past forever. Just as I can see the Tartar pedlars and their wives who for some reason or other had moved in below us. Some had two wives, some had three – along with all their children and that peculiar smell of Kazan soap which accompanied them everywhere.

'One would have thought that my childhood imagination would have been confined to things urban, but in fact it was nourished on country impressions. Although we lived in the town, our courtyard was more like a village and we were surrounded by things rural. This courtyard with its carts and wagons, its horses and oxen, its *chumaks* and coachmen and Tartars – helped enrich my artistic imagination enormously, as well as develop my sense of observation.

'Every evening peasants would arrive to stay overnight, bringing with them their bread to sell. Their lodging would cost them only a few kopecks. By nightfall the yard would be filled to overflowing with wagons, people and animals. There was a strong smell of manure and the sound of neighing and chewing was everywhere. Even now I can still smell that peculiar odour of horses' harness and tar, I can still hear the muffled lowing of oxen, the snorting of horses quarrelling and somebody's sudden and penetrating cry: "You swine!" The customary sounds of this great encampment died down on the eve of great feasts when everybody would go home to their villages and estates, and by night time, the courtyard would be pitch dark, its empty stables yawning like gigantic jaws. And only in our tiny flat, which lay adjacent to the empty wing of the hotel, would family life follow its own course.

'Of course you'll remember my first childhood drawings. But do you remember my first Lorenzo de Medici? That Maecenas of a yard-keeper who ordered my first *Hare-Hunt with Borzois* and who paid me five kopecks for every painting like it? What was this true art-lover doing amongst so many petty shopkeepers and the denizens of a coaching inn? I can remember standing in front of him when I was small, with him holding onto me and carefully following every movement of my pencil, exclaiming from time to time: "That's it! You've got it just right!" I remember the borzois chasing after hares as well. Sometimes the dogs would be white, sometimes grey, depending on which ones he wanted for the painting. Where did I get the paints from? And what kind of drawings could they have been, for I was hardly up to tackling such tasks at that age (I was no more than six or seven years old). Meanwhile, he had a reason for paying me for these pictures: they used to adorn the walls of the gatekeeper's lodge.'

I can only properly remember my early childhood from the time when Father's affairs took a turn for the better and he rented the vacant area described above – the courtyard and wing. 'Gryuzdov's House' was known throughout the regions and visitors used to travel from afar since the rooms were very cheap. Where we lived, on the outskirts of the city, was very provincial, almost like a village. You could see the sea, as well as the little settlement of Romanovka near by. We now lived in more spacious accommodation, consisting of a kitchen and two small rooms. This little flat, where I spent most of my early childhood, has a firm place in my memory, first of all because of the simple wooden staircase, open to the elements, which led fairly steeply into our flat from the outside. This wobbly staircase stretched to one and a half

flights and had been built onto the flat long after it was finished. In our family there were no servants and of course we didn't have a nanny. We children were left very much to our own devices, and the younger ones, with nobody to look after them, would often fall head over heels from the top of the stairs to the bottom. Only the sound of the unfortunate child's shouting and crying let the rest of us and our ever busy mother know that the usual catastrophe had happened again. The older children would run downstairs, usually carrying a mug of water to sprinkle over the poor devil's face before lifting up the routine victim of these ill-fated stairs. Being the smallest child, I would often lose my footing on the top step, and would fall right down to the bottom, where I would normally remain – shouting and crying – until my despairing mother arrived to pick me up. For some reason, the place where she lifted me up would also be sluiced with water. I can remember these regular disasters even now. Suddenly everything would lose its customary firmness of outline, objects would begin to spin round, swapping positions with each other until part of the body got badly knocked and began to hurt to the tune of screaming and groaning. I can well recall stumbling and noticing immediately how the sky and roof, then the roof and windows and finally the entrance and ground would spin round rhythmically according to the position of my body. But God was merciful and everything turned out all right – until the next somersault.

My second earliest memory concerned the kitchen where Asya, Sasha and I, the three youngest children, would spend most of our time in the winter, clinging to our mother's skirts. There was one especially warm, clean and comfortable spot in that kitchen – right by the stove where Mother used to cook marvellously tasty and sweet-smelling loaves.

During the long winter evenings Mother would go there herself first of all and would then gather us younger children together to listen to moving stories about her life in the country before she got married, and about her own past. It's for this reason, of course, thanks to her own frequent descriptions, that I can 'remember' the scene of me in the cradle which I described above. There was no pleasure greater than sitting by the stove where it was so warm in winter and listening to our mother's stories.

Of the small landowners who used to have estates close to the city of Odessa, I can remember one particularly unusual pair – a priest whose name I have forgotten, Father somebody or other, and his wife, the 'vicar woman' as the peasants used to call her unceremoniously. He was nicknamed 'The Bear'. He was a tall, thin,

irritable man in a grey cassock who looked not the slightest bit like a bear except perhaps for his deep-set, tiny grey eyes. His wife was his complete opposite. A large, very fat woman, she was extremely good-natured and would talk about things in the minutest detail and at breakneck speed, jumping from one subject to another, completely unrelated. As she did so, her intonation would also change completely, but there were no logical transitions and she would often finish a conversation by asking unexpectedly: 'And how do you bake this bread, dear hostess?'

People used to say of her husband that he'd once begun to complain because some 'drunkard' of a priest had a rich parish while he, who never touched a drop of vodka, had a poor one. To this the bishop is supposed to have replied: 'The devil doesn't drink either, but look how much harm he does to people . . .'

I am indebted to the priest's wife for one extremely vivid childhood memory relating to the *Yarmonka,* as the Odessa market used to be known colloquially. Once a year at the beginning of autumn a special building beyond the city limits used to serve as a venue for the fair. This was the empty Nikolayevsky house, built after the fashion of a Moscow riding-school, and here it was that the peasants from the surrounding villages would gather together after selling their harvest produce. The priest's wife took my mother and us younger children there a couple of times. We used to harness a charabanc and cover its floor with fresh hay to make the journey gentler and more comfortable. But, alas, the way it bumped over the stone roadway was still awful. Our hearts, however, were in such a festive mood that we used to forget about all the bumps. Before reaching the building, we would hear the loud din of the fair coming towards us. There were all kinds of different noises – the clamour of tradesmen selling their wares, the tinkling of bells at the lemonade booths, the sound of children's toys, the hum of the crowds. As happens with children, the whole thing was magnified tenfold and the effect produced on me was quite deafening. We went into the building itself and were greeted by the marvellous smell of honey-cakes, new sheepskin coats and Russian leather boots. I can still smell that peculiar mixture of odours. In actual fact, apart from what I have already mentioned and a few tents selling toys, I can't remember anything of what was on sale there – only the clumsy peasant boots, strong-smelling and smeared with tar hanging in front of the booths, and a few stalls with sheepskin coats – but the sounds of tradesmen attracting customers and the general hubbub were stupefying! In a word, it was just like what you used to get on Palm Sunday in Red Square in days gone by – on a smaller scale of course, but all the more deafening because it took place in an enclosed area.

Tired from walking over the freshly strewn sand, exhausted by the crush and din, and with honey-cakes and cheap toys in our hands (Oh! how I remember those painted wooden horses – I can see them even now, as I can still smell the aroma of those sweets), we returned home, full of contentment and deeply affected by our experiences of the day.

As I have already said, I started to draw very early on and came to like it very much. The drawings of my elder brother David (who died when he left school), made an unforgettably deep impression on the four- or five-year-old boy that I then was.

It is difficult to understand how the family of two such simple people as my parents, who were remote from art in every way, should have contained two artistically inclined sons. I regard the law of heredity as being beyond dispute, and in fact my father did possess artistic ability. There were rare moments in his hard, work-filled life when he did allow himself a little levity by giving an excellent depiction of somebody's way of speaking, behaviour, etc. My mother, on the other hand, who was born and raised in the country, loved nature and flowers to distraction; roses in particular. Thus on the one side, there was my father's power of observation and his love of mimicry (grasping intuitively what was most typical in a person's speech or behaviour) and on the other, there was my mother's love of nature and its colours. These traits are the essential elements of fine art and were combined differently in the two of us.

Having spoken of my early passion for drawing, I should say that in the spartan atmosphere of our home (this is how we later used to refer to the upbringing we received from our father), my parents were not only angered by my enthusiasm (they regarded it as a senseless caprice), but they were also alarmed and disturbed by it.

My mother grew up in conditions of hard labour and deprivation. All her life she feared penury above all else and could imagine only with horror that her 'Benjamin' (I was the youngest member of the family) would grow up to be a simple artisan-painter, to judge from his penchant for drawing and 'daubing' all the time. The uneducated environment in which I was raised meant that people could have no conception of what art was, or what artists did. To them 'daubing' was the work of artisans who painted floors, roofs, the outsides of houses – men that were always soiled and dirty. Was this the future that one might wish on one's favourite son?

At the beginning, people at home still tolerated my attempts to

be alone, but it wasn't long before the business of catching me drawing would make them sigh and shout out in desperation: 'Oh! he's drawing dirty hindquarters again!' This strange definition of what I was doing was the result of the following. My brother Sasha once got hold of part of a circus poster with an elephant printed on it. For want of anything better to do, I drew a copy of it. Then I started to colour the drawing with some wax that my brother had got from somewhere. My family caught me colouring in the back half of the elephant's body and, for some reason, from that moment on any and every work of art of mine was greeted with a sigh and that same sarcastic exclamation. This scathing estimate of my work lived on in my family for a long time and accompanied any effort of mine to learn anything for myself. 'Aha! he's drawing dirty hindquarters again!' reverberated around the room even later when I was a bit older and attempting to paint Grützner's[2] pink-faced monks, eating oysters with gusto.

My dear mother, who knew the suffering of poverty from her own experience, loved her children to distraction, and her every aspiration was directed towards launching them into the world with at least a modicum of capital attained by the slow amassing of every kopeck. She was more in favour of education than my father and succeeded in getting my younger sister into the girls' high school. By dint of denying herself the more necessary things, she managed to achieve her dream: Asya began to take piano lessons! It was intended that I should become a doctor or a lawyer, however. I see now that my parents were fully justified in wanting to protect their son from the hard life of a simple worker or house-painter, although they failed to understand that it would be difficult to destroy my innate flair for drawing which was to appear again with greater strength in the future. But at that time my whole childhood and youth were a long and sustained struggle for my vocation and for the opportunity to receive any artistic education at all. Only now do I understand the suffering and division which must have been engendered in my mother's soul when she, an angel of goodness, incapable of harsh measures, was forced to act against her own gentle nature by burning my drawings in the stove in order to eliminate the evil at the roots and to save me from future misfortune before it was too late.

I hadn't the slightest notion at the time of the existence of oil paints or of how they were used. For this discovery I am indebted to a simple decorator, a real house-painter, who was at work in our house. He told me of the existence of such pigments, that they were sold in tubes and even pointed out a shop in Greek Street on the Old Bazaar where I could buy them. For a long time I put money aside from what was given me to spend on lunch at school

until I had finally collected thirty or forty kopecks, enough to buy me a single tube. But which colour was I to choose? I made up my mind: it would be emerald green. I was very happy to have acquired this precious tube, although at bottom I hadn't the faintest idea what to do with it.

But one day an artist of sorts came to our courtyard. He was a real Ukrainian, a pupil of Shevchenko and apparently in dire need. He used to paint young Ukrainian girls in national dress with wreaths of wild flowers in their hair and would sell them for a song in the doorways of Deribasov Street. I shall never forget that it was from him that I acquired my first canvas – a winter scene copied from a study of his. But this landscape ended its life in the same stove.

Primary School and High School

Here is an event from my childhood which could serve as magnificent material for those celebrated school compositions on the theme of 'The Lofty Significance of Art and its Beneficial Influence on People's Morals'. This was the triumph achieved by my 'Siamese Twins'. Before entering high school I attended a local primary school. Its headmaster was a coarse, cruel man who used to punish his pupils for the smallest trifle and who was accustomed to beating the children in a particularly cruel and merciless way after removing one of his galoshes. He suddenly underwent a spiritual renewal when he happened to notice that one of his pupils, or rather victims, had drawn a picture of the Siamese twins, very fashionable at that time. He seemed to be so amazed at this unusual occurrence in his life that, having first set my mind at rest, he took me by the arm and conducted me to his own flat so as to show me and my work to his wife, who was a pleasant old lady. At the same time he carried my drawing as if he were showing it to the whole school.

There are a few episodes from this period of my life which I remember perfectly and which show that, despite the opposition of my family, I continued to draw, especially after I entered the Richeliev High School, and also that my work earned the approval of the whole class.

It happened when I was in the second year, which means that I

was aged eleven. I drew a picture on the blackboard of our bad-tempered German master whom we used to call 'Hippo' because of his corpulence and general clumsiness and also because of the mumbling way he began his sentences. The whole class insisted that the drawing shouldn't be rubbed off but left until the teacher arrived in the classroom, and also that nobody should give away who had drawn it. 'Hippo' arrived, stared at the blackboard and grew savage with rage, suspecting that it was indeed a caricature of himself. He sent for the inspector. My heart sank. I was petrified. Supposing they gave me away? What would happen to me, what future lay in store? Expulsion, I supposed. And what about my family? What would my father do to me?!

The inspector arrived. Everybody stood up. 'Hippo' mumbled: 'Hum! Hum! the number of times this has happened!' (a manifest lie as this was the first time). The inspector: 'Who did it?' No reply. 'Who did it?' Not a sound. The silence was eerie. 'Who did it?' He repeated these three words several times but nobody gave me away. 'The whole class will go without lunch for the whole week!' With this the interrogation came to an end. The whole class really did go without lunch for several days in a row, but that was the end of the incident. Comradeship was held to be sacred by the pupils. It is true that the pupils were of the old seminary type. It will seem implausible now but the second-year class in which I was the youngest also contained pupils of such an age that one of them, a very good-natured fellow called Dolgy (the name means 'Long' and might have been specially invented for him) didn't leave the class until he was twenty years old, and that was the end of his education! He went back to his place in the country where he was supposed to take over the estate after the death of his father.

The fact of the matter was that the Richeliev High School was the last educational establishment in the city to retain boarding-houses for its pupils, where the children of landowners living not far from Odessa could receive full board and lodging. These lonely 'children' – like Mitrophanushka in Vonvisin's play – would bring tops with them into the classroom, driving them along with whips. When the teacher entered the class, these sixteen- or seventeen-year-old 'children' would lackadaisically wander back to their desks at the rear, slowly, silently and with great composure. We'll never see the like of them again!

I could relate quite a lot about my high school days in general, about the events and pranks that I took part in, but I will only touch on things that were directly connected with my drawing.

From the Richeliev High School, which for the most part educated members of the Odessa bourgeoisie, I was transferred to the fifth class of the second Odessa State High School. It would

take a long time to recount how I first entered the preparatory school against my will, left it and went back to the Richeliev School, which I abandoned once again unbeknown to my parents, returning to the Second State High Schol, etc. There it was that I met the person who, despite the enormous difference in our ages, became my best friend – the French teacher Claude Yakovlevich Liote who revealed the new horizon of modern art to me, and to whom I am indebted for a great deal. The most pleasant and good-natured of men, he was interested in art and, as a Frenchman, in French art in particular. He had once drawn in his youth, and he used to tell me about many interesting things I had never dreamed of – exhibitions, picture-galleries, museums, the collections of celebrated artists! In the cultural desert in which I lived, his friendship and stories were regular oases. He was the only person at the time who supported me in my aspirations and dreams concerning my future work as a graphic artist and painter. He was the only person who encouraged my vocation in general.

Thanks to him my dreams took a firmer form. Every summer he would return home to his family in Besançon and bring me back catalogues of the drawings and paintings of various artists. In Besançon there lived the famous painter Gigout,[3] a friend of his, about whom he talked often and in great detail. I would listen to and imbibe all these stories about the life and work of a real artist, something which I could scarcely imagine. As usually happens with teachers of non-compulsory subjects, this French master was badly treated by his pupils. They would get up to all sorts of childish pranks in his classes and would exploit his humanity and good nature. But to me he was the dearest of men.

When I was already fifteen, he came to see me at home. The fact that a teacher in uniform was visiting a pupil at home was quite an event in our family. Art, which was so incomprehensible to my parents, thus received the right to exist. It caused an even greater sensation when Liote once brought a Mr Marazli[4] with him. A great friend of Liote who had once lodged with him, Marazli was a serious art-lover, too, and Mayor of Odessa to boot. In our provincial life such a visit (what an honour!) naturally gave my drawing some sense and importance. I can no longer remember the purpose of the visit, but I was already older by then, in the eighth class, I think.

Liote must have mentioned my artistic achievements in the staff room, for one fine day I got a terrible fright when the headmaster summoned me to see him. He asked whether I could paint a portrait of the district administrator, Mr Golubtsov, as a gift from the school to mark his retirement or transfer to another area, I don't remember which. I naturally agreed. The commission was

unpaid and not even artistic because I had to paint his likeness from a photograph and not from life. But it was a total success and the contented headmaster never stopped thanking me.

Actually, this was my second 'commission', properly speaking. The first was to produce a great coloured banner to decorate the school on the occasion of some anniversary or other of Alexander II's reign.

The great advantages of this 'commission' were as follows: 1) I didn't have to prepare my lessons and wasn't called upon to answer questions in class for a long time; 2) when one of my classmates didn't know his lessons, I was able to call him out to help me in my work; but above all, 3) we were brought tea, tasty buns, jam, etc. from the headmaster's table. The banner turned out magnificently and the headmaster shook my hand to thank me, not in any official way, but with complete sincerity.

The most important memory of my schooldays concerns the humorous magazine which, unbeknown to the headmaster, I used to draw, write and periodically 'publish' myself. It used to come out in notebooks containing caricatures of the headmaster and teachers and also of some of my comrades. The journal used to pass from hand to hand until finally it ended up as the property of my friend Liote.

You can imagine my astonishment when, having left school and received my diploma and various documents, I discovered from him that despite all the measures I took to ensure that the magazine should not fall into the hands of the authorities, it was not only well known in the staff-room, but used to enliven the tedium of the teachers' daily routine, causing much amusement and animation. The teachers, it transpired, even awaited the next issue with great impatience. This was what dear Liote confessed to me. At the same time he told me that he had managed to get the headmaster to guarantee that he would pretend to know nothing about it and that I would therefore 'not catch it from anybody'.

And indeed, in confirmation of this, I can quote an episode which will seem fantastic and improbable to anybody who knew the reputation which our mathematics teacher, K.A. Chepinsky, enjoyed in the area. He was the bane of the whole Odessa district, and positively the whole city knew to what extent Chepinsky was the scourge of the young high school boys.

A lanky, desiccated man with sharp grey eyes and a chilling gaze, he would walk into the classroom with his conduct book under his arm, bringing with him an icy silence and a feeling of nightmarish, inexpressible fear. You could almost hear the beating

27

of the pupils' hearts, like the ticking of clocks in a clockmaker's shop, and this ominous silence would continue until he sat down, placed his pince-nez on his nose, opened his book and began to look at it. Everyone's blood froze in his veins: whom was he going to ask? Whom? 'Pasternak!' his voice sounded briefly. 'Here,' I replied. Knowing my lesson and suspecting nothing, I cheerfully approached the blackboard to await his question. Suddenly he turned towards me and said something. I couldn't believe my ears. 'Now Pasternak, old chap,' he said, pointing to the board, 'just draw a picture of me here.' I was paralysed with fear and went quite cold. 'He's seen it!' The thought flashed through my mind. 'He's seen the caricature I drew of him. I've had it.' I was quaking with fear and my vision began to fade. Stupidly, as if still not understanding him, I started to mumble in a scarcely audible voice, 'I know my lesson, Kazimir Antonovich, just ask me . . .' To which he replied: 'Forget about that. Please, just draw a sketch of me, I beg you!'

But what had happened to Chepinsky? His usual severe features had given way to a human expression, to a smile!

And so he went on, asking me the same thing in apparent sincerity. I realized that I'd have finally to abandon my naïve, perplexed behaviour, so I came to my senses, calmed down and promised to bring him a sketch done specially for him the next time.

The picture I sketched was one of him grilling a group of girls at some examination commission for new teachers. He was sitting there threateningly. One after another the candidates, with fear and terror in their eyes, fell into a swoon, whereupon water was sprinkled over the unfortunate victims, and so on.

When I brought him the drawing, he was apparently so pleased with it that, at the beginning of the next lesson (we had two mathematics lessons in a row that day), he entered the room and – I can recall my amazement – began to apologize for forgetting to thank me for the picture. And this was Chepinsky? He was talking in a completely different language! Never in my life would I have believed that such a metamorphosis was possible.

One caricature from my journal which, thanks to Liote, Chepinsky succeeded in glimpsing in the staff-room, depicted the teachers (including Chepinsky), overcome with joy that the district administrator's visit to the school had just passed off satisfactorily, dancing the can-can for all they were worth (the can-can being a fashionable dance at that time). Another caricature of the same administrator showed him leaving the school in two carriages, one of which contained himself, the other his ears (he really did have very big ears).

Word of the episode with Chepinsky soon got round the town. One mathematician, a professor at Odessa University, begged me to do a copy of the sketch and offered to buy it from me. But I refused and didn't produce the copy. On the day I received my diploma, Chepinsky put me on my guard about the unpleasant or even dangerous consequences which could result from my drawing of caricatures, and said: 'Look here, Pasternak, don't do it any more.'

It came about that our courtyard was visited every day by a young man with intelligent, open features and laughing, light-blue eyes who always had a bundle of newspapers and magazines under his arm and who interested me greatly. I felt strongly drawn to him from the first moment I saw him. It turned out that he was renting a room from the people who lived in our house, and whenever he came back home from town, I would encounter him at the gate and follow him with my eyes, feeling instinctively that we had something in common. Nobody introduced us, but we soon became old and close friends, as it were. I discovered that he was the editor of various illustrated journals (containing caricatures) and above all, the humorous art magazine *The Wasp*, which was enormously popular with the reading public and which I liked particularly for the talented drawings by de Bruchs. M.F. Freudenberg found out about me from one of the conversations we had at the entrance to the courtyard. Later he told me himself that when he first met me and noticed the delighted look in my eyes, he had thought, 'There's a kindred spirit!' Some time went by. Freudenberg, or as we had come to call him, 'the Wasp', left our house and I didn't see him again for some time. Subsequently I discovered that poor de Bruchs had died of consumption.

One day, however, I was walking down Deribasov Street when I bumped into Mikhail Fyodorovich Freudenberg coming in the opposite direction. 'Now there's a coincidence! You know how to draw, if I remember rightly. You wouldn't care to come to my place for a moment?' I was very happy to do so but it turned out that he had simply wanted to test my abilities. 'Can you draw a lady?' I drew a lady. Then perhaps I would draw a gentleman too? I drew a gentleman. 'Excellent. It's all going to work out. You see, my journal *The Beacon*[5] is due to come out in a few days. And the thing is that I need a picture to go with my verse on the first page, one depicting a motley crowd made up of differing social types and all heading towards a group of people dancing around a golden calf etc., etc. Could you do it?' I began to refuse, justifying myself on the grounds that I had never drawn complex things like a group

with many figures and that I could only just manage individual figures. 'Well, have a go, all the same! You never know, it might work out! I have to pop out for a few minutes but you just sit here – here's some paper and pencils and I'll see you later. I'll even lock the door – who knows, you might run away before I come back!' As an intelligent and decisive person, he immediately realized that he'd only get what he wanted by acting forcefully. When he did return, however, – rather later than he'd promised, of course – he was so delighted with what he saw that he could only keep saying over and over again: 'Well, I'm saved, thank heavens! Excellent chap! I knew you could do it. Well done! I'd appealed to our two regular artists but God knows what was going to happen! You know the first number has been announced, and I've still got no illustrator for it. And now the Almighty has sent you along and it's all going to work out splendidly for us all!'

Everything really did 'work out splendidly'. Although I was still in the eighth class at school, I became a regular artistic contributor to *The Beacon* and then to *The Little Bee*.[6] The main thing was, however, that Freudenberg and I became very attached to each other and remained friends all our lives. He even became my brother-in-law when he married my youngest sister.

Like Liote, he too was a connoisseur and lover of art, and for that reason he encouraged my efforts to become an artist. He believed in my natural gift and became the closest to me of all my friends.

The first illustration I did for *The Beacon* taught me a great deal – not only how to cope with a complex composition (about which I hadn't the slightest inkling), but above all, how important it is to be bold and not to retreat in the face of any new endeavour. I would never have dared to test my strength for a printed journal, but my friend solved this problem 'by forcible means' as he later admitted, and thus the aim was achieved.

Every time I was on the edge of ruin for my pranks (about to be expelled from school), I was terribly fearful of the consequences (punishments from my father). But God always spared me and I got away with it. Fate would suddenly come to my aid at the last minute, as in adventure stories.

I could write a whole book about my own pranks and those of my school-mates. When I remember them now and think of the considerable unpleasantness we must have caused to our teacher and mentors, I feel dreadfully ashamed. But our escapades weren't all that malicious. Here is one of them that I remember particularly well.

The headmaster's son, who was not quite right in the head,

sometimes used to step in for our Russian literature teacher. He would tell us about Derzhavin, whom we rebellious pupils despised as a 'court flatterer' and as the one who had received a golden snuff box for his ode *Felitsa* (written in honour of Catherine the Great).[7] The class came up with the idea that I should take a copy of the book about Derzhavin's poetry and print (draw) an extra line in it to rhyme with the end of *Felitsa*. 'A box of snuff my reward shall be', was what we came up with.

I took the book (which was school property!) and added the words as skilfully as I could, imitating a line of print. The class decided that when the teacher wanted to read this ode to us, they would all begin to beg that Pasternak should read it since he was a good reader and could 'manage different voices'. The teacher arrived and, sure enough, when he reached the said ode, everybody started to beg him to let me read it – I was, they said, so good at declamation. They went on so long and so insistently that at last the teacher agreed. I read the ode out loud adding clearly and distinctly the words: 'And a box of snuff my reward shall be.' 'What? What? What's that nonsense you're coming out with?' demanded the teacher. 'But look, that's what's printed here, after all!' He snatched the book out of my hands, insisting that it was impossible, looked at the offending line and nearly had an apoplectic fit. All this time the class was given over to laughter and general hubbub. Some were shouting for me to read it out again, others were making indignant remarks about Derzhavin, and so it went on.

From an early age I have reacted sharply to all manifestations of injustice. Being essentially not a man given to physical struggle and protest, I considered that the best way of exciting influence was through the written or spoken word. I remember the ridiculously naïve speeches I used to make as a child in the rôle of defender of the weak and persecuted, which bore witness to my compassionate nature.

Once when I was about eleven or twelve years old, I was returning home from school by way of the Old Bazaar where a few old women were sitting, selling apples, pears and other local fruit. Suddenly one of the market watchmen (the one who did the cleaning) turned on a trader-woman, swearing at her for selling poor quality produce and kicked over her basket for good measure, spreading her ill-fated goods all over the roadway. While she was picking her fruit up off the ground, crying all the while, I, tearful with indignation, let fly at the watchman. How dared he treat an old woman so badly? He seemed flabbergasted by this

31

unexpected attack and started to justify himself. Meanwhile the other women had decided to take their comrade's part and joined in my attack, as a result of which the watchman decided to withdraw as quietly as possible. In the end the hunted and persecuted of all kinds sought me out (we lived quite near to the Old Bazaar) and begged my protection from all sorts of injury. Soon, however, I had to abandon this role of knight-errant (or 'people's protector' as they nicknamed me at home), for the following episode dampened my enthusiasm.

There was a low drinking establishment near our home. It was a common sight for women to be thrown out on the street and belaboured by their drunken spouses, or vice versa. One such incident of a drunken man mercilessly beating his wife had such an effect on me that I couldn't stop myself running up to him and shouting that he should not dare beat and torment the poor woman. I threatened to call the constable but at that moment the wife turned towards me, screaming: 'And what's it to do with you?! You're a right one! It's none of your business if my husband beats me – because he's *my* husband!'

This unexpected turn of events sobered me and taught me never to interfere in family quarrels again. But the indignation that I felt at the sight of violence and brute force lording it over the weak has never left me.

Odessa. The School of Drawing. Moscow. Yevgraf Sorokin. Moscow University.

In 1879, when I was still in the top class at school, I entered the Odessa School of Drawing.[8] To secure a place at this School, your parents had to make a personal application. My father naturally refused to petition the School on my behalf, since he was not over-fond of my artistic proclivities and considered that this School would hinder my work at the other. But I succeeded, through my school-fellow A. Klein, in finding a member of The Society of Fine Arts who would arrange for me to be taught there, and free of charge at that.

It was there that I first encountered life-drawing. Despite the difficulties involved (difficulties of form, light and shade, not to mention proportions), I managed a creditable performance, and the teacher decided to give me a whole figure to draw (a statue).

Moving on from drawing a head on its own to tackling a whole figure was really difficult; all the more so when you consider that pupils usually spend a year or two drawing heads and busts, and only then move on to sketching whole figures in their natural size (this corresponds to the head class, then the figure class etc.).

I was able to cope with these tasks, but painting a male nude in the so-called life-class was something completely new for me. It was a source of endless fascination. I had, however, become acquainted with pigment before I entered the School and I soon noticed that I was being left to my own devices without any guidance, and that the teacher was hardly correcting my work. But the main thing was that I couldn't visit the classes very often because of my work at the high school.

However small the School and however limited the abilities of those who taught there I have to recognize my debt of gratitude to M. Morandi,[9] the director of the School (or perhaps its founder, I cannot remember), partly an architect himself, partly an enterprising and passionate lover of the arts. It is puzzling that in Odessa, a commercial city with a motley population, trading interests and provincial horizons, this School of Drawing and the Society of Fine Arts should have been founded. From members' contributions and the donations of local patrons, Morandi succeeded in creating an institute attractive both in its patriarchal character and its absence of formality. It was a veritable haven of the arts where local talents, artists of the future, were able to pursue their studies. Vrubel studied there before entering the Academy, as did Rubo, the painter of cattle-scenes. Kostandi studied there, too, and later taught at the same place. Other students of the School were Braz,[10] Ladyzhensky,[11] Kishinevsky[12] and many others who later became famous Russian artists.

At the age of forty-two I travelled to Venice for the first time. When I tired of contemplating the works of the Venetian masters I would go up to the open window of the great hall in the Doges' Palace and look out at the sun-drenched lagoon with its multitude of sleepy, sharp-prowed vessels, the orange-red tiles of the roofs below and savour its peculiar marine smell. And then the impression of something long familiar, something profoundly my own would come upon me. 'Why, this is my childhood!' Odessa. The port, the pier. 'Peresyp' where we used to go to swim. The same hot, sunny mornings, the same stagnant summer heat, the same reddish clay tiles on the houses as in Odessa, scorching in the sun, the same slumbering bay with the masts of innumerable sailing vessels sticking up like needles, the same distant sirens of

steamships – all that had once fascinated me as a child when I stood on a hill and looked into the distance.

When I moved away from the window in the Doges' Palace and looked again at Tintoretto's colossal canvas *Paradise*, at the Veronese ceiling, at Titian's *Entry into the Temple* – all these Italian masters seemed to me to be somehow connected with my childhood, with something familiar and dear. And I realized why it is that the Italian masters and Italian art appeal to me more than any (with the exception of Rembrandt).

And the nights! One peaceful moonlit night, I stood entranced by its magical beauty, its tender warmth. I could sense the incredibly familiar odour of seaweed and melon peel, and I could hear the splashing of gondolas and boats, a sound which I can remember particularly well even now. I was standing there lost in memories, when suddenly I heard the voice of an old comrade behind me: it was Brizzi[13] who had been at the Drawing School with me. 'Just like Odessa, eh?' . . . Oh! my childhood! . . .

Some of these old Italian types were still alive among us, as if the centuries had passed them by and left them untouched. There was old Signor Iorini,[14] for instance, for all the world like a tall, thickset, agreeable old man straight out of the Renaissance. He was a stonemason and taught drawing and sculpture at the Odessa School. He was a bachelor and alone but for his sculpture. Marble and mallet were his whole world – apart from the pipe in his mouth. He loved his pupils as if they were his own children and he had spent the greater part of his life in Russia, but even so hadn't learned how to speak Russian. When a pupil wished him 'Happy New Year', he couldn't understand what was being said and, suspecting some insult, could only shake his head and mumble: 'And you too . . . and you too . . .' My fellow pupils, like Brizzi and the talented youth Molinari[15] and others, loved the old man dearly.

It seems to me that Vrubel's passion for the Italian Renaissance was to a certain extent the result of the time he spent in this semi-Italian School. The whole teaching staff consisted of two people: old Iorini, the Italian, (sculpture and elementary drawing from models) and the German, Bauer,[16] who used to take everything else, (what in other schools was covered in the plaster, head, figure and life-classes).

Thus my teacher was Bauer. We became friends despite the strictness and severity for which he was much feared. He was a typical German and could scarcely speak in Russian. He belonged to the 'Nazarene School'[17] (Cornelius, Overbeck and others) and

used to paint at home a bit – just 'for his own pleasure'. He seemed to be an unhappy man, burdened with a family and hard up for money. The School could pay little, since it was not supplied by the State and led a tenuous existence. Bauer would arrive punctually every day, sit down in a chair by the window and read a book or smoke and think. He was always thinking about something. From time to time he would go up to one of his pupils and say something scarcely comprehensible to Russian ears. 'The devil only knows', was the only phrase that could be made out. I was in the eighth class at high school at that time and could speak a little bit of German, so he felt himself more at ease with me than he did with the others. He would give me pieces of advice and seemed to know a lot, but there was always something about him that bespoke his unhappy fate. I felt sorry for him and often tried to speak with him about art, which would help distract him from his thoughts and raise his spirits somewhat.

When I finished high school in the spring of 1881, I decided to enter the Medical Faculty of Moscow University – for my parents' sake entirely, so their minds might be set at rest by the thought that I would become a doctor and not a dyer. The Petersburg Academy didn't attract me at all, whereas in Moscow I was hoping to join not only the University but also to register at the School of Painting, Sculpture and Architecture, about which I had heard many good things.

When I arrived in Moscow and settled things at the University, I set off for the School with some of my work, intending to ask if I might be taken on. This was the last year that Trutovsky[18] was director. Alas, I arrived too late and registration time had long passed. He liked my work and consoled me by saying that in the following year I would most certainly be accepted. He said a lot of kind things in general but by the following year he had gone. His place had been taken by Professor Vipper,[19] a famous art historian who said that there was only one vacant place, and two candidates for it: myself and Countess Tolstoy. The council would decide which of us to accept. Needless to say, Countess Tolstoy was admitted.

I was in despair, but so as not to waste any more time, I decided to travel abroad to try and get a place at the celebrated Munich Academy, the most famous artistic centre after Paris.

Vipper advised me to apply to Professor Yevgraf Semyonovich Sorokin, since it was possible that he might admit me to his studio and teach me on a private basis. His own former pupils were supposed to work with him. Sorokin looked at my drawings and

gladly offered to take me, while I was happy in the knowledge that I would now be able to work in an enormous and real studio.

Sorokin was a large, handsome, somewhat corpulent man and cut a splendid figure in his coat. He was the living image of one of those retired academicians in Rome at the time of A. Ivanov. He seemed to be a somewhat disillusioned man, disappointed perhaps at the way his life had not turned out as he had hoped. He was one of the last of the Mohicans, one of those academicians who could draw the nude human figure at full height without so much as hesitating, starting either from the heels or the head. Or, he could draw a classical figure moving any way you liked! I was filled with admiration for him when I saw him paint the image of Alexander Nevsky for the Church of Christ the Saviour. First of all, without a moment's hesitation and relying entirely on his own resources, he did a charcoal sketch of the naked figure at full height on a board with primed a white surface. Then, without looking at the model posing before him in a cloak, helmet and sword in hand, he went on to sketch in the figure's apparel (chain-mail, cloak etc.) according to academic traditions.

My first work at his studio was to copy in oils a study of a head which he'd done himself and which he'd given to me, probably in the hope that 'I'd potter about with it'. But I did the copy quicker than he'd thought, so he praised me and said, 'Well, sir, what shall we give you now? How about this?' – and put into position the well-known plaster bust of Jupiter. 'Paint this in oils,' he said, and walked out of the studio panting asthmatically. A few days later, when Jupiter was already esconced on my canvas, he sat next to me and deftly used his brush to adjust the figure's eye that he knew so well. I was very interested in the beautiful, confident way he moved his brush to paint in the eye. But as I realized only later, this was no longer painting but pure calligraphy.

I soon understood that for all Sorokin's willingness to help me, there was strictly speaking nothing for me to do under his guidance. On the other hand, I did learn a few new things from two of his pupils who was also working in his studio. One of them, called Yanov, was painting – either for himself or a competition – a picture called *Night Patrol*. Both Yanov and the other pupil, who lived in Sorokin's house, were executing studies on set themes; what was called 'composition' and this was something that was new to me to some extent. I also decided to try to execute a composition on a theme set recently in the School of Painting. The theme was 'The Death of Socrates'. While working on it, I got to know several traditional devices of academic composition. I found this very interesting. From these pupils I discovered what themes were given and I set about these compositions quite independently.

I even executed my first little genre painting on a paste-board, entitled *Drinking Tea* – a non–classical subject with traditional figures: a fat merchant's wife, naturally, sitting by a samovar, a merchant making some solemn utterance and a drunken monk. All this was entirely in the spirit of the Wanderers and art-lovers of the time, that is to say it was 'satirical'.

I did some work for the journal *Light and Shade*[20] (something along the lines of *The Alarm Clock*)[21] and began to earn enough both to support myself and to save for my journey abroad to the Munich Academy, as I had decided to waste no more time and to start seriously to learn my artistic stock-in-trade.

However much I tried to please my parents by working in the Medical Faculty, I was none the less obliged to leave it and transfer to the Law Faculty of the same University. I was unable to overcome my loathing for corpses, for dissecting and the whole business in the anatomy theatre. I just couldn't get used to it.

But that part of anatomy which has its use for the artist, osteology and myology (the study of bones and muscles), I did find interesting and even performed 'excellently' in my half-yearly examinations under the strict and famous Professor Zernov.

But to return to my decision to go abroad. How would I manage it without breaking off my studies at the University? This was a very difficult and serious issue for me. Fortunately, I heard (one can scarcely believe that such freedom existed then), that if I registered as a student of Odessa University, I could travel abroad to hear the courses of famous professors, and then receive further permission to prolong my absence if I produced evidence of illness.

At the end of the year, however, the student was obliged to return to Odessa so as to take examinations for entry to the next year. Then he could travel abroad again to continue his studies there. At that time there were no formalities linking students with the University. They only emerged later and were then mainly confined to the wearing of uniform, cocked hats and other symbols of student 'freedom'. And so I decided to transfer from the Law Faculty of Moscow University to that in Odessa, and in so doing succeeded finally in choosing my own environment and was able to begin my real and systematic artistic education.

At the beginning of the 1880s, Munich with its Royal Academy of Arts was famed as an artistic centre second only to Paris, and foreigners travelled there from all over the world (especially America) to receive an artistic education. I had heard about this long before from an Odessa acquaintance of mine, the painter Verbel,[22] who was the first to open the way for Russian artists in Munich.

I left Odessa with Kishinevsky, my old comrade from the School of Drawing. There was no doubt that he would pass the entrance examination. Compared with such older pupils who had been coached at school, I was something of a dilettante, an amateur student, and I was very much afraid of failing the entrance examination.

My fears increased, particularly when I saw that the candidates were drawing the models' heads in charcoal. This is a very difficult technique and I was unfamiliar with it. Out of shyness I occupied the first free seat I could find at some distance. During the first interval the pupils usually went to look at each other's work. I also looked around and discovered to my extreme surprise that I hadn't made a bad start. I felt relieved and even began to cheer up.

I finished my work in the allotted time (only four hours for the life-drawing as I recall), and as a result I was given first place in the *Naturschule*. Those who passed the exam were able to register with the professor in whose studio they wanted to work. I put my name down for Professor Herterich[23] and continued to occupy first place in his life-class for the next two semesters. Then in the spring of 1884 I was awarded a medal for excellent performance and transferred to the painting studio (the *Malerschule*).

After so many difficult years in which I had had to struggle for an artistic education and been cut off from any artistic environment, I had finally gained a place at the Academy and was happy, indeed inspired. I threw myself avidly into my work and devoted myself to it body and soul.

The meagre funds sent to me by my father and elder brother (generally about thirteen roubles per month, some thirty-six marks at the prevailing exchange rate), were scarcely enough, however, to keep body and soul together. I literally had to half-starve myself. It is true that life was cheap in those days. A room with tea in the morning cost ten marks a month, and lunch about forty pfennigs (twenty kopecks), but sometimes there wasn't enough money even for that.

Opposite our studio there was a little restaurant for workers and students where we used to go to eat and relax together, all of us (Russians, Czechs and others). Our lunches were cheap, as I've said, and jolly. Nobody was served without beer and a half a mug was included in the twenty kopecks!

Our work was extremely intensive. Apart from our daily classes from nine o'clock till twelve which formed part of the Academy's official programme, some of us pupils used to pool resources and organize our own private study group without a teacher. We used to draw male and female models in historical costume, as well as female nudes which I started sketching for the first time. The latter figured in the Academy's programme only as part of the *Malerschule* for older students.

After our morning classes there was a short break and then all the studios joined together in one large hall either to spend two more hours drawing models, or to do rapid sketches under artificial light. Various professors (including artists famous at the time) used to offer consultation in turn.

And so our days and evenings were filled with intensive work. What with this and the minuscule lunches I could afford (by the end of the month, only bread and radish) I lost so much weight that people thought I was suffering from consumption. When I returned home for the vacation, however, I quickly gained weight again.

In the 1880s when I entered the Academy, Munich was one of the most beautiful cities in Germany. Although it was the capital of the Kingdom of Bavaria, it was still a small place, perhaps no more than a third of the size it attained a few years ago, when I last saw it. The city ended at the Triumphal Gates. Beyond them was open country containing the village of Schwabing, which itself later grew into a whole new town. After I finished my course of study there and returned to Russia, Munich's famed artistic circles were set up, including the group of semi-decadent young German writers and performing artists. A Russian colony settled there, too.

In my time, however, Munich, which partially copied Italian Renaissance models, was a good-natured city, full of simple charm. Life there was a cheerful, none too noisy affair and very cheap, too – well within the resources of students at the Academy, the University and the Polytechnical Institute. The whole city seemed to exist by them and for them. But then, alas, it grew into the noisy capital of Bavaria and lost its simplicity and its former appearance. If you add to that the ever-increasing number of foreign tourists, especially Americans who, Baedeker in hand,

would scurry round the museums, art galleries and, particularly in summer, the tasteless palaces which Wagner's friend, Ludwig II, built in the environs, then you can't help but remember with affection the agreeable Munich of earlier days, provincial as it was.

My greatest pleasure and relaxation when not working at the Academy was visiting the *Kupferstichkabinett*, the famous engravings section of the *Neue Pinakothek*, which contained one of Europe's most outstanding collections of original drawings and prints by the old masters. This is where I became acquainted with the art of engraving. What a pleasure it was to sit in the silence of those specially constructed rooms and to examine folder after folder of Rembrandts – his drawings and particularly his etchings. It was an even greater pleasure to visit the *Alte Pinakothek* – one of the greatest treasure-houses in Europe – which contained the paintings of the old masters.

I entered the Munich Academy during Piloti's[24] last year as director. Famous for his gigantic (and boring) historical canvasses, he had none the less raised the Academy to an eminence which it had never enjoyed before, nor ever again thereafter. This was particularly true in the case of drawing, which many students preferred to study in Munich rather than in Paris. But painting, as it was taught in the majority of the Academy's highly praised studios, was not to my taste. I was much more attracted to French painting with which I was already well acquainted by then.

At that time the Munich Academy was divided into the following classes or *Schulen*, as they were known in Germany: 1) the *Antikenschule*, the lowest class where drawing was taught from plaster casts; 2) the *Naturschule* (corresponding to our life-class) which concentrated exclusively on drawing from life; 3) the *Materschule* – the painting class and 4) the *Komponierschule* or composition class where pictures were painted on set themes under the direction of a professor. Each class had several professors or teachers, and the student would choose his own member to register with.

Apart from our compulsory studies and the voluntary work organized by the students themselves, which I have already mentioned, we also used to arrange so-called composition evenings. We would draw studies on themes set by the well-known artist and illustrator, Professor Litsenmeyer,[25] who would direct these evenings. The completed compositions would then be discussed, and the person whose work was considered best would be awarded a prize in the form of a photograph of his study, to be distributed to his fellow-students who had taken part in the evening.

All this work was essentially voluntary, but the result was that the students' time was entirely occupied. These evenings, and, above all, the students' discussion of Litsenmeyer's critical remarks, were of considerable interest and pedagogic value, and contributed greatly to the pupils' development. They would take place in a separate room of the same restaurant-cum-beer-bar where we used to have lunch. Over a mug of beer in friendly surroundings, the professor and students used to feel happy and at ease. As a result I managed to become much more friendly with Litsenmeyer, a very sympathetic and good-natured man, uncommonly well educated for an artist.

When I arrived in Munich, the Academy's new premises were not yet ready and some of the studios were still huddled together in the old Academy, housed in an ancient monastery on the Neuhauser-strasse, as I recall. In the place where the Starnberger station now stands, temporary accommodation was built for the life-classes which were mainly taken by two of the best professors, the well-known artists Herterich and Gizis.[26]

I had chosen Professor Herterich, whose studio was very famous at that time, and I took first place in it. Gizis' studio was adjacent and first place in it was taken by Ludwig Marold,[27] a handsome fair-haired young Czech with a good-natured, open, childlike smile. He was the delight of us all and later became famous in Paris where he moved after completing the life-class at the Academy.

I have met many talented artists in my life, fewer very talented ones and even fewer – indeed one can count them on the fingers of one hand – of whom it could be said that they were marked out from above. But so elect and blessed an artist as Marold I have never met again. He, if any, was an artist by the grace of God. Whatever he drew – even if it were only a few strokes of charcoal at the beginning of a sketch – was spontaneous, beautiful and utterly tasteful, so that you could not but feel that there was something exceptional, something divine in his talent and indeed his whole being. (Raphael was in all probability like that, or could have been.) What a good, dear and sincere comrade and friend he was. He died young, alas!

I remember the enthusiasm I felt when I saw the sketch he was working on during the first interval in our entrance examinations. I had never seen anything like it and could scarcely imagine that charcoal could possibly express so much pictorial taste and beauty.

I do not wish to use banal expressions but I am obliged to say that every drawing he executed (especially female nudes) was, in

some measure the song of his own personality. Unfortunately, Paris devoured him with its endless orders for drawings and illustrations of contemporary life, so that he never managed to develop his gift in painting, as he had in drawing. In Paris, where he was surrounded by French artists, he was the most French of all, as far as taste and delicacy of execution were concerned.

At the end of the week Herterich would arrive, tired and gloomy, and would proceed to correct the work of some of the weaker students. His corrections consisted of wandering all over the drawing with a thick stick of charcoal, leaving nothing at the end but a dirty piece of paper. This way a whole week's work would go to waste and the pupil would be left wondering where to go from there. Perhaps this did have its uses, since it made the student wonder whether it wasn't time to leave the Academy.

When he came up to me, Herterich would calm down and stare at my work for a long time, muttering: 'All right, all right,' then he would begin to praise it and wave his arms around, saying 'Make it broader, wider . . .' And apparently pleased, with a smile on his face, he would then add: 'Be so good as to execute the next head *à la* Rembrandt!' And the next time, the same thing would happen, except that he would then say: '*À la* Holbein next time, please!'

I am deeply grateful to Herterich for what I received from him – above all for the total freedom he gave me in my work, for his encouragement and for the artistic spirit and atmosphere which distinguished his studio.

After receiving a medal, I transferred from the life to the painting class, but didn't spend long there. The techniques and trends of painting at Munich didn't satisfy me. I firmly resolved to leave the Academy and not to enter the composition class since I considered it an unnecessary waste of time.

As far as painting was concerned, Paris was the centre – that was where I had to go, that was where I had to work. German painting didn't please me in the slightest. But before moving to Paris, I had to return home to Russia, sit my examinations in the Law Faculty and graduate from Odessa University.

From my earliest childhood I was brought up in a puritanical, ascetic atmosphere in which nearly all the romantic things in life were denied. My family was very unusual in its own way, and certainly unlike other families of the same social class (simple, semi-literate folk of middle income). The family consisted of my parents and five children. Four other children had died, three of

them at birth and the fourth, my elder brother David, at the age of seventeen. He was a gifted boy who could draw superbly. I can remember his sketches even now. Of my sisters, the youngest, Asya, was the most talented among us.

My father accustomed us to a simple, severe, joyless way of life from our childhood. As he used to say himself, the purpose of our upbringing was 'to accustom us to misfortune'; we were 'to depend on nobody and nothing' and we were never to be in debt to anyone. As a result the whole family came to admit the necessity of personal freedom and independence while at the same time becoming fully conscious of the importance of duty and responsibility. We never had any fun or entertained any guests at home. Any display of affection was slighted in each of us, any show of sentiment was mocked, and so on.

My mother was the complete opposite, but she – good nature personified – had submitted to him entirely. There was a lyrical side to her nature and she inclined to the artistic. The main feature of her character was compassion, which is the basis of love towards one's fellow men and of love in general.

In 1885 I finished my university education. At last all my obligations to my parents were fulfilled. I was in complete control of myself and my own future. But before this, I had to go through one more ordeal – that of a year's national service. I entered the artillery as a volunteer. In my free time I would draw, and I sketched everything I saw in the barracks and on the artillery range – horses in harness or by a tethering-post, ammunition wagons and their personnel, cannons at rest, garrison life and conditions, the comrades in my unit etc.

It was at this time that I made the acquaintance of a young, but already famous, pianist – Rosa Kaufmann, my future fiancée and wife.

When I had completed my year's service and entered the reserve, I left to wind up my affairs at the Munich Academy with a view to switching my studies to Paris. In order to get everything ready for this decisive change in my life I returned to Odessa from Munich. There, however, things took a different course from what I had desired and imagined and instead of taking me to Paris, fate brought me to Moscow, where family life of another kind began.

Rosa and I became acquainted at the house of Semyon Titovich Vinogradsky, a talented journalist famous not only in Odessa, but throughout Southern Russia. He wrote interesting and trenchant *feuilletons* on art and current affairs under the pseudonym of Baron X. His parties, which he used to hold regularly and with great

panache, would bring many people together, including performing artistes and musicians. These were always very noisy occasions with plenty of arguing as well as plenty of music, singing and dramatic readings.

My innate good spirits and vivacity, freed from the constraints of my spartan upbringing, now came into their own. My artilleryman's uniform was also very becoming and this contributed to the effect. I had got to know Rosa Kaufmann's parents and was often at their house where a lot of young men would gather round their daughter. I felt more attracted to Rosa than to her girlfriends and other young women. This was not only because of her exceptional musical talent – like any natural gift, this conquered all – but also because of her mind, her rare good nature and her spiritual purity. Life was to show later what a strong personality she had and what a marvellous comrade and person she was.

Now that I had broken free of the narrow confines of family life, I naturally savoured my newly-won freedom, the carefree simplicity of my life and my growing passion. In such a mood and full of the most joyful thoughts, I departed for Munich, returning again soon after for what I thought would be a short period before finally leaving for Paris, where I hoped to achieve all my hopes, expectations and desires. But it was not to be! My passion for Rosa, the carefree existence I had been living until then, my anticipation of the happy future which lay before me in Paris – all this turned against me and I had to face a serious psychological ordeal.

People suddenly began to gossip. Some even congratulated me on my forthcoming marriage (such comments were misplaced and quite premature). All this introduced a dissonant note into my life, which made an unpleasant impression on me. It was a question of my most intimate thoughts and desires, which were not even clear to me, being delved into by other people. Being uncertain of myself and unwilling to stand in the way of Rosa's career as a pianist, I decided that I had to end the relationship before a genuine romance developed. But all this was in vain, and my best intentions turned against us. We tried to stop meeting but circumstances had it otherwise. We met by chance and against our will, if anything even more frequently than before. My innate sympathy for people in misfortune wouldn't allow me to become the cause of her suffering, and yet by my actions I did cause her sorrow. It had seemed to me that there was only sympathy between us, whereas in fact it was already a question of mutual attachment. At times it seemed to me that I did have enough strength to act meaningfully, but when I concentrated on one thing, its opposite grew stronger, as if fate were secretly dictating counter-orders.

Gradually I lost my strength of will and sank into apathy. I was in an impasse and had ceased to be myself. I gave up laughing, and then talking, and wasn't always aware of people speaking to me. I retired into my shell, began to indulge in self-analysis, abandoned my work and couldn't summon up the resolve to do anything. In this condition I carried on living, time passed, but, of course, there couldn't be any question of my journeying to Paris. Gradually I slipped into a serious, almost mental, illness. One unsolved question did not cease to torment me: was it possible to combine the serious and all-embracing pursuit of art with family life? Rosa, on the other hand, more through her instinct as a woman than anything else, was better able to cope with questions of this sort. She helped me in my decisions in any way she could, and contradicted me in nothing.

The wonderfully solicitous attitude of her extremely kind and intelligent parents, who refrained from applying any pressure on us, helped us overcome my condition.

And so it gradually became apparent that my trip to Paris would have to wait a little. It was decided that I should spend some time in the country as a guest of my acquaintance, a friend almost, the artist Kuznetsov,[28] a portrait painter and one of the Wanderers who had already exhibited his fine large canvases with considerable success. He was ten years my senior. It seemed likely that a change of place – the countryside, a new life in new surroundings etc. – that all this would have a beneficial effect upon me. And so, indeed, it did. I spent quite a long time with my genial host in the country. The company of his other guests (most of whom were artists), our joint painting sessions, the simple and cheerful way we spent our time, the regular, peaceful pace of life – all this together gradually restored me to a normal existence. I began to work seriously and felt revived by a new surge of strength, by a new impulse and craving for real painting. I therefore returned home, on the mend and once again inspired by hope. Then we came to a decision. Instead of rushing off anywhere, it became important to achieve what had come into my mind while I had been in the country – namely to paint a large picture of garrison life, to which end I would travel to Moscow, a city which I had come to love during my time spent at the University there.

As far as Rosa was concerned, she would stay in Odessa for the time being, neither altering nor interrupting her established musical routine. By this time she had become a great and consummate performer. She became a supervisor and teacher in the master-class for particularly outstanding final year students at the Odessa Musical School of the Petersburg Musical Society (later restyled as a branch of the Petersburg Conservatoire).

On arriving in Moscow, I moved into furnished accommodation of the hotel type (called commercial rooms) in the Lyubyansky Passage and began to paint my first large, independent canvas there – *Letter from Home*. The freshness and realism of this picture which I painted from life and not from memory, seemed to please the young artists I met. People began to talk about it, and long before the date of the exhibition, P.M. Tretyakov came to view it (while it was still unfinished) and bought it for his gallery. This brought me much happiness and had important consequences. His visit happened to take place the day before Rosa (after a long correspondence and much soul-searching) was due to arrive in Moscow with her parents. We decided to get married and actually named the day of the wedding – 14 February 1889. Thus two of the greatest events in my life occurred during the same twenty-four-hour period. Soon after we were married, we travelled to Petersburg for the opening of the Wanderers' exhibition, where I was making my début with *Letter from Home*. To tell the truth, I was very anxious all the time and didn't in the least expect my picture to have the success it did. It was noticed by the reviewers, and the most flattering articles and notices appeared in the newspapers. All this pleased us very much and inspired us with hope for the future. Our stay in Petersburg was a holiday from beginning to end, a recompense, as it were, for the difficult year that had preceded it. We visited various galleries, especially the Hermitage where I acquainted my young wife with the magnificent works of the old masters. How often we would visit exhibitions, museums and galleries together thereafter!

The happy, late winter days which we spent in Petersburg were full of hope and expectation, but they were coming to an end. My wife's vacation was nearly over, I needed to begin new work and our money was gradually disappearing. We returned home to Odessa for the time being. We spent the spring there, and the summer by the sea. Thus our new life as artists together began — and long would it last. But the future was still shrouded in mist and we dreamed vaguely of Moscow as a new and permanent place for us to live and work together.

The Polenov Circle. Drawing Evenings

After arriving in Moscow we moved into our first real Moscow flat in Oruzhenyi Lane not far from the Triumphal Gates. At that

time we couldn't even consider getting a flat with a studio either attached or in the vicinity. In the whole of Moscow there were only two artists with their own studios: I. Ostroukhov (on the Volkhona) and K. Korovin (in the Butyrki), but they were separate from their flats, and only V.D. Polenov had a studio actually in his flat. We could not even have dreamed of it!

The Moscow Society of Art Lovers used to arrange yearly displays at that time, the so-called *Blanc et Noir*[29] exhibitions (a mixture of drawings, engravings etc.), and I found this very helpful during the first year of my life in Moscow. The studies I had done of heads and so on at the Munich Academy were executed in charcoal, an unusual technique for Russian artists at that time, and I exhibited them in Moscow. Some of my drawings were acquired by Tretyakov, and one of them, the head of an old man, was purchased by S.I. Shchukin.[30] When I visited him later, I saw this drawing in the residential part of his house (later turned into a magnificent gallery of French art). My pen and ink sketches were also exhibited and they were likewise freely executed in a technique little known among Russian artists at the time.

The press drew particular attention to my charcoal sketches and to the fact of their acquisition by galleries. The art journals published reproductions of them. This brought my work to the attention both of artists and the public at large, and I quickly established the reputation of being a genuine graphic artist, not only among my young comrades, but also among the famous artists of an older generation, the Wanderers, who would ask me for sketches from my album as mementoes.

When Repin saw my studies of heads, he began to recommend earnestly that I should publish them, as models for art schools, in the form of an album. Lack of resources made it difficult to do this then, and in any case I had no time.

A year before my marriage, when I was still living in the commercial rooms on Lyubyansky Passage, I became closely associated with a circle of young artists (most of whom were pupils of the School of Painting) grouped round Vladimir Dmitrievich Polenov, at whose house we often used to meet. This 'Polenov Circle' marked an important stage in the development of artistic life in Moscow. Polenov's sister, Yelena Dmitrievna, was a clever, very talented artist possessed of great hospitality, who managed to arrange drawing evenings and joint discussions of current questions and needs.

These evenings used to be attended by Arkhipov, Vinogradov, Golovin, S. Ivanonv, Serov, Levitan, Nesterov – and sometimes by Shanks,[31] Ostroukhov and others. It was always one of our fellow artists who would pose. Once, as I recall, it was Levitan

who posed in an Arab turban. He asked for my drawing of him so I had to give it to him.

At one time K. Korovin used to arrange drawing evenings at his studio on the Butyrki. Vrubel, Serov and I used to attend them, (so did Shcherbinovsky,[32] as far as I can remember). We used to have a marvellous sitter; I had never met anyone like her for beauty of colour and form – a model in the Titian or Veronese mould. She wasn't beautiful herself, but when she used to lie down on a bearskin, she was first-class. At that time it was impossible to find female nudes, and even this one (who came from a nearby tavern) posed two or three times and then ran off, even though she was well paid for each sitting. She got bored. To my regret I never managed to finish that water-colour which I hadn't started at all badly.

One experiences some curious coincidences in life. When I had got to know the Polenov family and visited their house for the first time, Natalya Vasilyevna and Yelena Dmitrievna both found that I was very much like the singer d'Andrade,[33] who had scored an enormous successs not long before in Mozart's opera *Don Giovanni*. Since I had never seen d'Andrade, I attached no significance to this and forgot all about it. But then I happened to be in Petersburg with Nikolai Dmitrievich Kuznetsov at a lunch organized by the Wanderers. He introduced me to Repin there. I found it strange that throughout the lunch Repin didn't take his eyes off me. Afterwards Kuznetsov told me that Repin would be very pleased if I would agree to pose for him as the main figure in his latest painting. I was very glad to visit Repin and fulfil his request, and duly arrived in his studio at the agreed time. The picture was entitled *Don Juan at the Cemetery*. Don Juan (dressed as a monk) was kneeling before Donna Anna. The latter, as I realized at once, was a portrait of Princess Tenisheva.[34] The whole figure of Don Juan had also been completed, but Repin wanted to add the features of my face and he did a marvellous study of me at one sitting. The result was a splendid portrait. Afterwards I regretted that I hadn't had enough courage to ask Repin for the study which was an excellent likeness. Later I discovered that Repin had been dissatisfied with the painting and he was even said to have destroyed it.

When I returned home to Moscow, I met Serov and told him the whole curious story of *Don Juan* and Repin. 'Yes, yes!' he said. 'Now I've remembered at last. I know this painting of his' (Serov was almost one of the family and used to stay with the Repins) 'and I always wondered whom Don Juan resembled, and sure enough,

it's you – only I couldn't remember before . . .' But this wasn't all. When I paid my first visit to Berlin Museum and had a good look at the paintings of the well-known German artist Slevogt,[35] I was struck by the obvious resemblance between myself and d'Andrade (in the portrait depicting him in the role of Don Giovanni!)

Before our marriage, Rosaliya Isodorovna Kaufmann had been a professor of the piano at the Imperial Odessa Musical School (a branch of the Petersburg Conservatoire). In charge of the office was one Olga Fyodorovna Trubnikova, an orphan who had been brought up by the Simonovich family, relations of V.S. Serova. Once, when Rosaliya Isodorovna was in the office arranging for some time off before departing for Moscow to get married, she somehow got talking to Olga Fyodorovna, who asked her: 'Are you going to stay in Moscow for a while, Rosaliya Isodorovna?' Rosa replied: 'No . . . I'm going to a wedding . . . I'm getting married.' Olga Fyodorovna was surprised: 'I'm also just about to be married and I'm going away in a few days, too, only to Petersburg! Whom are you getting married to, Rosaliya Isodorovna?' 'The artist Pasternak.' Olga was even more surprised: 'No, really? I'm getting married to an artist, too – to Serov! What a coincidence!'

The remainder of the conversation revealed that both colleagues, who met each other every day at work, had kept their secrets to the last minute. It also emerged that both artists had known each other for a long time and that, furthermore, Rosaliya Isodorovna was also travelling to Petersburg with her husband after the wedding. They therefore agreed to meet at the Wanderers' Exhibition where we were intending to exhibit our works, (Serov the portrait of his late father, as I recall, and myself *A Letter from Home*). We did indeed meet at the agreed time and were much amused at the strange coincidence and the almost mystical beginning of our wives' friendship, one which continued to the day they died. They were sincerely fond of each other and extremely devoted to one another. Olga Fyodorovna was a very good, kind and intelligent woman who personified 'faith, love and truth' for Valentin Aleksandrovich. She suffered much grief in her life, poor soul, especially after her husband's death.

After our weddings, both we and the Serovs moved to Moscow and began to earn our livings. Children followed, and with them financial need. There was a time when Olga Fyodorovna would visit us to borrow three roubles. And after the sum was repaid my wife would as often as not go to Olga Fyodorovna to borrow the same three roubles. And so it went on, the same old story. For

some reason, it was always three roubles, neither more nor less. In this way, the three rouble note which wandered from house to house became a symbol of our everyday life.

After the successful appearance of my painting *A Letter from Home*, I started on another large canvas entitled *The Blind Children's Prayer* (1890). Conveying artificial light in the church at evening was a difficult, though interesting task. I had long been interested in light effects at night and I subsequently returned to the problem of rendering the intimate, almost musical quality which lamplight or candlelight can give to a scene. The Wanderers rejected this canvas however, and it was later purchased by Schütz.

Our first flat was the scene of the birth of our son, Boris, in 1890. The signs of our financial need and insecurity were everywhere, and our endless worries about the family and what the morrow would bring were to continue for a long time yet. Fortunately, however, a dear cousin[36] of mine and his family made our lives a lot easier through their loving care and attention, and they helped us get over our financial instability in all kinds of ways.

While I was still living in Odessa, I used to exhibit my little genre paintings and studies (like *The Old Clothesdealer* and *The Gate* and so on) for sale in Rousseau's French bookshop. I used to execute these in pen or oil from memory – something which changed fundamentally later when I attempted to draw absolutely every-thing from life. Some of these genre studies I managed to sell with great difficulty to two or three artistic journals, which themselves were scarcely able to survive. Apart from contributing to these Odessa journals (*The Beacon, The Little Bee, The Wasp, The Alarm Clock* etc.) I also regularly contributed two or three drawings a year to the journal *The Cricket*[37] during my first few years in Moscow. Of course I was paid very little for these pen and ink drawings and my main income came from working for the Moscow journal *Light and Shade* to which A. P. Chekhov contributed.

Even before I had left Odessa for Moscow, I read an account in the newspapers of the forthcoming appearance in Moscow of a large new journal devoted to literature, the theatre, painting and music, to be called *The Artist*.[38] This promised to be an interesting and progressive phenomenon.

Its editor and publisher was Kumanin and it was financed by the young factory owner, Novikov. Professors Storozhenko[39] and Veselovsky[40] were in charge of its literary and theatrical sections.

Its artistic editor was supposed to be the well-known painter and poet Count Sollogub.[41]

I sent a few of my genre studies (characters, scenes from theatrical life etc.) to Kumanin at the journal's office and received an answer to the effect that 'one or two' of the sketches would do, but that the drawings 'weren't really finished' and something else along these lines that I can no longer remember. I was naturally upset; this wasn't what I'd expected. But straight after receiving this reply, I got a very kind and cordial letter from Count Sollogub. He wrote that Kumanin had shown him the drawings and that he, Sollogub, had been very enthusiastic about them. When Kumanin told him about the letter he had just sent me, Sollogub was very angry and said to him: 'But you understand absolutely nothing! I'm going to apologize to him on your behalf, and we'll not only accept everything he has sent us, but we'll ask him to let us have more of the same in future. And we'll also ask him to be artistic director of *The Artist*.'

So it was that quite unexpectedly I became artistic director and started to take an active part in the life of the journal.

Many, many years later I met Balmont (at the house of Yurgis Baltrushaitis,[42] I think). Balmont had published his early verse in *The Artist*. I got talking to him about times gone by when we had first become acquainted and our conversation turned to that journal. Balmont was full of praise for it as a forerunner to *The World of Art*.

Unfortunately, *The Artist* did not give a genuine reflection of artistic life, for it concentrated rather on theatrical and literary matters. Literature was the dominant interest, and the balance was overwhelmingly in favour of writers. At first I used to dream of restoring that balance by fighting for the artistic side. Sadly, however, Sollogub soon had to leave the editorial board through illness and I realized that arousing serious interest in things artistic amongst literary people (especially at that time) was an almost impossible task, so I gradually abandoned my editorial duties.

Amongst the amusing anecdotes from that period, I remember the following. A.P. Chekhov wrote his one-act study *Calchas* for the journal. As a mark of special recognition and respect for the play, Kumanin asked me to illustrate it. I did a pen and ink sketch which everybody liked. However, it turned out that I hadn't read the scenario carefully enough where it mentioned a prompter with a beard, and I'd drawn one who was clean-shaven. People told me that when Chekhov saw my illustration he immediately 'shaved' his prompter by crossing through the word 'bearded' in the manuscript and substituting 'clean-shaven'. We exchanged letters about this. My original sketch for *Calchas* is probably at the Theatrical

Museum,[43] or with the families of Kumanin or Chekhov.

After arriving in Moscow I gave private lessons for a time in the families of friends – the Garkavis[44] and the Shaikeviches,[45] for example. I also taught the widow Sverbeyeva, the niece of K. Gorchakov.

When these private lessons began to take up too much time, the artist Shtember[46] and I set up Moscow's first drawing school. Soon I opened my own art school, however, based on foreign models. The ideas behind it were completely new for Moscow, as was the method of teaching which concentrated mainly on drawing from life, as in Munich and Paris. The method which I introduced of doing life-drawings of heads in charcoal was later adopted at the School of Painting. Private schools like mine soon became a common phenomenon. They were opened by my former pupils of the School of Painting, like Yuon, Mashkov[47] and others.

My private school was very successful and gave us a certain financial security, at least to the extent of financing our flat and our modest way of life. There were moral results as well as material ones, however. The success of my pupils gradually increased my reputation in artistic circles and in society at large as a teacher of drawing and painting. From 1889 to 1894 my good name became so firmly established that I was invited to teach at the School of Painting. Polenov, who valued my work highly, was particularly insistent that I should be included in the teaching staff at the School.

The Wanderers' main concern in their work at that time was not form or draughtsmanship – but plot, pure and simple; a painting was supposed to 'narrate something'. The young artists, like myself, who were grouped round V.D. Polenov, were instrumental in freeing Russian art from its subjugation to plot – and this was true no matter which techniques we used (charcoal, pencil, water-colour, pastel etc.). Our generation strove after, and finally achieved, the freedom to work and exhibit pictures using any techniques, and not just oil, as the Wanderers demanded. I remember that water-colours weren't accepted for Wanderers' exhibitions at all at that time.

If there was the slightest possibility of drawing from life – whether at Korovin's, or Polenov's or (somewhat later, it's true) at Prince Golitsyn's, I was always one of the most fervent participants. And

I can say the same about Serov. We became known as 'sketch-book' enthusiasts which was the more embarrassing since, as professors at the School of Painting, we were not supposed to 'denigrate ourselves'. Almost all the best artists would attend the drawing evenings at Golitsyn's, but there weren't many who would take to sketching in full view of everybody else. And yet some of the most beautiful society ladies would pose on these occasions! How could one resist so serious an artistic task as drawing from life?! But when our hostess invited the 'famous' artists to join in as well, they would refuse and point to Serov and myself, exclaiming lightheartedly: 'Well, you're masters already, you know best', or 'We can't bring ourselves to do it in public', and so on.

These evenings were organized by S.N. Golitsyna, the wife of the former Mayor of Moscow, and they took place at their private residence on the Bolshaya Nikitskaya. Our hostess used to draw, too, and wasn't at all bad for an amateur. The simplicity and informality of these occasions contributed to the fact that every-body, both guests and painters, those who did sketch and those who didn't – all felt perfectly comfortable, and at their ease. In the large rooms adjacent to the hall where the drawing took place, tea was always served along with open sandwiches, fruit etc. and people could help themselves (there were no servants present).

As I have already said, the women who posed for us were very interesting from the artistic point of view, and sometimes they would wear historical or old Russian costume. They were mainly relations of Princess Golitsyna or close friends of hers. It would have been difficult to find a similar opportunity to paint such interesting sitters without all the usual difficulties and problems involved, so one accepted a few inconveniences. Lady friends of our hostess, for example, would arrive with their sons and daughters – all the 'Nickies', 'Kockies', and 'Mickies'. They would chat and look at how the artists were drawing – and whom. Bending over us, they would peer through their lorgnettes, sigh-ing and exclaiming: 'How lovely!', 'Ah, how interesting!', 'It's like a dream, *such* a likeness!' and so on. A real writer could have done such a good piece on these evenings!

Interest in these occasions reached the very highest circles. Quite by chance, I was once distracted from my drawing for a moment and instinctively turned round. Through the suite of rooms, I suddenly saw in the distant dining-room a tall, lean, familiar figure in a general's uniform. It was Grand Duke Sergei Aleksandrovich, Governor-General of Moscow. He was chatting to our hostess. Golitsyn was very free and easy with him, thereby emphasizing his independence, perhaps, and despite the fact that he was host,

he didn't accompany Sergei Aleksandrovich when he entered another room.

I continued to draw. A few minutes later, I heard the ringing of approaching spurs and the sound of heavy footsteps which stopped behind me. I carried on working as if I didn't know who was standing at my back. I remember who it was we were drawing, who was posing for us. It was one of the most interesting women in the Golitsyns' circle. She was dressed simply and elegantly with a large pearl necklace as her sole ornament. Her hair was completely grey, which was very becoming, and her face was healthy and beautiful in tone. She was like a genuine eighteenth-century marquise who had stepped out of a portrait. It was Princess Yusopova, Countess Sumarokova-Elston. The general stood behind me for so long that it was becoming quite weird. He was obviously comparing the likeness of my portrait with the real person standing before him.

At the next regular exhibition arranged by the Society of Art Lovers this sketch of Yusupova was purchased by Sergei Aleksandrovich – he had obviously 'compared' it to his satisfaction! He also acquired another portrait – a sketch of Princess Golitsyna's daughter, which I had drawn from life on another of these occasions.

When I arrived home that night (I had made use of the Grand Duke's visit to observe him closely), I sketched him, not without a little exaggeration, standing in his characteristic pose (as stiff as a poker). The drawing turned out well; people passed it from hand to hand but finally, alas, it disappeared, or rather, somebody grabbed it. (Sergei Aleksandrovich was a trustee at the School of Painting where Serov and I both taught.)

But to return to the evening at the Golitsyns'. There was yet another attraction that night. During the interval the hostess's sister – a Madame Bulygina, the wife of the Prime Minister – arrived with Grand Duke Konstantin Konstantinovich (the famous poet who signed himself K.R.). By comparison with Sergei Aleksandrovich, who was imposing both in manner and appearance, this one was rather shy. He kept close to the wall, as if embarrassed, and was quite unassuming in his behaviour.

After the interval, the 'regular workmen' (Serov and I and two or three other amateurs), continued to work. We left together and when we came out onto the street, Serov said to me with his usual caustic humour: 'Well, what an evening! They could have charged five roubles for admission!'

Shortly after the Art Congress in the summer of 1894, I was approached by the Director of the School of Painting, Prince A.E. Lvov (then still Secretary of the Moscow Society of Arts), who invited me, on behalf of the School Pedagogic Council, to become a teacher at the School.

As soon as I joined the staff at the School, my financial situation became healthier and more stable. Worries about the morrow gradually faded and during my non-teaching hours I was able to devote myself entirely to my work as a creative artist. Besides my monthly salary, the main financial benefit was the free flat complete with studio. Prince Lvov, moreover, soon succeeded in carrying through a number of improvements in the School, among those being the financial position of the teachers. He was continually at pains to do anything which could benefit the School and was always trying to attract the best artistic forces in the country. All his plans grew out of his single-minded desire to create a first-class School.

After the reform of the Petersburg Academy of Arts some teachers left the Moscow School to take up posts in Petersburg and in their place Prince Lvov appointed the most talented artists – suffice it here to mention Serov, Paolo Trubetskoy and K. Korovin.

On the basis of my own experience and familiarity with analogous artistic establishments in the West, I can safely say in all sincerity that our School of Painting, Sculpture and Architecture was the best, and in its own way, unique, both in the diversity and freedom of its artistic education, and in the exceptional make-up of its outstanding teaching-staff – not to mention in the absence of the red tape which commonly hampers artistic development and training.

Prince Lvov succeeded in achieving all this only with enormous difficulty. He managed to eliminate bureaucracy which runs rife in practically all academies and he removed the awful routine which goes hand in hand with the red tape. And I have to reiterate that in those days, even in the West, there wasn't a school like it.

Of course there were some defects and differences of opinion but without those, a live, developing organism would be unthinkable. Gradually the School expanded and new studios began to appear: a portrait studio, a landscape studio, and one especially for the study

of animals. There was also the so-called General Education Department which was specially set up to prepare students (many of whom were semi-literate, but talented, peasants) for transfer to a higher department of art. In consultation with the teachers, V. Serov[48] was placed in charge of the portrait studio. For some time before this he had directed the life-drawing class, which I then took over. The landscape studio came under the direction of E. Levitan; (after his death A. Vasnetsov took charge), and A. Stepanov took over the studio for animal study. In this way the staff structure alone was already an indication of the School's high standards and the director aspired to consolidate these standards with the best representatives of artistic life in the land in order that his students should receive the best possible education and be nurtured in a special creative atmosphere.

In each class there were supposed to be two teachers. This system, a relic of the old School structure, was devised to make it possible for teachers to take their duties in turns and thereby have free time to work in their own studios. In the life-drawing class in which I taught, the other teacher was Abram Yefimovich Arkhipov. We alternated with each other on a monthly basis since this was a more useful arrangement for our own personal work than taking the class alternate days, which other teachers did. Abram Yefimovich was a talented artist of upright character and a colleague possessed of an innate sense of tact. During a quarter of a century of joint service we enjoyed a relationship based on friendship and consideration; we never had a single argument or difference of opinion, nor was there any friction or clash of interests in the classroom.

Involvement in this class where the students concentrated exclusively on painting and drawing male and female nudes from life, and reproducing them in life-size proportions, was in direct contrast to their previous experience of doing little studies of the conventional Tom, Dick or Harry. This new experience was extremely useful to them, and also to me personally since I was able to do life-drawings along with the students. For me, these sketches were like the daily exercises of a pianist at the piano. The contact with my young students, my collaboration with them, and the constant presence of live models in our midst, were very instructive for me. All this helped develop and improve my life-drawings and accustomed me to the absolute necessity of 'sitting tight in the saddle'.

The School of Painting, alas, was completely destroyed by the violent influence of all the fashionable 'isms' – Cubism, Futurism,

and so on. It became more and more difficult for the School Council both to fight for academic standards and to keep in view the extreme leftishness of the times. Some people, by the way, mistook what was happening for something of a revolutionary nature, whereas these 'currents' in art were of a purely bourgeois and snobbish character. My former enthusiasm and inspiration became less and less marked; and I became more and more certain of the utter pointlessness of every activity and the complete uselessness of any endeavour to help the School.

It would of course be interesting to dwell in more detail on the mood of the time and the paradoxes inherent in some of the facts. Who could have believed, for example, that D. Burlyuk, after giving his Petersburg lecture[49] in which he vilified utterly the reputations of Pushkin, Tolstoy, Raphael, Repin and Serov, returned to Moscow to take up his place again in my life-drawing class, where he worked assiduously, if unsuccessfully, to finish his study of a model.

However much I wanted to leave the School no one would accept my resignation. Finally I announced that, because of failing eyesight, I could not continue my teaching there. I was naturally very sorry to leave behind my four or five able and talented students who deserved the chance to go on with their studies. Within the precincts of the School, this was difficult to arrange since we would have needed special premises. I promised to do what I could since I was convinced that interesting artists, original and unlike one another, would emerge from this group; and as I later learned, some of them did go on to justify my hopes.

Trips abroad. (Italy, Berlin, Holland, England)

I have been abroad with my family on several occasions, both on account of my wife's ill health and for other reasons.

Ever since my student days at the Odessa School of Drawing, I had dreamed of visiting Italy. From the point of view of an artist, however, only a prolonged stay in the country would have been worth while, and in those days, I had neither the means, nor the free time. My trip to Italy was therefore always put off 'till next year'. And how those next years mounted up! Finally, however, my dream became reality.

In the spring of 1904, a large-scale international exhibition of art and industry was to be opened in the German town of Düsseldorf. For those days, it was a great event in the art world. I was invited to be an organizer at this exhibition and to represent the section on Russian art (painting and sculpture). This invitation provided the reason for my trip – first, in the line of duty, to Germany, and then – to Italy!

That is how, one warm summer night at the beginning of June 1904, I found myself approaching Venice. I was exhausted from a whole day's travelling in an airless carriage, and I have to admit that I had seen nothing of the lavishly praised, indescribable beauty of the Italian landscape. There were only the dull station buildings and dusty plots of land supporting trees intertwined with garlands of grapes. Tiredness notwithstanding, I peered greedily into these areas, searching for the promised orange groves and ripening lemons – but, alas, in vain! There was nothing but the same old railway sheds and scraggy, dusty trees wound round with grey ivy.

But as we approached Venice, something like a dream began to take shape. Travelling along a dyke, with water to right and left, we arrived at the station, where a gondolier took my things. I went down a broad flight of steps and sat down in the rocking gondola, and this was real, not make-believe.

The gondola slid between sleeping houses which rose straight out of the water. Lining the canals were the *palazzi,* their black windows gaping, their *portières* lowered – such a decorative motif for a painting. Smoothly, carefully, silently, the gondola skimmed through the narrow canal before gently floating up to the steps of the hotel. It was all like a dream, but I remained wide awake, gazing with wide-open eyes, the more to observe the fairy-tale reality which was like nothing I had ever seen before.

I visited Venice for the second time in 1912, and in 1924, some twenty years after my first Italian trip, I was there for the third and last time.

In 1924, on the homeward journey from Palestine, where I had taken part in a painting expedition, our ship put in at Venice. It stood at anchor for more than two hours, during which time almost all the passengers went ashore. I, however, chose not to disembark, fearing that after too many experiences in the intervening twenty years, I would look at Venice differently, or that my distant impressions of the city would suddenly lose their charm. I preferred to view the city I loved from aboard the massive ship, beside which the Venetian houses and *palazzi* seemed tiny,

childish and somehow toy-like. With tears in my eyes, I gazed at them until the ship weighed anchor and started for Trieste. Thus Venice disappeared from my life forever.

When I first visited Italy in my forty-second year, I often happened to see marvellous frescoes of the Gothic period depicting some saint or other casting out evil spirits from a man possessed. Devils, large and small, complete with tails, flew straight out of the mouth of the sick man. When I saw these portrayals, I couldn't help recalling the episode from my earliest childhood when our neighbour, the tailor, cast out from my own body the demon that was choking me, and thus brought me back to life.

Need I describe my lifelong sense of gratitude to the tailor for his successful exorcizing of these evil spirits? But neither he, nor even my parents, managed to drive the good spirits out of me! It is my belief that these good spirits are the normal and indispensable companions to creativity. They look through the painter's eyes onto the outside world, nature, and the beauty of form and colour which overlays all God's creations, from the tiniest little flower. These spirits dance with delight and excitement and do not leave the artist until he has completed his act of creation and given life to a work of art. The spirits then stay calm for a while, until the next surge of excitement. Their work begins in the cradle; long before I could understand the difficult words 'creation' and 'art', I was impressed by beauty in the form of the plump, rounded arms of Madame Tkhorzhevskaya, a friend of my mother's, who nursed me and took a great liking to me. The beauty of those splendid arms has remained with me all my life and is the reason why I always was, and am still, enchanted by the loveliness of the female arm, which I cannot restrain myself from drawing. Titian! He is the one who succeeded in immortalizing its beauty.

I am not going to describe Italian travels in detail; perhaps I shall manage that on another occasion, but for the moment it would take too much time. Suffice it to say that the sight of the paintings, sculptures and frescoes of the old masters always filled me with endless delight.

In 1905, the School of Painting was temporarily closed and I therefore took the opportunity to travel to Berlin until such time as classes resumed.

In those days I had a flat at the School, quite a bit bigger than our earlier accommodation, and not, as before, in a wing in the courtyard, but in the School building itself. Its windows looked out

onto Myasnitsky Street and we were therefore acutely aware of the upheaval of those times. For the rest of my life, I shall remember the difficult time we lived through then. In December of that year, my younger daughter had fallen ill with croup; severe inflammation of the lungs brought her close to death, and we were awaiting the crisis. At that time, the classrooms and lecture theatres at the School were constantly being used for political meetings, which were often attended by soldiers of the Moscow garrison. The headquarters of the auxiliaries – armed students and workers – were on the ground floor. In short, everything was in a state of maximum tension.

At the height of events, the Director of the School came to see us and announced that he had received an ultimatum from the Governor-General to purge the School of 'revolutionaries', to liquidate the headquarters of the armed auxiliaries, and to disperse the students; if, by nightfall, the building had not been cleared, then the School, by order of the Governor-General, would be put under artillery fire.

Prince Lvov added that the teachers and all the other employees who had flats in the courtyard had already left long ago, and it was now absolutely essential that we, too, leave the building. What were we to do? Where could we go, and how could we possibly move our daughter whose condition was so critical?

My wife and I went out to look for some sort of refuge among the furnished rooms in the vicinity. But all the available rooms we saw were completely unsuitable. How could we move a sick child into such accommodation? My wife, numb with grief, vowed to me from the depths of her despair that, the circumstances being such, she could not go through a move with our little girl: 'As God sees fit, what will happen, will happen.'

At home again, I went downstairs and called the 'leader' who turned out to be one of my students from the department of architecture. I told him all about the sick child and begged him to help us. He understood the tragedy of our position and promised to do all he could. An agonizing period of expectation ensued.

Eventually the student returned with the joyful news that there had been an order to move the headquarters to another secretly agreed place, since its presence in the School had been discovered, and everything had therefore to be renewed and liquidated in the shortest possible time.

What good fortune! Such was my emotion that I scarcely had the strength to convey the news to my wife.

As soon as our daughter was better and the railways were in operation once again, I took my family abroad to Berlin. Our journey took place at the end of December and was accomplished

only with great difficulty in conditions of severe frost.

In Berlin, I gradually settled down to work. I painted several portraits, did a great deal of etching and, at the insistence of my wife and our new friends, I even organized a joint exhibition at the Salon Schulté[50] with the Finnish artist Axel Galen.[51]

In November 1906, regular classes resumed at the School, and I returned to Moscow with my family.

As a portrait painter, I was naturally familiar with the reproductions of the famous English artists of the eighteenth century, which was the heyday of English portrait painting. My dream was to visit London and see them in the original. As was always the case with me, my dream would never have materialized but for the intervention of fate. When I was in Moscow, I suddenly began to receive very intriguing letters from an Englishman who had seen reproductions of my coloured pencil sketches of children in the English art journal *Studio*. He had been very much taken with them, and in his letters, he asked me whether I would consider going to London to paint the portrait, or even just to do a coloured pencil sketch, of his eight-year-old daughter. I found it quite amazing that someone in another town, in another country, should think of making such a proposal, especially in view of the fact that England had many fine portrait painters of her own.

As my wife and I had dreamed for a long time of visiting London, and only the fear of crossing the 'eternally stormy Channel' and our anxiety about sea-sickness had held us back, I promised him that I would come in the summer of 1908. That summer we were intending to visit Holland and Belgium; perhaps we could summon up enough courage to make the Channel crossing.

Having exhausted the museums and galleries which housed the great Flemish art, we stopped for a while in the peaceful, pleasant town of Bruges on our way to Ostend. In Ostend, however, all we did was to sit each day on a bench on the beach and gaze longingly at Great Britain on the opposite shore, which, to all appearances, was a mere stone's throw away. We could only look sadly in its direction, for although the sea did not seem to be at all 'eternally stormy', neither of us (but especially not my wife) could summon up the courage to make the crossing. And each evening we would once again return despondently to our hotel in Bruges.

At that time 'Dead Bruges'[52] (as it was called in Rodenbach's celebrated novel) was teeming with people who had gathered for the celebration of *Toison d'Or* (The Order of the Golden Fleece).

This historic festival ended with a real tournament in period costumes. This took place in the city square which was surrounded by stands for the public. I only just managed to obtain tickets for the two of us. We sat and waited for the spectacle. Suddenly, from the lower part of the stand, I heard someone call 'Pasternak!' It was my friend, the artist Struck,[53] whom I had not seen for a very long time. He signalled that he would meet us at the end of the tournament. We were delighted by this encounter, so unlikely in a crowd of many thousands of strangers. It turned out that Struck had only just come from London – the weather and the Channel crossing had been marvellous. When he heard about our sad 'sittings' on the beach in Ostend, and about our unforgivable indecisiveness, he began to talk us into going and insisted that right then, without a moment's reflection, we should buy our tickets and leave that evening for London. 'The weather,' he said, 'is exceptionally calm, and you'll see, before you know it, you'll be in Dover. I shall come with you now to Ostend and buy the tickets, otherwise I know you won't go.' We set off for the hotel, I paid the bill, and the three of us went into town where Struck bought our tickets for the ferry.

My wife and I asked practically every porter in sight if the crossing would be rough, but they simply stared at us in amazement and answered: 'What, in weather like this?' We must both have looked a picture as we followed the porter who was carrying our things, hanging our heads like condemned men. There was no turning back! After saying goodbye to my friend, we went into a sort of restaurant or buffet to have a cup of tea before the departure, and we didn't notice that we were on the boat itself: it was arranged in such a way that there was no gangway, and the restaurant floor, which was actually on the boat, was level with the jetty. Only by a light rocking, which was scarcely distinguishable, did we realize that the boat had cast off, imperceptibly, before turning round smoothly to give us a view of the shoreside garland of round white harbour lamps, burning brightly in the restaurants and on the quayside.

On the advice of a very kind Spanish lady who explained that it was 'less rocky in the middle', my wife settled herself very comfortably, while I, having shaken off my former fear, became more and more lively and cheerfully decided to go off to the buffet to have a glass of cognac, after which I felt like a regular old salt.

The boat did rock, but only very slightly, and towards morning both of us had even managed to doze off. On opening our eyes, we saw that we were near the white chalk cliffs of England! Dover! About two hours later, we were in London, on a London station – (Charing Cross, I think).

A great deal has already been written about London, its picture galleries, its art treasures and, most of all, about the heyday of the English portrait and the late eighteenth-century portrait painters. Here I must restrict myself to a few words. The English, like the Dutch, have always loved the art of portraiture; nowhere else in the world does one find so many portraits as in Amsterdam, The Hague and in London.

It cannot be said that the English did not have good portrait artists of their own, but among the rich merchant classes, love of the portrait was accompanied by a desire to have it painted by Holbein, Rubens or Van Dyck, regardless of cost; and this was true, not only in those days but up to quite recently. French artists were also frequently in demand.

When I eventually saw the originals by the celebrated eighteenth-century English portrait artists – Gainsborough, Reynolds, Romney, Lawrence and others – I was enraptured by their skill, which was quite staggering! All of them share a common virtue: though very different from each other, each, in his own way, has solved the problem of his era – the majesty, the ornamentation of the grand style. They had at their disposal huge expanses of halls and walls; they all had enough space to spread themselves out colourfully and decoratively; and they all had the ability to fill up these walls with their enormous canvases. They were helped to achieve this incredibly difficult task by their great artistic erudition.

This same Englishman, who had kept writing to me in Moscow, and whose daughter I had sketched, passed on to me one day an invitation from his brother (who was shortly to become a Lord) and his wife to visit them at their estate in Esher, not far from London. They suggested that we spend the day with them the following Sunday.

Interesting though it would have been to see the English equivalent of our country estates near Moscow and how life went on there, we unhappily had to decline the invitation for the simple reason that we had not brought suitable visiting clothes with us on our trip. When going abroad, I always tried to travel light, without burdens and trunks and the multitude of suitcases which lead to delays at customs, and I had not on this occasion expected to be invited anywhere as a guest. But however firmly we refused the invitation, explaining quite candidly that it was a question of proper appearance, our Englishman would not take no for an answer and said that our fears were groundless. We were forced to

agree, and the following Sunday, we were taken to Esher by motor-car.

Our host turned out to be the owner of Esher Place, an historical castle which had once belonged to Cardinal Wolsey, the hero of Shakespeare's drama. The ruins of the old castle remain to this day. The residential part of the estate was a building in the style of Louis XVI, a beautifully proportioned building, situated among flower beds, clipped hedges, peacock-shaped shrubs, and so on.

As we approached the main entrance up a gradual slope we already felt quite out of place, clad as we were. The butler who opened the door was of course better dressed than we were, though I was surprised that he wore not black, as I had expected, but a kind of light-grey tails. In the huge entrance-hall, which was like a museum, there stood a beautiful little painted antique carriage, reminiscent of our *kolymaga* carriages in the Armoury.

The butler asked us to inscribe our names in the book of 'distinguished guests'. The English are fond of ranks and titles and the status of an Academician is well appreciated. As I bore this title, and also in order to make up for our informal appearance, I entered it in the book, which obviously delighted the butler and partially relieved me in my embarrassment. He then beckoned us upstairs where another servant was already waiting with jugs of cold and warm water for 'ablutions'. After this we descended into the main reception hall where we were greeted by our host, advancing in our direction. He was a tall, stately, handsome cheerful man, in Scottish dress (a kilt, revealing bare knees). One could sense an inner strength in his whole appearance, a tranquil confidence in himself, and all that surrounded him.

He presented us to his wife – tall, slender, middle-aged, but young-looking, apparently a former beauty and society 'lioness' from an aristocratic family. She was very lively, witty, and well known in the world of sport.

Our host began to show us his collection of paintings which included a Rembrandt and a splendid Franz Hals. Among the works by contemporary artists were three portraits of the lady of the house by famous portrait painters: Franz von Lenbach[54] (a German), Benjamin Constant[55] (a Frenchman), and John Singer Sargent[56] (an American). This was evidence of our host's great wealth and also testified to the traditional English interest in portraiture.

After lunch, at the request of our host and hostess, my wife played a few pieces on the piano. Our host turned out to be a great connoisseur of music, and my wife, therefore, went on to play a few serious pieces – Chopin, I think.

Meanwhile, a friend of our host, a very modest young man who

listened to my wife's playing with great interest, arrived with two young boys who were apparently our host's nephews. There was one thing which struck me as being peculiar and uniquely English: the elder of these two boys (a fifteen- or sixteen-year-old) bore the title of a Scottish duke, whereas the younger (about thirteen) was the most ordinary of mortals. In English law, it appears, only the eldest of the family inherits the rights, ranks and titles of his ancestors, while the other male offspring have nothing.

Afternoon tea was served in the garden and this was a most interesting ceremony. Under an enormous, very old and tall tree, whose trunk could only be encircled by the arms of several people and whose branches were supported by iron brackets, a huge red carpet was spread out over the grass – the famous English closely-cropped, silky lawn. This deep red against a background of luscious green gave a strikingly festive effect.

When we said goodbye, my kind host, using all manner of persuasion, tried to talk me into settling in England, where, according to him, I would be a much sought-after portrait artist. But I did not even want to think about leaving my own country.

When I went to Berlin in 1921, the British ambassador there was a certain Lord d'Abernon, but I didn't realize that this ambassador was the same Mr Vincent whose castle we had visited, and for whom my wife had played so many splendid piano pieces. That it was one and the same person came out quite by chance. I happened to be visiting the artist Struck, and among his other guests were some English people, who had come to spend a few days in Berlin. We started talking and I told them how much I had liked London, describing our amazing visit to the castle, its unheard-of luxury, the inhabitants, and so on. Following my description of the place and its name, one of the London guests said: 'But that is Lord d'Abernon, our ambassador in Berlin!' 'No,' I replied, 'that was not the name I heard there, it was someone else.' Then came the explanation: 'Formerly he was simply Mr Vincent, and then when he became a Lord, he called himself after the nearest village, d'Abernon. He has been our envoy here for two years.' Naturally, I confirmed this the following day, and was cordially welcomed by the d'Abernons.

Italy. Congratulations Picture. The Wounded Soldier Poster

In the summer of 1912, I took my wife for treatment to the famous Bad Kissingen. Our daughters and younger son came with us; our elder son, Boris, was spending the summer term in Marburg, at the University there. When my wife was better, we decided to spend the rest of the summer in Italy, and setttled not far from Pisa in a charming little seaside town (it was called Marina di Pisa), from where I could go on excursions to nearby towns – Pisa, Florence, Sienna, Perugia, Assisi – and be back home by evening. I discovered that the famous Sienna Festival (held every four years) with the Palio horse races, was shortly to take place. Naturally, I wanted to see this rare and picturesque festival, to which, according to Baedeker, people came not only from all over Italy, but also from abroad.

It was only with great difficulty that I managed to obtain a ticket, and the stands which had been erected for the public in the main square were full to overflowing. Yet among this crowd of thousands, a most unexpected encounter took place, just like the one a few years before in Bruges, also during an historic festival. I was sitting in the top row of the tall stand when suddenly, from down below, came the cry: 'Leonid Osipovich! Leonid Osipovich!' It was Petr Petrovich Konchalovsky, my old friend from Moscow.

The races, which commenced with standard-bearers in historical costumes marching in from various directions, twirling their banners in the air, provided an unusually interesting and picturesque demonstration of pageantry. Later, in Moscow, working from sketches and from memory, I did a pastel drawing *The Palio in Sienna*, though I have no idea where it is now.

After the races, the artist Konchalovsky and I went off to have dinner together and drank a large carafe of wonderful chianti.

When I visited museums abroad and feasted on the great works of the old masters, I would always leave the building with a certain sadness, feeling a sense of loss at the impossibility of making a copy or even doing a sketch of some picture I had especially liked, if only so as to have at home the palette of the work in quesiton (like a tuning-fork in music), thereby retaining a general impression of the range of tones in a particular piece.

In the museums one was actually allowed, without any special

formalities, to make small copy-sketches 'on the move', so to speak, and with this in mind, I procured a special small portable box, with a palette fixed on the bottom, and a small canvas for the sketch attached to the open lid; the other necessary tools of the trade were contained in the box itself. Holding my box as one usually holds a palette, I succeeded in half an hour or an hour in making an exact, coloured sketch of all the tonalities of the original picture, and thus obtained on a small scale a coloured memento of the given master.

Specialist copiers, who concern themselves with details and the business of reproducing the canvas methodically, section by section, essentially miss the main charm of the painting: the general sonority of colour and tonality, that special beauty which is particularly enchanting in the original.

These quick colouristic sketches then made up what I call my 'gallery of old masters', and every time I look at them, I experience moments of joy and artistic elation. Everybody who came to visit me, whether they were fellow-painters or simply art-lovers, used to appreciate and take delight in these sketches and the original method I used to produce them.

I remember one day coming out of the old Pinakothek in Munich with one of these small copies which I had just done of Rubens' *Shepherdesses*. I bumped into I. Grabar and showed him the sketch, which he liked very much indeed.

Here is a list of some of my copy-sketches: Bennozzo Gozzoli's *Grape-Gatherers* and Orcagna's *Triumph of Death*[57] from the frescoes in Campo Santo, Pisa; two Rembrandts from the Louvre (*Self-Portrait* and *Christ at Emmaus*); two Rubens, two Van Dycks, three Tintorettos; one Velasquez (from Vienna) – also his *Philip on Horseback* (Florence) – and a Veronese (National Gallery, London). But particularly beautiful from the point of view of colour and their monumental design were the above-mentioned Gozzoli and Orcagna. Most of my copies were done in oils, but these two were done with pastel and tempera. Besides their general interest, my copy-sketches of Gozzoli and Orcagna have a certain historical value, since the bombing of Pisa during the Second World War completely destroyed the frescoes at Campo Santo, and my copies are now, perhaps, the only artistic evidence of these marvellous works.

In every art form, one has to set oneself great tasks. However, I ought to make the reservation that very often it is not the large problems, but the fairly small, which take just as much time and effort.

Among the many and varied problems which I have confronted in the different stages of my artistic career, I can number the following: mastery of very firm and precise drawing; achievement of laconic representation and freshness of execution in the art of portraiture, incorporating at the same time an attempt to capture a likeness, together with colouristic ornamentation and, above all, incisiveness.

One of my most ambitious works was *V Notchnoye*, a picture I undertook in the country near Maloyaroslavl. It depicts peasant girls, riding about wildly on barebacked horses, illuminated by the red rays of the setting sun in the landscape background, with the girls themselves dressed in bright red coats and kerchiefs – a sort of Russian Valkyrie in its way! It was a most difficult task in all respects: composition, drawing, colour, whirling movement. Here it was absolutely essential to capture nature on the wing. Such a composition was also interesting from the point of view of colour-ornamentation.

I did studies for the picture, sketches of horses and girls riding on horseback at full speed (all from life in the open air!) An unfortunate accident, however, prevented me from ever completing the work; my elder son, Boris, who attempted to ride an unsaddled horse, came across an unexpected obstacle in the form of a ditch, and fell from the horse, breaking his leg. The huge canvas with life-size horses and riders remained in its initial form as a pastel sketch, and later, during the war, even this sketch was lost.

Another of my works which relates to 1914 – *Congratulation* – should also be classed as a monumental work on the grand scale. It was essentially a turning-point in my artistic career. With this painting, one whole period of my life came to an end, and I stood on the brink of another. I lost my interest in genre painting, and gravitated towards the large form of the colouristic, decorative portrait. *Congratulation* was the first of my works in this vein and I should therefore say something about it in more detail.

After my trip to Italy, we spent every summer from 1913 to 1917 on a large, neglected, beautiful country estate called Molodi, which was in the Moscow region, near Stolbovaya Station on the Kursk railway line. This estate dated from the time of Catherine the Great and, according to legend, was built as a travel-lodge, where the Empress could stop and rest on her way south. Whether this was really so or not, is immaterial, for it certainly dated from Catherine's time. It was in two storeys, majestic in style and proportions, which its owner had exploited by dividing it into three large flats rented out for the whole summer.

We rented a large flat on the first floor; our terrace – almost the whole width of the gable-end of the building – gave onto a large,

wide avenue, flanked by ancient lime trees.

When I looked over the house and came to the large hall of our flat, I was fascinated by the size and height of the accommodation. All the rooms were of magnificent proportions and seemed to have been created for large canvases and grandiose compositions, of the kind I had just seen in the Italian country houses and *palazzi*.

There were the circumstances and surroundings which pushed me in the direction of a work I had conceived long ago. The previous winter, I had decided to paint a large canvas, a family group portrait, 'for myself' (*Mir zur Freude*, 'For my own joy' – as R.M. Rilke entitled his cycle of poems). My plan was that it should portray us, the parents, being congratulated by our children on the morning of our silver wedding. As well as the four figures coming to greet us, the canvas would include two more – myself and my wife, turning towards our approaching children: in all, six figures of life-size proportion. Unfortunately, however, owing to the enormous length of the canvas, I had to cut off the part depicting the parents; the remaining portrait of the four children was completed and exhibited in 1915 at the Union of Russian Artists' Exhibition, where it enjoyed great success.

On 13 July 1941, it was announced on the radio that the USSR and Britain had concluded an alliance and had signed a treaty for mutual military (and any other) aid in the fight against Germany. This announcement made me remember the occasion, twenty-seven years earlier, and also at the end of summer, when war was declared between Germany and Russia, then too in alliance with France and Great Britain. We were spending the summer in the country, in that same estate of Molodi where I painted *Congratulation*. The day war was declared, we stood on our balcony, watching the peasant carts one after the other passing the estate on their way to the mobilization point. A horrible sight.

A few days later, I was visited by a delegate from the Moscow municipality, who passed on a request from the city of Moscow to do a poster for a charitable trust in aid of war victims. I gave my word that it would be done.

So as not to distort the poster with too much of my own, I asked to be sent a soldier in full battle-dress so that I could check the details from real life. I turned my drawing into an autolithograph so that each print of the poster would come out from the lithographic stone like an original. There is no better method if you have to print an unlimited number of copies. Using only a few colours, the poster depicted a wounded soldier, his head bound

with a white bandage, leaning against a wall and just about to collapse.

I could never have imagined how successful this poster would be. When it was pasted up all over Moscow on the day donations were to be collected, crowds gathered in front of it, women wept. The collection was organized by well-known theatrical artistes under Sobinov, and they sold expensive postcards in tens of thousands with reproductions of my *Wounded Soldier*.

I transferred the unrestricted rights of use and reproduction to the city of Moscow. The material success of this venture, both in Moscow and in other Russian cities, exceeded all the expectations of the organizers of this charitable collection. From Petersburg, the State Duma President Rodzianko asked me to let him have tens of thousands of copies for his collection of donations, and so on. The best English art journal *Studio* reproduced my soldier, and the poster appeared on confectionery wrappers, labels and even trademarks.

One of the Tsar's adjutants came from Petersburg to ask me to draw a cover for the periodical of a military hospital run by the Empress. In the course of our conversation, he told me of Nicholas II's dissatisfaction with my poster; he maintained that any soldier of his held himself like a man and not as I had depicted him.

Four years later, in the autumn, I came from the country to Moscow for the day, and was surprised to see my poster *The Wounded Soldier* reprinted and stuck up all over Moscow again, on kiosks, stations, etc. This was done without my knowledge, and was intended as anti-war propaganda.

The head of the State Publishing House, Egorov, a very pleasant man, explained that everything that had been printed earlier was state property and could be reprinted without special permission from the author. He also asked me to give him something else along the same lines, but I had already decided not to do any more posters. I did draw some portraits and group pictures of meetings, conferences, and so on, the most important and interesting of these being the portrait of V.I. Lenin.

Berlin. Expedition to Palestine. The Monograph. Exhibition of Work. Removal to England.

I must say something about my artistic work abroad. In 1921 we went to Germany for a while for the sake of my wife's health. We

planned to be there only for a short time, but as a result of the protracted nature of my wife's medical treatment, our stay turned out to be much longer. It's true that the doctors did succeed in getting her back on her feet again; and it even became possible for her to take up music once more. But she was still much too susceptible to heart attacks and so we had to keep postponing our return to Moscow.

From the very first days in Berlin, I longed to get down to work. Having met up with old friends who were able to offer advice and support by way of commissions, I began to paint a great deal – portraits for the most part. I also drew many portraits, including those of Struck, Verhaern, Cohen[58] and Karpov[59] (*eau-forte* and lithographs). The oil portrait of my younger son in his green jacket was considered to be one of my best of this period. It was painted when he came to visit us in 1923, and was subsequently exhibited at my first Berlin exhibition where it enjoyed great success, as the press duly observed.

I began to work intensively and made many bold experiments using different techniques. After spending a few years like this, I made a number of new acquaintances among the members of Berlin society, people who cultivated, and were genuinely fond of, painting, music and art in general. I painted several portraits of distinguished representatives of the arts and sciences: the theologian A. von Harnack,[60] Professor Einstein, the artist L. Corinth,[61] M. Liebermann,[62] the dramatist G. Hauptmann,[63] and others.

Having been invited by the Berlin Secession (in 1923, if I'm not mistaken) to exhibit something *hors concours* – something exempt from the judgement of the hanging committee – I decided to show my oil portrait of Einstein, which was later acquired by Jerusalem University. A year or two later, again for the Secession, I gave a large still-life done in water-colour. Gradually I came to the conclusion that I ought to try and mount my own exhibition so that I could show the full range of my work.

I want to say something here about a very interesting undertaking which led to my making a trip to the East.

At the beginning of 1924 I was approached by an editor from Paris, Aleksander Eduardovich Kogan,[64] publisher of the art journal *Jar-Ptitsa* and author of several magnificent monographs on Russian painters and artists (Bakst, Pavlova and others). He suggested that I should take part in an expedition to Palestine, the aim of which was to publish a series of coloured paintings and drawings which would create an up-to-date image of Palestine, the

Palestinians and the character of the country.

Although in principle I was not averse to accepting his invitation, I was at that moment busy putting the finishing touches to a commissioned work and wasn't in a position to join the expedition which was setting off from Paris. The idea of travelling alone and meeting up with the expedition in Jerusalem didn't appeal to me and, besides, the possibility of sea-sickness, an agonizing one for me, was a further restraint – so I declined.

But Kogan wouldn't take no for an answer and prevailed upon me in every way possible to go, even if it were only for a shorter time. All expenses, both for the return journey in maximum comfort and the period of my stay there, would of course be paid.

When our doctor said that he would accept responsibility for my ailing wife and that I could leave her with an easy and free conscience, either in Berlin or in Munich with my elder daughter, and that I ought on no account to forgo such a rare opportunity, I finally agreed to the trip, and having sent a telegram to Kogan to that effect, I quickly set about preparing myself for the journey.

I remember that much of my unwillingness to undertake a trip to Palestine stemmed from a kind of mental fatigue which was the cumulative result of previous experiences; I despaired of being able to summon up renewed strength and interest in the things I would see on this trip after all I had beheld on my previous trips to Europe – in the museums, the galleries and collections of the old masters. I could hardly expect to find the requisite material for the spiritual and aesthetic elevation which was essential for an undertaking of this kind.

When I spent the night in Trieste, however, I understood how far my apprehensions had been unfounded. One glimpse of the outstretched harbour at the foot of the town, aglow with a thousand lights, was like a fairy-tale, and ample reward for a tedious day in the train. From the moment of our arrival in Trieste, everything was altogether new and enthralling. At the station, a porter was called and we were taken to our steamship *The Héluan*.

One evening, as I ventured on deck, a picture was unveiled to me, the grandeur of which is impossible to convey in words. There, for the first time in my life, in the soundlessness of the sea, I experienced the legendary qualities of a southern night. Above me, in the blue-black heavenly expanse, blazed myriads of stars. Although I myself had been born in the south and had become familiar with Italian night, I had never before perceived such brightness together with such solemn blackness – one could have seized it with the hands! I stood at the ship's bow, as at the centre of the universe.

One early, fragrant morning, in keeping with our schedule, the expedition, having left Jerusalem behind, started the journey to Palestine. On the way to Tiberias, which was to be our first stop, I couldn't help gasping and exclaiming at the landscape, glimpsed fleetingly as it rushed past us. Not even in Italy, in Umbria, had I ever seen anything like it: the elegant black shafts of the cypress trees, piercing the horizon; and those greyish, light-blue olives flanking dazzling, dusty roads, scorched by the sun – and so much else.

Despite all the advantages of modern methods of travel as compared with the past when people had to ride on donkeys, nevertheless, for an artist, the fast, modern car is sheer torture and torment. You hardly have time to exclaim enthusiastically at something flying past the window on the right, when suddenly, on the left, you glimpse another beautiful spectacle – a caravan of camels shying away to the side – there only for a moment as you rush by. And it was the same for us all the time: there one moment and gone the next! I begged to be allowed to do one little sketch, but the editor, who was in charge of the expedition, said by way of pacifying me: 'We'll stop on the return journey; for the time being, we'll just have a general survey.' And so, obedient to the times, we travelled at breakneck speed, zooming along the magical Palestinian roads, or flying up to the summit of a hill, or running down the steep, winding highways into the beautiful valleys below, until we arrived at Tiberias, and went down towards Lake Genissaret. The scenery here was indescribably beautiful!

It was here, to be precise, as we travelled alongside the lake, sparkling in the sun, its shore dotted with grey spotted stones, that I experienced with particular force and emotion the feeling which had never left me for one second the whole way. We went up the side of the mountain and stopped at a holy Jewish sepulchre. I got out of the car and turned round. In front of me, Lake Genissaret stretched out in all its power and majesty; to the left, Tiberias, breathing out the palpitating white heat of its mosques and little dwelling-houses, softly traced the curve of coastal surf; and opposite, extended before me, was a violet-rosy range of mountains with the scarcely visible top of the Hermon. Such silence all around, such ineffable, majestic peace!

There were other young artists besides myself on the expedition – young 'modernists' from Paris. There was also a special photographer to take snapshots. It was interesting to note, however, that in the time it took me (sitting in the car, about to move off) to sketch a characteristic scene, say, a caravan of camels, or some

moving figures, the photographer had only just managed to get out all his apparatus, and then the view from the window would suddenly change, and his picture would be lost. My young colleagues didn't take up sketching at all but towards the end, they acknowledged, cap in hand, my skill in dashing off quick drawings. They, however, were forced to resort to picture postcards of the landscape for their sketches.

Despite the brevity of my stay in Palestine, I managed to complete a whole series of pictures – drawings and studies in which I tried to create a visual memory of everything I had seen in the country. Part of my Palestinian work was shown at my first Berlin exhibition, and some of it was published.

There were a number of private salons in Berlin which had been formed in the Parisian style, and which undertook to arrange personal exhibitions for artists. I favoured one of the foremost salons, the Hartberg, and in 1927, I managed my first Berlin exhibition. Its success exceeded all my expectations both in the material as well as the spiritual sense.

I have already mentioned some of the portraits I did of men of science and celebrities from the arts; thanks to our friendship with the Russian ambassador, Yakov Z. Suritz,[65] my wife and I also made the acquaintance of various members of the diplomatic corps in Berlin. I did portraits of several diplomats, their wives and children, and I also sketched the portrait of Suritz's wife and daughter.

When I was busy teaching at the School in Moscow, it was always a source of great regret that I never seemed to have enough time to be able to enjoy nature or commit my impressions to paper by painting flowers, fruit or pictures of the landscape. Now at last, this turned out to be more possible, especially in the summer when my wife and I went to stay with our elder daughter in Munich. I've kept a whole series of studies – mostly water-colours or coloured pencil drawings of the Bavarian landscape, its lakes, mountains and fields. They were mainly still-lifes, but a large number were sketches of my wife, children and grandchildren.

On the whole, I worked tirelessly during these years and achieved a great deal.

Five years later, in 1932, when a sufficient quantity of work had accumulated, I mounted my second Berlin exhibition, which coincided with my seventieth birthday. It enjoyed a huge success. I must say that local artistic circles and Berlin society in general behaved towards me without a trace of disparagement or preconceived ideas, even though I was a foreigner. It is with deep

gratitude that I remember their attentiveness, their respect, and the friendly reception they gave me.

All this, of course, was before the Nazis seized power. With the advent of Nazism, everything changed, and our intention to arrange another exhibition in five years' time for my seventy-fifth birthday could not be realized.

As soon as my wife's health improved, she began to help me once again as she had done, and continued to do, throughout our life together. Her advice, her moral support, and her influence in general were always invaluable. But she helped me in a practical way too. She managed the difficult business of packing and mailing my illustrations for *Resurrection*, and she corresponded with journals both in Russia and in Europe and America where Tolstoy's novel was published simultaneously in 1900. When her health permitted, she would also help me by attending portrait sittings where she would either engage the sitters in animated conversation, or perhaps play the piano, to prevent the expressions on their faces becoming set. Her conversation, her music, and the whole atmosphere she created enlivened the features of my models, and she thereby contributed in large measure to the success of my work. Even in Berlin, in spite of her ill-health, she helped me in my new resolve, and thanks to her practical collaboration, I was able to prepare the necessary material for my monograph which A. Stybel[66] wanted to publish.

This monograph was published in 1932. Since he wanted to produce a high-quality book, Stybel handed over the printing and preparation of reproductions to Selle, a first-class typographer. Selle invited me to be artistic editor, in charge of reproduction for the monograph. Thanks to my experience in this field with Sitin[67] in Moscow, I really was able to raise the standard of reproduction, especially the offsets, which were of a very high quality for those days, considering the achievements of the Germans in this field. In fact, the edition was a masterpiece of its kind.

The ambassador in Berlin, Yakov Zakharovich Suritz, did me many good turns, especially with regard to my intention to send my work home and arrange an exhibition there. Boxes were ordered and my pictures were provisionally stored in the embassy. But dark events were imminent. There were rumours, which proved to be well founded, that all Soviet citizens, without exception, were being expelled from Germany, and that the authorities were apparently already working through the alphabet.

What could we do with the pictures; where could we send them? Would the Germans even allow them out of the country now? All this was very upsetting, our nerves became even more shattered, and my angina, just begun, became much worse.

Two years earlier, my younger daughter had married a University research fellow who worked in the same psychiatric laboratory in Munich. He was an Englishman, and they had settled in England. In view of events in Germany, she persuaded us to stay with her for a while so that we could collect ourselves a little, and rest before finally returning to Moscow.

London. Death of My Wife. Oxford.

I arrived in London completely exhausted, hardly able to cross the street. For us to have undertaken a journey to Moscow in such a condition would have been madness. It was madness to think that we were capable of anything at all or that we could ever undertake what my wife had been dreaming of for several years till now.

But stringent medical treatment, together with peace (in so far as peace was conceivable in those nightmarish years), and the marvellous care and attention given us by our daughters – all this gradually restored us and healed our shattered nerves. Once again, the old idea of putting on an exhibition came alive.

The English are an incomprehensible nation. Fascism is spreading everywhere, Spain has already been ravaged, the whole world has gone out of its mind, and yet every day in front of my window, the old man who owns the house next door practises a game for hours on end – that of trying to sink a little ball into a special hole in the garden. It has obviously never entered his head that he and his family might be pointlessly wiped out, that he might lose his freedom, be exiled from his homeland or, in common with the current fate of thousands of innocent victims, be driven to a state of utter destitution and be robbed of all his rights.

The children and I tried many times to persuade my wife to supplement her short biography which was published in Odessa in 1885 by a certain Bachmann. But her modesty and all the things which kept her busy at home prompted the usual answer: 'There's

time enough yet.' But there were always obstacles, and what with all the anxieties and worries of these last years, her writing was always postponed. Then, when she finally took up her writing in earnest, death suddenly stole her from us.

The stories she told, first to me, and then to the children, of her meetings with Anton Grigorevich Rubinstein, or with Professor Leschetitzky, under whom she studied in Vienna, were always enchanting.

But how long ago all this was! How is it possible to restore, to resurrect her observations and descriptions without her, how is it possible to reproduce these valuable fragments of her reminiscences, when she is no longer with us? When she doesn't say anything any more?

Among the new friends we made in England was one of the directors of the British Museum, a Mr Hind, who was in charge of the Print Room there and also president of the Contemporary Art Society. He bought several of my drawings which later found their way into the British Museum. He also invited my wife, my daughter and myself to an evening of chamber music at his home. With Mr Hind and his daughters, my wife played the piano part in the Schumann quintet, which she so loved. She was already seventy-two years of age and had not performed for a very long time. Yet she played with such brilliance, such virtuosity, and such youthful animation that her fellow players and all those listening were entirely captivated. But she was playing for the last time, only two months before her sudden death. Just as a flickering candle flares brightly for the last time only to go out in the next moment, for ever . . . so with my wife.

This quintet, her favourite, became her swansong.

April 1942

My writing has been interrupted by my eightieth birthday celebrations. There were very nice notices in the *Oxford Mail*, the *Oxford Times*, *The Times* and other London newspapers. I received a mass of congratulations, letters and telegrams – it took nearly three weeks to answer them all. But I wasn't happy. In my heart, I dislike all these festivities and celebrations; but it had to be. The

notices did, however, make mention of my wife, which made me happy for a while.

Beginning of 1943

Now, at the age of eighty, and suffering from angina, I am no longer in any fit state to work quickly, to rush about as I used to, or even to stand for a long time. Some time ago, in November 1942, I painted a portrait of an Englishman and wondered whether it would be my last. My hearing began to deteriorate, my eyesight worsened, and meanwhile I have quickly to write down what I can still remember; in short, I have to prepare to leave this world. Only a few years ago, when my wife was still alive, when I knew nothing of angina, and before the world went quite mad as it evidently did with the onset of war, I used to think that between youth and old age, stood only the barrier of physical strength. It seemed to me that the consummation of artistic strength came at the end – witness the finest fruits of maturity in Titian, Rembrandt, Michelangelo and others. Now, I'm forced to admit that deployment of all one's accumulated artistic experience is impossible without the blessing of good health or the appropriate physical strength, for, as the ancient Romans used to say: 'Old age is itself a disease.' And this must be reckoned with. Added to that is all the hardship and suffering of the war, unprecedented in the history of mankind: 'In times of war, the muses fall silent.'

My Meetings and Models

V.A. Serov

Notes

I still haven't managed to recover from yesterday's blow, I still can't take it in. I look around in confusion, seeing nothing, understanding nothing. What could be the reason for such an untimely death? He was still so young, at the height of fame, in the prime of life. It's true, he did complain of feeling tired . . . but why was his heart unable to stand the strain? You have to be so strong; as an artist, everything is felt so keenly and finely, everything perceived so deeply. Serov was such an artist, never indifferent to his surroundings; but he was never either a strong man or a healthy one. As his close lifelong friend, my heart aches the more.

To find out more quickly what had happened, I ran to his house, but as I drew nearer, my pace slackened as if to avert the painful moment of truth. I climbed the familiar staircase with a sinking heart. I was still deceiving myself that the rumours could be false. After all, it was only a few days since I'd seen him in my classroom at the School. Serov dead? No, impossible, impossible . . .

I still can't get used to the idea that Serov is no longer with us. Reason cannot be reconciled with the brutality of the incomprehensible.

Serov's death will make itself felt throughout Russia. There is even a moment's comfort inasmuch as his passing has delivered him from suffering on the stage of life; but just as the news of his death stunned like a cold, harsh clap of thunder on that first day, so now the cruel, unremitting pain returns: Serov is no more.

What a sad, sorrowful year! Since last November three great artists have left this world. The first, a master of words, our great Russian writer – Tolstoy; the second, our great historian – Klyuchevsky; and now the painter Serov. It's a heavy loss for everyone to bear, for the whole country, but that much heavier for those who were close to them and knew them personally. Perhaps their lives were too dissimilar, their spiritual domains too different, for their greatness to be of the same order; but in their hearts they shared the same intense, unyielding striving for that dearest of treasures – artistic truth. That three such men should have died in one year!

How dreadful it was to cross the threshold of his room where a deathly silence reigned. The expression on his face, released from suffering, said so much. Most poignant of all was the silence of his easel bearing the sketch for a new portrait, ready to be picked up where he'd left off. But never, never again, would the hand of the great master take up this work.

Strangers come in, go to the table to write something, taking his pencil without asking . . .

. . .His albums are silent, his paints are silent, likewise his brushes on the window-sill. Everything here is silent. Serov is no more, but his works are immortal and will continue to keep him alive. How grave, how mysterious is the silence . . . ★

A great deal has been written about Serov, much of which is biased and not always in accord with the essential nature of the man.

I already knew him when he was just embarking on the difficult career of an artist and I continued to meet him almost until the day he died. During the best period of his creative life and during the twelve years or so which he spent as a teacher at the Moscow School of Painting, Sculpture and Architecture, we worked together virtually side by side.

★As Josephine Pasternak explains in the Moscow edition of the *Memoirs* these notes were written immediately following the death of Serov and are obviously the artist's first attempt to try and give some meaning to the tragic loss of his dear friend and colleague.

When I was still a student at the Academy in Munich, my friend and colleague Vidgoff,[68] who later became famous for his drawings, once suggested that I make the acquaintance of a very interesting Russian family whom he knew well. At that time they had as a guest in their house, Valentina Semenovna Serova, who was said to be a very talented composer.

I had heard a great deal about the composer Serov while still in Odessa, but I had no idea that his wife, Valentin Aleksandrovich's mother, was also a composer.

As there were very few Russian families living in Munich then I was happy to follow Vidgoff's suggestion and we set off to see them without further ado. On the way he had time to tell me in more detail about Serova, whose maiden name, it transpired, was Simonovich. Now the Simonoviches were a very venerable and cultured Odessan family who used to live not far from us, though I knew about them only from hearsay. And indeed our hosts that evening were very pleasant, as were the other guests who had gathered there.

Valentina Semenovna was a rather plump and large-featured woman who gave the impression of being very talented and strong both in will and temperament.

She was happy to play many pieces for us that evening and finished with excerpts from her new opera *Uriel Akosta*. Of the melodies she played, I particularly liked the male chorus from the Jewish Synagogue Service. I understood nothing about music then, by the way. It was only later, thanks to my wife and her playing, that this whole new world was revealed to me, and then I began to understand and value music as much as its sister art form, painting. At the request of her audience Valentina Semenovna repeated several particularly felicitous passages from her composition. She proved to be a splendid pianist. It was said of her that in creative talent she was the equal of her husband, the late A. Serov.

The Serovs often used to travel to Munich and to the Bayreuth villa of Richard Wagner with whom they had formed a sincere friendship. Valentina Semenovna made frequent visits to Munich even after her husband's death. Valentin Aleksandrovich used to tell me subsequently that the only Bayreuth impression to stay in his memory was how he used to ride on Wagner's gigantic St Bernard dog. Of the composer Richard Wagner himself, he remembers practically nothing.

That same evening Valentina Semenovna spoke at length about her St Petersburg friends, about Repin, about her son, that he was also a painter, that he had started to draw very early and that after his father's death, he had been brought up in Repin's house, where he also studied drawing.

Try as I may, I cannot remember where in fact it was that I first met Valentin Aleksandrovich. Was it in Odessa, in Munich, or did we get to know each other in Moscow? Serov was actually in Munich (in the middle or late 1880s) copying Velazquez's portrait of a young Spaniard in a skull-cap at the Pinakothek. But most likely it was in Odessa[69] where he used to visit the Simonoviches, his relatives on his mother's side, who also brought up his bride-to-be, O.F. Trubnikova.

Like all young artists we experienced the usual financial hardship at the beginning, but we quickly settled down and began to earn enough to maintain a modest standard of living. Both we and our growing children soon made friends with each other. Gradually our circle of acquaintances expanded, although few of the others were painters. Besides Konchalovsky, the Polenovs, Repin and Braz, I can't name anybody. I was on the best of terms with my colleagues at the School of Painting, expecially with K. Korovin and Vasnetsov, but we didn't meet socially at each other's homes, and subsequently my family became close friends only with Serov and with S.V. Ivanov and his family.

An identical upbringing, identical aspirations and identical tastes produce a similarity of views both within education and outside it. There is nothing surprising in the fact that two such different people as Serov and myself should sometimes express strikingly similar views and give identical appraisals – I want to recount one such example.

The Moscow School of Painting, as a higher educational establishment, was divided into three departments: painting, sculpture and architecture. In each of these departments the respective teachers supervised monthly projects which were exhibited at the end of each month and evaluated by a committee made up of artists from every specialist field. At the end of the year, works completed during the year were exhibited, and on the basis of this it was decided whether the students should be moved up to the next class.

At one of the intermediate examinations I was walking past the students' paintings, which were standing on easels, when I was involuntarily struck by one such study. I stopped in front of it. Though it was a painting executed by a student, it could have been attributed to the hand of Rubens – it was practically a miracle! The colleague standing next to me – a teacher, like the rest of us, by the way – remained totally indifferent to this study. But then Serov, whom we had been expecting, entered the hall, and before speaking to anybody, he immediately singled out from all the

other studies the painting which had struck me. With a joyful expression unusual for him, he put his hands in his trouser pockets and nodding his head towards the painting, said to me cheerfully: 'Pyotr Pavlovich! To a T!' (Pyotr Pavlovich was what we used to call P.P. Rubens at the Academy – the nickname came from Chistyakov, I think, who had once called Rubens that.) Of course I was very glad that so great an authority as Serov had confirmed my impression and that I was able to verify it in this way. The student kept the nickname (though Serov altered it to 'Pal Petrovich' for some reason).

This similarity in our judgements and our valuations of students' work can also be explained by the fact that few of the teachers at the School knew and empathized with the old masters, or indeed foreign painting in general, so well as Serov and myself. Artists at this time had scarcely been abroad and with a few exceptions knew little about foreign art and had little interest in it. The fact that Serov and I both knew and loved the old masters and had seen them in the original, and also valued contemporary Western art, were further factors which brought us together.

Here is another example of the kind of inner artistic affinity which existed between us. Having returned from abroad in autumn 1908, after the School's summer break, I met Serov and began to recount the impressions from my journey. We started to talk about England, which I had visted for the first time. Full of enthusiasm for the artistic treasures to be found in the museums and galleries there, we got onto the famous antique sculptures at the British Musuem in London. I started to talk about the heights attained by ancient Greek art, and the sculpture in particular, about how I had been struck by the world of antiquities and enchanted for ever by the Elgin pediment and amongst its figures – the highest achievement of art – the celebrated horse's head which we all knew very well from plaster casts but which in the original was such that it simply could not be compared with plaster copies.

These famous figures, the so-called Elgin Marbles, are the original frieze from the pediment of the Parthenon. More than anything else, I was impressed by the figure which concludes the group to the right, the famous head of a horse emerging from the ocean depths. It is only the head, but it seems to be quivering with life, caught in an onward rush of movement, snorting and flaring its nostrils in the foam.

I had known this head only from photographs and plaster casts. Once I glimpsed the indescribable beauty of the original I was so gripped by it that I was unable to leave. The more I looked at the head the more enchanted I was by it and the smoothness of its marble, painstakingly polished as it was even at the back, which

nobody ever saw. There was an example of a finished work of art, without any trace of the aridity and tedium which always lie in wait for the artist. I couldn't go away without sketching it in my album; without, as they say, sealing it in my mind. I asked my wife, who was accompanying me, to carry on walking round the neighbouring galleries while I sketched the head. 'I'll soon have it finished and then I'll catch you up,' I said thoughtlessly.

So then I started to sketch the head in my album. But it wasn't as easy as it seemed. I started to draw its outline, but it came out so badly! I rubbed it out and started again, improving here, erasing there – but no, it still wasn't right. I drew, I erased, I corrected – but it was all wrong! I captured nothing, neither the divine nobility of the beast, nor its quivering life. I erased it again, I panted, I sweated, I fought and fought but finally had to abandon the attempt, exhausted and in despair, having failed to capture either the vitality or the beauty of this ancient masterpiece.

I told all this to Serov. He, an excellent sketcher of horses, listened all the time and said nothing, his eyes closed. Then, as if remembering something suddenly, he turned towards me and shaking his head (a characteristic gesture), said with the sound of despair in his voice: 'With me too, it was exactly the same. Nothing worked out for me either.'

Serov was a great humorist. Subtle, sometimes caustic, he loved to joke while maintaining his customary serious, almost gloomy expression. A typical story of his has stuck in my memory.

After a serious illness, Serov found it exhausting to go home for lunch and then return to work on days when he was on duty at the School. Furthermore, he had to keep to some sort of diet. We came to an agreement with Olga Federovna that on days when he was on duty he would have lunch with us, as our flat was now situated in the School building itself.

Once, over lunch, my wife asked him how his large portrait of a certain very interesting lady was progressing: 'Will it soon be finished?' 'What a question!' replied Serov, 'I started the portrait and opposite my studio they began to build a house. Just imagine it, I started to sketch the mouth, and opposite I noticed that they had begun to dig the foundation trench. Well, they finished the trench and even covered over the foundations and started to erect the walls, and it was really a big building! I arrive one day and they have already built the walls so high' – and with a vivid, flowing gesture he showed us how the walls had already risen higher than his head – 'and I am still only drawing the mouth . . .' Who could

have conveyed the difficulty of mastering artistic form with greater humour and animation?

Incidentally, his answer also reveals the modesty which was the distinguishing mark of our times. So great a master as Serov was not ashamed to say: 'I have such difficulty in drawing a mouth.' This, by the way, is one of the most difficult things in portrait painting, especially in oil. That is why I used to draw in pastel at one time so as to cut down the time of sittings and to link two techniques at the same time: drawing and painting. For greater speed, freshness and decorativeness I started to adopt a composite technique for the first time – using tempera and pastels. But that was considerably later.

Once we started to talk about the point when portraits could be considered to be complete. My wife began to complain to him that her husband never knew, and could never say, that he had completed a work. In justification, however, I can say that I used to paint a portrait in six or seven sittings. 'He can never tear himself away from it and is always adding finishing touches. And how is it with you, Valentin Aleksandrovich?' Serov, as ever, did not reply immediately but waved his hand and then said that he had never been able to finish, but that circumstances usually finished the job for him. 'With me, Rosaliya Isidorovna, it's very simple. Either my lady (the one whose portrait is being painted) goes away, or I have to go away myself – and there you are, I've finished.'

Valentin Aleksandrovich only appeared to be strict, silent, dry – or austere, as our *nyanya* used to say. For some reason she used to pronounce his name Surov, which in Russian means stern, severe. In reality, he was a good-natured and accessible man and colleague, a person possessed of very high moral aspirations; towards his family and children he was gentle, if restrained. But he could also be very strict with them. Once in my presence he reprimanded Yura[70] so sharply that I felt very uncomfortable. He was a great humorist by nature, and in the modest picnics we used to have with Korovin, Konchalovsky[71] and others when we were young, he used to enjoy himself to the point of exhaustion, making other people laugh while remaining gloomily serious himself. He was a great mimic, too. His whole sense of humour would sometimes find expression in a single mute gesture or in the minute almost imperceptible play of his features; suddenly you would be presented with some characteristic new face, or with a dog slowly waking up before your eyes, and so on.

Like any great artist, he was an original: he had his own special tricks, his own turns of speech, his own characteristic movements and his own words and expressions invented by himself, like, for example, his celebrated phrase 'optic compasses' (visual memory

and powers of observation, and not a 'measuring gauge'). He also used to say to me: 'You have vanquished the child', referring to my drawings and portraits of children. Children are indeed the most difficult subjects for a portrait artist.

We used to mark the opening of our yearly Union of Russian Artists exhibitions with what in those days was called a *vernissage* – a ceremonial dinner at the Hermitage (we had done the same in previous years for exhibitions of the Thirty-Six).[72] Apart from the artists who were taking part in the regular exhibition, we also used to invite the artists' friends, art-lovers, collectors, patrons and sometimes performing artistes. Chaliapin was nearly always there of course – the artists' best friend. The dinner would be a very jolly affair; the food was good and people would eat a great deal, but they would drink even more, proposing toasts, conveying good wishes, engaging in interesting conversations and so on till late into the night. The dinner would usually get off to a very good start, but people would gradually get tired and things would imperceptibly slide into a minor key.

Without ceremony Chaliapin would take his seat at the piano, run his hands over the keys and there would follow a succession of wonderful romances, intimate Russian songs – often with neither beginning nor end, but running gradually one into the other – as if he were performing for himself rather than for anybody else. The music had an intimate quality which you don't get in a concert hall and the fact that it was such an artist as Chaliapin who was singing made it perhaps all the more moving.

After one of these dinners which had gone on for so long that it was already becoming somewhat boring, many people were beginning to depart when suddenly someone's voice rang out: 'Let's go to the Yar and listen to Varya Panina and her gypsies! Let's go! Let's go!' Of course there were always carriages and drivers waiting at the Hermitage for their customers.

Since I was almost completely sober and no great lover of such 'jollifications', I tried to slip away unnoticed, but my colleagues – Arkhipov,[73] Vinogradov,[74], Ivanov, Serov and the others, knowing how I disliked this kind of thing, refused to accept my refusal and shouted insistently: 'Come along with us!' and 'Drag him along!' They lifted me up and forcibly seated me in the carriage and Ivanov took me into custody lest I should escape. When we arrived, the rooms were lit up and various patrons were assembling. Gypsy men and women dressed up to the nines in chic European costumes were wandering around in groups. There was champagne once again – in inexhaustible quantities! There was a

disagreeable atmosphere of boredom broken, it is true, by the singing of the famous Varya Panina and her choir, ordered by our friends and art-lovers. The singing of the gypsy choir was new for me and they made an interesting group, while Varya Panina, accompanied by choir and guitar, sang romance after romance, each better than the one before, in an unusually deep and pure contralto; a marvellous, almost masculine voice!

Later I even wanted to paint her with her choir in the background. She would be seated before them like an Abyssinian negus, like some Menelik,[75] dressed all in black with sequins and in a characteristic pose, her hand covered in rings resting on the arm of the chair. I wanted to paint her, to depict her as an unusual phenomenon of Russian life, and I regret that for various reasons I kept deferring my plan so that in the end I didn't paint this colourful scene at all. I remember that I did do a sketch in one or other of my albums, but where, in which one? I can't remember now!

Vanya and her choir were called into another room to perform. Now even this item was exhausted. I didn't like drinking and wasn't able to drink much (my colleagues knew this). I wandered from room to room; it was already very late. Past three o'clock and boring beyond endurance. Then I firmly resolved to escape. I walked into the next room in the direction of the exit and suddenly saw in the corner not far from one of the doors, Serov, who had drawn up two more chairs next to him (in the way children play trains) and placed his legs on them, half sitting, half lying, hunched up, his head pressed down onto his chest, hands in his trouser pockets and dozing, miserably bored and mean, very mean . . . I went up to him and said: 'I can't stand it any more, I'm going home, I'm hellishly tired, I can't . . .' 'Nooo!' drawled Serov in his own inimitable way, staring at me gloomily with good-natured spite. 'Nooo!' he cried decisively, 'stay a bit longer . . .' And opening one eye, but without changing his pose or position, he said maliciously: 'What did you think – that having a good time was easy? No, you're not going yet!'

Finally, having had its fill of jollification our company dispersed homewards. And for the rest of my life I have remembered Serov in that characteristic pose making that malicious remark, 'Did you think that having a good time was easy?'

Meetings of the School's artistic councils were usually boring and wearisome so we naturally allowed ourselves to indulge in harmless artistic entertainment. Serov would come and sit beside me on most occasions. From his pocket he would surreptitiously take out

a game dating from the days of the old Academy of Ars – five wooden balls, sometimes tied together with thread. As in dice, one person had to throw the balls, and the other had to draw the outline of a man in any position, using the fallen balls as co-ordinates. Then it was the other's turn to throw and the first person would draw. Another game of ours involved observing the people who were speaking, catching whatever was funny and chuckling at their eccentricities.

A great source of entertainment and consolation at these meetings, and one which could even be quite useful, was to do caricatures and serious sketches. Serov used to draw, too, of course. I actually did a sketch of him drawing at one of these meetings. I sketched him surreptitiously, as I knew that he didn't like it. He himself was busy at the time drawing the person sitting opposite him and didn't see me. When he stopped drawing, I was already sketching somebody else. Having observed this characteristic pose on many occasions, I depicted him thus in my group painting[76] entitled *Meeting of the Council of Artist-Teachers*. There I drew him in profile with a typical expression on his face, gloom engraved on his forehead and the eternal cigar between his teeth.

We used to give nearly every sketch of these meetings to Prince Lvov, since he valued then highly. In this way, a large collection of these portraits of teachers was formed. Most of the sketches were done by Serov, Korovin, myself and one or two other people. Prince Lvov wanted to donate this collection to some museum or other after his death. What happened to it, and whether or not it disappeared, I don't know.

Serov had retained various memories of Odessa and Munich and we often used to talk about them. He was able to tell very funny stories about the customs of the Bavarians and the citizens of my beloved Munich. As far as Odessa was concerned, he naturally stayed with N.D. Kuznetsov whenever he paid flying visits there from Petersburg. It is quite possible that it was actually at Kuznetsov's house that we got to know each other. It was there that Serov painted his famous study of two oxen and a cart near a barn.

It was never my intention, and I do not now intend, to write a monograph encompassing the whole of Serov's personality and work. Nor do I intend to give an analysis of his enormous creative output. I have simply committed to paper a few reminiscences of him as they arose in my memory, attempting to sketch in the typical features of his character and talent which are more closely

linked with his artistic work than is the case with most other people.

His high moral sense, his honesty and the firmness of his artistic beliefs made him for a long time an authority amongst those of us who were still young progressive artists. But I knew that he was oppressed by his high rank among the artists of the time, and by the role which he was destined to play.

Serov stood firmly for what he believed in: he made no concessions and would not betray his principles. As a result there was no love lost between him and some of the teachers. They liked neither his independence nor his liberal views, nor his refined tastes. But they were very much afraid of him and could not bring themselves to attack him openly. But to make up for it, they attacked me as a like-minded person and friend.

Circumstances favoured Serov from the very beginning and this helped to develop in him a spirit of independence. Being the son of famous talented composers, Serov grew up in an artistic atmosphere. After the death of his father, he was brought up in Repin's family and it was Repin who gave him his first lessons in drawing and who encouraged and supported his proclivity for art. All this strengthened his self-confidence and made it easier for him to join the artistic community. Once he had become a professional painter, he continued to move in the circles which he had known since childhood and to which he belonged both by birth, education and closeness to Repin.

The difficulties which I had to overcome were unknown to Serov, especially after Mamontov[77] became his patron. All the same, there is a certain similarity in our artistic development, in our domestic environment and in our interests. We were members of the same generation, shared identical views and tastes and preferred drawing (the expression of form) and above all we were both enraptured by the old masters and both knew and loved the work of Western painters. Even in the realm of education we developed almost identical methods of teaching.

A few more words about Serov in the portrait class. He found teaching this class a burden since he considered it unnecessary. He always regretted leaving his favourite class, life-drawing. He found the portrait class particularly alien and oppressive in the last years of his life when new artistic currents from the West led to the denial of our methods of teaching. Serov was already encountering open disrespect – as were all of us – from a number of students who yielded to these tendencies (D. Burlyuk, M. Larionov, N. Goncharova, I. Markov, P. Kuznetsov and others). Serov with his

heightened sensitivity found this decline in his authority in the classroom simply unendurable, and it became ever more serious. The sharp tone of Serov's 'open letter' is eloquent testimony to his feelings and it is quite evident to what extent the teaching of that class had become a burden to him. More than once he intended to leave the School. On these occasions Prince Lvov, myself and Olga Fedorovna persuaded him not to do so. Once, at their house, at Olga Fedorovna's request, I begged Valentin Aleksandrovich not to leave the School, pointing out that he ought to continue to work there for the sake of his family – besides, he was indispensable at the School and his work and influence were of the first importance. I remember how savage he became! Stamping his feet, he cried: '*Me* – teach *them?!*'

Anybody who had the slightest knowledge of Serov could not but be struck by the peculiar contradictions of his life, particularly in his final years. On the one hand, his career seemed to have been gilded by fate. Everyone knows the exceptionally brilliant way in which his life and artistic career developed. Genuine success from his very first steps, success which continued to grow until the moment he died. He was generally acclaimed. He enjoyed enormous respect in society, whilst among his friends and at home he commanded unshakeable authority. Family happiness, success and contentment. And yet . . . cheerful and good-natured, he could also be morose and gloomy, he could scowl, and with an expression of continual suffering, he would wander around rapt in thought, as if embittered. How can this life of rare success, glory and plenitude be reconciled with the signs of anxiety imprinted on his face?

If you examine Serov's life more deeply, it turns out to be full of hidden tragedy. He suffered profoundly and constantly. Only introspection, endurance and the special psychological qualities of a sensitive man together with the reticence and pride of an independent character prevented him from complaining.

His fondness for the people was beyond question; his sympathies were on the side of the simple folk rather than of the devotees of modish salons, slaves to the latest fashions. He was a genuine Realist who had once[78] belonged to the Wanderers, but he differed from them markedly, lacking the falsity and mawkish hypocrisy so typical of some members of their Society. He fitted in even less well with the refined aesthetic circles in the Beardsley[79] style to be found on the banks of the Neva;[80] as for the modern movements, well, that goes without saying! He even stopped

visiting the Shchukin modernist collection. 'Disgusting,' – that was his opinion of them.

Serov always remained true to himself. His judgements were always sincere. 'I can't see the colour here for the life of me,' he would say to me while examining some stunning painting. He was, in my opinion, closest of all to the Union of Russian Artists which, as is well known, did not force any particular taste on anybody, but on the contrary used to allow any painter invited to exhibit the right to retain his own artistic credo and personality.

What, then, were the main contradictions which tormented his life? One was that despite his democratic aspirations, he painted portraits of people who represented the plutocracy that he hated. Another was that the sharp turn in the development of art began to erode the authority of this very proud and easily wounded man. But above all, perhaps, the members of the 'World of Art' took him over to their side, extolled him in their journal and then used his name as an aegis, of course. This offended against the truth which he loved and valued, and wounded his sensitive conscience. He was very severe with himself – I know this from our conversations – and praise from this quarter was always offensive to him. As he often used to say to me: 'Good God, what people I do please!'

Life went on, however, and continued to make its demands. Serov had perforce to breathe in the bitter incense of their praise. He hadn't the strength to resist it and this, too, was not without its own drama.

In our conversations I often used to say to him that he had been born with a silver spoon in his mouth. He agreed with me and did not deny that he had been one of fortune's favourites. His first portraits were undoubtedly very bold and fortunately were of people to whom genuine works of art meant a great deal.

He was an outstanding representative of the Russian people and possessed of that quality which is rare in our times, a sensitive conscience which was hurt by the deformities of everyday life. He couldn't become reconciled to them, but they ensnared him, so that struggling with them was unthinkable.

When examined carefully, the life and death of Serov acquire profound significance. Those of us who were close to him both as a man and an artist, saw his rapid growth, his unusually early, though well-deserved fame, and observed how fortune smiled upon him and indulged him. The more fate gilded his journey through life the greater his spiritual suffering became. Life remorselessly demanded that he devote more and more of his artistic energy to areas where he least wanted to expend it.

How he loved nature and animals! His spirit found these a source of such joy and repose, and yet he painted portraits of elegant society ladies, cold and without souls – why? He could have painted the portraits of far more vital and interesting people! He used to say of himself with caustic irony: 'I'm like a doctor, you know, I work around people's houses.'

It's strange, but the celebrated eighteenth-century English portrait painter Gainsborough said to a friend just before his death, when he was at the height of his fame: 'You see how tragic my fate has been: I paint portraits while what I really would like to do is paint landscapes and nature which I have always so admired. At bottom, you know, I don't like portraits.'

Serov loved the Russian village with its peasants' huts, barns and horses. Like a true artist, he looked upon them with loving eyes and saw what was so distinctive about them. Everywhere he captured the charm of form, starting with a crow sitting on a fence, dogs, horses and ending up with what interested him most of all – the characteristic forms of people. His portraits of Fedotov, Mazini, Tamagno and others were painted in this way. He was seeking the person's soul in them, he found it and expressed it.

As is the case with all great artists, his whole behaviour bore a special stamp. Like the majority of painters, Serov did not like meetings and discussions. He was usually silent at them and on the rare occasions when he did speak he was laconic. If his sharp mind and subtle powers of observation did embrace some thought or impression, then it was expressed concisely and with great precision and firmness.

I loved his apt, graphic expressions, especially when it was a question of exchanging thoughts on our professional concerns. Admittedly he used to speak about himself in a jocular tone but there, too, he was without mercy.

I attended his posthumous exhibition,[81] an instructive and unforgettable event of exceptional artistic interest. For me it had an unexpected and invaluable interest of a different and special kind. I experienced once again both my own past and his, filled with precious memories of our youth and our mature working lives, fraught with ceaseless struggle. Never before had such long-forgotten, tender and heartfelt memories arisen so brightly and vividly – and in such a sequence – in my mind.

Serov had been used to living in an artistic atmosphere ever since childhood (life with Repin, friendship with Mamontov) and he thus allowed himself to paint freely and not as one might for paying customers, who could place constraints on one's artistic ideas. He would paint portraits of the people who were close to him, and for that reason would execute them lovingly. He painted the lovely portrait of M. Simonovich, for example, which is radiant with the enchanting spontaneity of the beautiful model and the bright purity and youth of the artist's soul. What a portrait! I can still remember that youthful time even now. At that time we were captivated by the work of Basten-Lepage. Serov used to talk about him with enthusiasm.

From his very first portraits of Verusha and Masha,[82] Serov penetrates more and more into the depths of his model. Ever sharper and deeper! Everything is subject to observation. Look at the portrait of Tamagno: every stroke and movement of the brush captures a form and a contour; the powerful neck is almost grasped by the collar of the shirt; the hawk eyes of the artist have bored their way right into the subject; contours are accurately engraved, and a reproduction is forged by the will of the painter! His mastery grows steadily. Like everyone, he has his dream: this is to be able to achieve the sharpness of a nail in his drawing, and this with the enormous simplicity the old Italian masters achieved on frescoes.

He was the exact opposite of those with expansive artistic natures who light-heartedly capture the imprint of their surroundings, rapidly, in passing – impressionistically: once – that's all right; another time – not so good, and so on. Serov by contrast was all penetrating observation, thoughtfulness, concentration. Even in his youth when he was sincere in his gaiety, he was always preoccupied, almost severe.

The elegiac tones of youth found expression in his marvellous studies of the Russian countryside (some works of this period can be found in the Tretyakov Gallery and the Alexander III Museum),[83] and of Russian landscapes aching with nostalgia. And yet suddenly you glimpse the artistic mockery which was part of his nature in that inimitable piece of old Moscow – *The Little Line to Kuzminki*. Ah, what boredom! What a hot summer, and the dust! Perhaps this work isn't executed quite according to the rules of aesthetics, but there is so much of Serov's character in it – it's almost Gogolian! What tragi-comedy! What love! Here you have it all – his soul: both the horses, and the people, and the heat and the landscape!

When you walk through an exhibition where the whole world of

celebrities, the so-called *beau monde* in all its forms is staring down at you from every wall, you might think that this was his world, that like certain famous foreign portrait artists, the society painter felt himself quite at home in such company. But you would be quite wrong. It wasn't his world, and he found many of his clientele profoundly disagreeable. Many of them divined this very well and sensed his attitude towards them. These Serov portraits will remain, like documents, for posterity.

Like Gainsborough, who painted society portraits while his spirit yearned for landscapes, Serov, too, unburdened his heart by sketching all sorts of animals and genre scenes. This was his way of cheering himself up. But in the end, you know, man, too, was a part of this world which he loved.

What an instructive exhibition this was for all those who so light-heartedly number themselves in the ranks of the innovators. There was so much dogged labour even for such a great master, and so much effort of will in the achievement of his tasks, and such a vast education! How this should give pause for thought both to those who deny his art and to the critics who should learn to distinguish between the vitally important and the superficial, between what can be achieved only at the cost of great labour and what is easily accessible even to the dilettante. There was a portrait from the time when we used to meet in the evenings to draw at Korovin's studio on Dolgoruky Street. And there was work from the time of the Lermontov illustrations. How enthusiastically Serov used to work in those days!

For a while he was under the irresistible spell of Vrubel whom he loved and valued very highly. This was during the time when we worked together, went for happy walks in the country with our comrades, shared artistic enthusiasms and argued with each other. It is with deep emotion that I recall this bright, distinctive period when so many different artists joined in the same work which profited by all that was best in us then. It was a whole era in our lives. The end of the 1890s marked the end of our youth.

With one hand, fate mercilessly and recklessly cut short Serov's life when he was at the height of his power and fame; with the other, through the efforts of his friends, she lovingly and carefully gathered together his splendid works: this is what he did, these are his achievements – look at them, delight in them and learn! And indeed, rarely does fortune so bestow on artists the possibility of expressing the whole of their nature, of displaying their entire work up to the very last moment, of crowning their artistic career.

This incomparable exhibition was seen by everyone – from Serov's admirers to those of his pupils who dethroned him; it was seen by the city of Moscow where he had passed the whole of his

working life and where the cast of his mind had been formed. Even for those who had known Serov closely, the exhibition contained so much that was new, that had never been seen anywhere before, so much of profound importance that they, too, had a very great deal to learn there, and this is not to mention the artistic value of the collection itself.

Serov was not only an astonishing painter, he was also a citizen, a patriot; people used to talk about his strong will, his imperious character, and so on. Yes, he was a man of principle who stead-fastly and with great dignity expressed in his work only himself, only *his* views and convictions. You would scarcely have found a person able to convince or persuade Serov of the rightness of something with which he was not in agreement. Even Repin was unable to boast of this, although Serov would listen to his opinion and set great store by it.

Nevertheless, something inexplicable did happen in his life: he suddenly fell under the influence of S. Diaghilev[84] who began to impress him in some way. And having once succumbed to him, Serov, God knows how, was already the captive (though it did not appear so on the surface) of a circle of people who were once again not of his world and very distant from him. They began using Serov's name as a shield. Outwardly Serov appeared to be the leader of the 'World of Art'[85] group, but in actual fact he gave in to this group of 'innovators' who were struggling with the 'grind' of Moscow life. It is true, they did innovate: they made a painstaking study of the graphic art, water-colours and painting of the Empire period of eighteenth-century France, and they studied the engravings of Hubert Robert, of Piranesi and others. They pored over typefaces and texts, rummaging around like antiquarians in libraries and in second-hand bookshops, something which neither Moscow nor Petersburg artists had done before, of course. These innovations went even further, in the form of monacles, smooth hairstyles and visiting cards – this is how Diaghilev always was, or the refined and caustic European Nurok, or the affluent S. Makovsky (who produced quite an impression for those days, even in Paris), or K. Somov ('he's sickened with violet', was Serov's comment on his palette).

None of this was Serov's world and such a world of art could scarcely nourish and fuel his creative work. Yet this quite alien world absorbed him more and more, at the expense of that pure and free environment which was so necessary and important for him. Serov, who had always been sickened by cliquishness and done his utmost to resist it, suddenly found himself all but the leader of just such a clique, and a warring clique at that, complete with its own journal. He lacked the courage or the strength to

break free from them – and all those who have spoken or written about him knew this to be the case from Serov's own admission. Was this not the tragedy of his position, and of his whole life?

He was considered to be impervious to things and people called him such. He was feared as an arbiter in matters of art and the most incorruptible of judges. A word of criticism from him was merciless and invariably correct. And such he was, firm in his convictions and judgements. As a child, however, he had been suspicious and timorous and extremely fussy about how he himself was judged by others. The moment at which his authority amongst the students at the School began to falter (as a result of attacks from ultra-new theoreticians of art amongst his own pupils) was not only painful for him – it was like a blow aimed straight at his heart. In this situation Serov was unable to continue his work at the School, however fruitful and indispensable it might have been. 'Impervious', he may have been, but he could not withstand and oppose these extremist movements (he could not accept either the colour effects of Matisse – green shadows, violet contours etc. or the decomposition techniques of the Cubists; he would say to me: 'However hard I try to see a subject like this, I just can't, I just can't!').

As regards this 'looking over one's shoulder' at what other people were doing – something completely new for him – he would often say to me: 'And how is cousin Sargent?' or 'And what's Boldini doing these days?' or 'It's like being in the presence of our masters', referring to all the innovations introduced by Diaghilev, as if he were in Europe – all those Exhibition Committees, Societies for the Friends of Art, Representational Art and other aristocratic fun and games. Yet he liked what was simple and modest. This naturally gentle man who could be quite cheerful at times, who had a responsive soul which suffered for others (he used to seek work and money for those who needed it – though in need himself, he used to help and advise others like Korovin and sometimes procure them custom), and whose character delighted everyone – this man suddenly became misanthropic, harsh, gloomy and unsociable. Was not this conflict, this contradiction his drama as an artist and man?

But that is enough! Those who didn't see him on his death-bed will never understand me. But understanding dawned on me when I saw that smile of liberation on his face! I shall never forget the truth that was suddenly revealed to me by an expression which I had never seen in Serov's features while he was alive – one of blissful peace and release as if a tired man had finally, quietly and peacefully settled down to sleep.

My Meeting with E. Ysaÿe[86]

It happened a long, long time ago in Odessa. I had only just met my future wife, the pianist Rosa Kaufmann. She was only young then but had already made a name for herself. We met at the house of a journalist who was well known in Odessa at that time, and throughout the whole of Southern Russia, one S.T. Vinogradsky who used to write topical and lively *feuilletons* under the pseudonym of Baron X. His receptions, which were noisy and well attended, used to bring together, amongst others, representatives of Odessan musical life and visiting performers from Russia and abroad.

I remember one such reception particularly clearly. The assembled company was impatiently awaiting the appearance of a new European celebrity, the violinist E. Ysaÿe, already well known even in Russia. Somewhat late, he appeared with his accompanist and entered the first large room which was filled with guests. It was Apollo from Olympus who had appeared in the doorway – no more, no less. Dressed all in black, he was handsome, imposing, with open, classical features, a clear gaze and a splendid easy bearing, his head raised slightly and his fine shock of hair falling down to his shoulders. I have never seen such a handsome individual since. Our host, who had a good command of French, began to introduce Ysaÿe to a few of the guests. When they reached me and S.T. Vinogradsky said: 'And this is our talented young artist' – Ysaÿe did not allow him to finish but exclaimed: 'An artist? – marvellous!' He offered me one hand, placed the other one on my shoulder and led me into a small room near by. Without enquiring how good my French was and without paying any attention to the fact that he appeared to be ignoring the presence of the other guests, he started talking to me about French painting, which he knew very well and seemed to understand. I do not know what he found so fascinating about me, but I had the feeling that we had been friends for a long time. He must have found the representatives of various sections of society rather boring. In any case we chatted freely for a long time, in my case with the help of my hands and even some drawing. Finally he invited me to his hotel and we continued to discuss painting and music in his room.

At concerts the inspired Ysaÿe drove audiences to distraction with his playing and personal appearance. He used to act very independently, taking no account of fashionable society's rules. It transpired that, apart from anything else, he was a fine billiards

player. He didn't give me a chance to pick up my cue twice, of course. The guests sitting in the hotel restaurant would get up one by one and go into the billiard-room to observe the skill of this handsome foreigner. What a charming appearance he had in those days! When I used to walk with him down Deribasov Street (the main thoroughfare in Odessa) people would involuntarily stop and stare at him.

Many, many years later, I saw him again in performance and I just couldn't believe my eyes. Where had his charming good looks got to? This former example of Olympian beauty had turned all to flab and fat. V.A. Serov drew him exactly like that. Well, I suppose Ysaÿe's beauty had all gone into his divine playing.

Nikolai Dmitrievich Kuznetsov

I must add to my Odessa reminiscences a description of my acquaintance and subsequent friendship with Nikolai Dmitrievich Kuznetsov, an artist, and a very talented artist at that. He was a friend of Repin, Polenov, V. and A. Vasnetsov and other progressive painters of the Wanderers group. At the time I am describing, I was about twenty-two or twenty-three and Kuznetsov would have been ten years older. He was a rich young landowner who had a large estate about thirty versts from Odessa, with a splendid manor house and an enormous artist's studio where the genial host could paint with his guests – colleagues and friends of the artist who had come to spend some time with him. The atmosphere was merry, lavish and exceptionally cordial. An enormous carriage used to drive along the narrow road to our little house (I was then living with my parents on Meshchanskaya Street), drawn by four lively horses. From the carriage would come a loud cry: 'Leonid Osipovich, hello there! Let's go to my place in the country! What oysters I've got for you!' (that was a joke since he knew I couldn't stand them!) 'And what marvellous Jaffa oranges I'm taking with me! . . . This whole box!' Then a handsome, brown-haired fellow would get down from the carriage – N.D. Kuznetsov, known in both capitals for his portraits at exhibitions of the Wanderers.

The unusual spectacle of a team of four strong horses drew the boys and girls from the surrounding houses. The social contrast was striking – poor Jewish children on the one hand, the ease and prosperity represented by this carriage on the other. Shouting 'Hurrah!', the children would accompany the carriage as we left

the narrow street. Then we would drive and drive, with the sea visible almost the whole time. By sunset we would be approaching the front steps of the country mansion. It was strange to see it standing alone in the middle of the open steppe. On all sides we would be greeted by the barking of hunting dogs, some of them shut up in the barn, some of them running free in the courtyard. In front of the house there was an unharnessed water-carrier's cart, next to it a hay wagon and, as in Serov's marvellous study, two oxen, one black and one white, chewing hay from the cart. All this was so unusual for me, a town-dweller.

On one occasion Nikolai Dmitrievich showed me the master's rooms and then the basement floor. But of course it wasn't really the basement floor which he wanted to show me but something quite different – it was a little girl aged three or four who came to meet us and whom he lifted up and stood on the window ledge: 'Well, do you like her?' I hazarded a guess. Marusya was the image of her father: the same pitch-black, burning eyes, the same temperament, latent as yet. And what a beauty she would be! The 'very much' of my reply was such that it contained the answer to any further questions of the same kind. Not everyone was shown her as yet – she still passed her time in the kitchen. But a few years later and Marusya would become the toast of Paris and the whole world – she would become a star of the Paris opera, would have her own salon, and to be received by her would count as a great honour. Scholars, flowers of society and ministers would jostle each other in her ante-room. Neither her father, nor still less her mother, dreamed of what a brilliant, meteoric appearance Marusya Nikolaevna Kuznetsov-Benoit[87] would make on the European horizon.

Her mother, a beautiful, good-natured woman, had been hired by Kuznetsov along with some other seasonal labourers to work in the vegetable gardens for the summer. Nikolai Dmitrievich had been very much taken with this beautiful girl, dressed in her *panyova*, a colourful, tufted peasant's costume. He fell in love with her and she returned home no more, but stayed with him. She turned out to be a clever, capable and beautiful mistress. He taught her to read and write and they married when they already had three children. Marusya and her two younger brothers were all legitimized by Kuznetsov. Now that she had become a lady, Madame Kuznetsova's innate tact told her how to behave in society and she always remained the kind and good-hearted Galya – this was the name given to this hospitable hostess and expert maker of marvellous liqueurs.

Life at the Kuznetsovs' was good and free and easy and, as I remembered subsequently, very interesting.

But there was also a dark side to the life of N.D. Kuznetsov. However touching his relationship with his beloved Galya, he was nevertheless cruel to her when gripped by fits of temper which he had inherited from his father. His father had been an old, dyed-in-the-wool serf-owner who, in his son's eyes, had treated his serfs with outrageous bestiality. When telling me about these fits of temper Nikolai Dmitrievich didn't spare himself. He was genuinely repentant and hated these manifestations of inherited cruelty in himself. At bottom, he was a fine fellow, a devoted friend and a good comrade.

Kuznetsov – a very talented painter himself – loved performing artists, and he never returned home from the town without some exhausted painter or performer crawling out of the carriage with him, especially if they were celebrities or from abroad. On my visits there I met Serov, Pokhitonov,[88] Razmaritsyn,[89] Kostandi[90] and Braz. The latter painted a marvellous study of a woman's back while he was there; Zorn himself might have put his name to this work; (it was purchased by Kuznetsov).

We have kept some curious photographs taken during our visits to the Kuznetsovs after I was married. Once my wife and I were there as guests along with the violinist Ondricek,[91] a European celebrity. One of the photographs shows a slightly tipsy Ondricek sitting astride the barrel of the water-cart described above and representing Bacchus who seems unable to drag himself away from Galya's marvellous liqueur – *vitecna* as he called it in Czech. And so *vitecna* stayed forever in our memory as the name of all the wonderful liqueurs which she prepared. Another photograph shows me playing a bravura piece on the piano at full tilt (I have never played any instrument) while the audience, horrified by my playing, are exchanging glances.

But after tea in the evening there was some serious music performed by two very great artists, music which I have remembered all my life thanks to the peculiar charm of this domestic environment. Ondricek and my wife performed a few duets, and then each played a few solo pieces. It was at that time that I drew Ondricek's portrait, both while he himself was playing and while he was listening to my wife.

M.V. Nesterov's Hermit

I should really describe in more detail how I arrived in Moscow in

1888, a year before my marriage, and took lodgings in commercial rooms in the Lyubyansky Prospect where I started to paint my first big canvas *Letter from Home*. In those same rooms, but with windows looking onto what is now the Polytechnical Museum (one floor above me) there lived a budding artist whom few people knew, the very talented and intelligent M.V. Nesterov. It was there that he began work on his now famous painting, *The Hermit*. We often used to visit each other and argued a great deal about the tasks and aims of painting. In an artistic sense (I would always paint from life) my painting was not progressing too badly and seemed to be enjoying some success amongst my young colleagues. But Nesterov was fretful. He came to me in great irritation and tried to prove that I ought really to paint pictures of the Jewish world which I knew, and not of what I had now undertaken. I tried to calm his nerves in every way possible for I understood very well that all this was only the result of difficulties he was experiencing with his own work. He didn't paint from life, but rather from within himself, and was always painting over what he had done – as a result of which his picture grew darker (oil-painting always suffers from the non–observance of certain technical require-ments). As our works progressed, his nervous state grew worse.

It happened that my painting caused quite a stir in artistic circles. One day P.M. Tretyakov asked me if he might come to look at it. It is difficult to imagine what impression his arrival produced on me! He liked the work and he decided to acquire it for his gallery.

It will be fully appreciated what this meant to a budding young artist in those days. I was beside myself with happiness. Then I thought of Nesterov and decided to ask Tretyakov to take a look at his painting, too – one floor up. To my great delight, Tretyakov liked *The Hermit* a great deal, and he acquired it as well. How happy Nesterov was! He ran to tell me and was a long time thanking me. Then his name became firmly established and he became financially independent. I wonder if he still remembers this episode now that he, like myself, is advanced in years?

I.I. Shishkin

My introduction to *eau-forte* (etching)

It is with deep gratitude that I should mention the name of I.I. Shishkin, considering how painstaking he was when I was learning different drawing techniques.

I got to know him on one of my trips to Petersburg for the regular exhibition of the Wanderers. When I got the opportunity I showed him my pen and ink drawings whereupon he exclaimed with something of a happy smile: 'But you're a born *eau-forte* artist!' I told him that I didn't know how to engrave, but that I very much wanted to learn. 'Come to my studio and I'll show you the methods of *eau-forte* engraving and within a few hours, you'll be doing brilliantly.' So I went. He gave me a little copper plate, covered it in varnish and blackened it with smoke: 'Well now, here's a needle – draw something.' With the needle I scratched a Finnish *veika* (a 'cabbie'), but it was rather poor. 'Fine, now let's etch it . . .' In short, after an hour or two I knew everything there was to know about engraving and on leaving I thanked Shishkin warmly. He was looking forward keenly to all the etchings I would turn out and to the pleasure they would give him. Alas, Shishkin's hopes were not realized and when, on meeting each other again several years later, he asked me: 'Well then, where are your etchings?', I began to fumble for excuses like a schoolboy, saying that there wasn't enough time, and so on. 'I know just what you mean,' said Shishkin, 'the trouble is that an *eau-forte* artist has to be a man of means. You need to have your own printing press so that you can work at it in your spare time.' He was right: it was only after several years that I was actually able to do my first intricate etching (a portrait of L. Tolstoy), and that was in Berlin in 1906 when I was living in the flat above the *eau-forte* artist, G. Eichmann,[92] who had everything to hand for etching – including his own printing press. He very kindly offered to let me work in his studio and since I had the necessary leisure time, I was able to draw freely and experiment there. Unfortunately I.I. Shishkin was already dead by this time, otherwise I would have shown him my work which would perhaps have pleased him. But perhaps he wouldn't have liked them since his own etchings were dull and at the time he had no idea of the enormous possibilities of etching. In etching it is possible to express oneself artistically in so many different ways.

Incidentally, I must mention that in Russia the presence of a printing press at home provoked suspicion from the police, who used to ask if any harmful political leaflets were being printed there. A printing officer (an inspector from the printing office) would come round all the time and your printing press had to be placed under his control. In short, there was so much trouble that the inclination to do this type of work practically disappeared.

One very interesting method was to work from life using the so-called 'dry point', and this means enabled me to achieve artistic results of which Ivan Ivanovich in his day could naturally have

known nothing. It was only considerably later that I myself became familiar with this method.

Since by this time I was already a teacher at the School of Painting, I campaigned to have a special *eau-forte* studio built, and I begged my friend and colleague S.V. Ivanov[93] to take on the role of director. The students themselves began to work enthusiastically and seriously in the hours that weren't taken up with drawing and painting, but someone on the staff had to take charge of the undertaking and be responsible for it. I even offered to give classes in this special studio on the various techniques. But nothing came of all this. I must add that I was always the most impassioned advocate of this artistic form and always strove to form my own *eau-forte* circle, even before I joined the staff at the School.

Meetings with N.N. Gué

My acquaintance with N.N. Gué came about quite by chance. It was in the early nineties when, having finally settled in Moscow, I began to get to know other artists.

Once when I was having evening tea at the Polenovs, I encountered an old man whom I hadn't met before. He was very picturesque and had a beautiful head. To my great joy, it turned out to be Nikolai Nikolaevich Gué.

Since I had never seen him before I was somewhat surprised when he greeted me and began to speak as if we had been long acquainted. More than that, he there and then announced for all to hear that he looked upon me as his successor, his disciple and exponent of all his artistic work and views – or words to that effect.

Though I felt extremely flattered to hear these words from such a prominent and venerable artist, such an outstanding representative of Russian art, I could in no way share his opinion. It remained for me quite incomprehensible both how and why I should have merited such an encouraging yet strange appraisal. Despite my obvious bewilderment, he went on: 'You and I have been friends for a long time. You will continue my work after me!' He was considerably older than I was and I felt somehow embarrassed that evening.

N.N. Gué was an interesting and very spirited raconteur. All the talk in the salons of Petersburg was about Gué's historical painting *Peter and Aleksey* which had enjoyed great success and caused quite

a sensation. One could sense that this artist had had a long and significant life. His face was lit up by lively, intelligent, passionate and – despite his age – young eyes. What a great and original intellect he had! He was so well educated and widely read, to say nothing of the fact that he was one of the greatest and most refreshing artists in the Wanderers group.

I very much regret that I never painted a large portrait of Gué. I'm glad all the same that I immortalized him with his great friend in my small painting entitled *Reading of the Manuscript*. He was a Tolstoyan and enjoyed a sincere friendship with Lev Nikolaevich. The latter read the manuscript of one of his marvellous stories to me, but instead of depicting myself in the painting I decided to paint Tolstoy's best friend Nikolai Nikolaevich Gué listening to the author reading. Besides this, I did a small life-drawing of Gué in his studio not far from the Butirskaya Prison; I depicted him reading his memoirs to L. Gurevich.[94] She was the editor of the Tolstoyan journal *The Contemporary*.

But to return to the evening at the Polenovs. As I said, N.N. Gué had stunned me with his sudden declaration that he saw me as his successor. He embarrassed me further when he started to praise some work of mine which he had seen. At the end of the evening he said that he would like to get to know me better and to see the things of mine which which he was still unfamiliar. It was with heartfelt joy that I extended him an invitation, and we immediately arranged the day and hour of his visit.

When he came to our house, he charmed all of us including *nyanya*. From the way that this old man – a serious philosopher and follower of Tolstoy – looked at my paintings, from the way that he scrutinized them, as if he were learning something from each sketch, each little drawing, each coloured study, it was evident that he was a genuine, impassioned artist, still young in spirit.

My wife came into the studio and I introduced her to Gué. 'Ah!' he exclaimed, turning to her, 'when I meet the wives of artists, I am in the habit of offering them my sincere sympathy; these unfortunate individuals are doomed to suffer and I always feel very sorry for them!' But exactly why this was so, he did not explain.

'I want to see everything you've got, even the tiniest little thing, so that I can get to know you,' he said, his eyes scanning all the walls from top to bottom. During dinner our four-year-old son Boris came into the room. He looked thoughtful and gazed at Nikolai Nikolaevich with wide eyes, full of wonder. Although he was normally very shy with strangers, he went straight to Nikolai Nikolaevich and, without a word, climbed onto his knee. Nikolai Nikolaevich held the little boy on his knee throughout dinner and

Boris, who had immediately fallen in love with his new-found 'Grandpa', wouldn't take his eyes off him. 'You see, Boris and I are already the best of friends,' said Gué. During one of his subsequent visits, he said to me: 'I have three friends in the world: Lev Nikolaevich, [I don't remember who the second one was], and your little Borya.'

After that I used to meet N.N. Gué at Tolstoy's house and on each occasion he used to charm me anew with his lively spirit, his originality and his sincerity.

I saw him of course at the exhibitions of the Wanderers – he was a member of the Fellowship. But he bore not the slightest resemblance to a representative of the Fellowship either in his appearance, his character or the unbiased nature of his opinions.

Once after meeting Gué at an exhibition, I began to complain about how we exhibitors were slighted by members of the Fellowship: they rejected some pictures because they didn't like the dimensions, they didn't accept others – as happened with my original illustrations for Tolstoy's *Resurrection* – because they were already 'under glass'.

Nikolai Nikolaevich then began to tell me how exasperated he had been with them and how he had stood up for me at the meetings of the Wanderers: 'You know he has already made his name abroad, he's even quite famous, yet you reject his things and refuse to elect him to the membership.' To this they replied: 'Pasternak's pictures are a bit on the small side this year – let him submit bigger ones next year!' 'Are you going to measure them in centimetres, or what?' retorted Nikolai Nikolaevich. Trying to console me, he said to me afterwards: 'Is it really worth your while taking any notice of them, Leonid Osipovich? You know, you have such good fortune – Lev Nikolaevich, I know, loves you!'

N.F. Fyodorov

Between the years 1892 and 1893 I visited the Rumyantsev[95] Library [now the Lenin Library] to research the military and civilian costumes of the year 1812 for my forthcoming illustrations for Tolstoy's *War and Peace*. The magazine *The North* had undertaken to publish a colour supplement of the illustrations and this had attracted the best artist-illustrators of the time: Repin, Kivshenko,[96] Karazin[97] and Vereshchagin (though he later pulled

out) had been invited and I, too, was approached.

In charge of the huge Rumyantsev Library at that time was a crooked little old man with grey beard and whiskers and hair spread thinly over a practically bald head. He was strangely and shabbily dressed in a sort of old woman's cardigan and his hands were invariably stuffed up his sleeves as if he was shivering with cold. One could feel the burning penetration of his keen, lively dark eyes sunken in his lean and wizened old face. There was something very strange and original about him, something of the ascetic monks as portrayed by Italian painters. It would almost have been possible to paint Francis of Assisi from him. As I later discovered, he did in fact have religious origins and followed an ascetic way of life with high moral principles.

He always took great pains to give the best and most comprehensive assistance possible to researchers in the library and to this end would haul out large heavy folios for them, saying 'Here you are, you'll find what you need in here.' He had a very good broad-based education both in the sciences and in literature. There was no question from a researcher that Fyodorov could not deal with; he would immediately set about looking for the appropriate book or journal.

Sometimes I would look up from the book in front of me and take pleasure in just observing him. He would notice this and I felt that he was bothered by the fact that I was not busy, so I would begin to busy myself again.

At that time I was not quite sure just who this Fyodorov was. I even quite forgot about him. It was only many years later when I was staying at Yasnaya Polyana that I met a young man who told me about him in more detail. The name of Fyodorov, hitherto unrenowned, became famous throughout Russia after his death in 1904 and there was not an educated man in the country who had not heard of him.

I still have a study which I did for my group portrait of Tolstoy, Solovyov[98] and Fyodorov. In this picture I painted Fyodorov from sketches which I managed to do surreptitiously in the library when he was not looking.

The discussions in the library of these three philosophers whom I portrayed continued late into the evening in Fyodorov's apartment, in his modest little room with its one chair and small kerosene lamp beneath a paper shade. He was the director of a magnificent collection and a brilliantly erudite philosopher and thinker but at the same time he gave away everything he had to those in need. He was even said to have bought and donated books to the library from his own salary!

In his room, scholars, philosophers and writers met to discuss

burning questions and their religious-philosophical arguments sometimes continued into the small hours.

Out of modesty, or perhaps in accordance with his principles, Fyodorov resisted any attempt, by anyone, to photograph him. If I had not happened to meet him and if I had not made use of my sketches in the library to paint his portrait, succeeding generations would have had no visual image of this great Russian man and philosopher.

Meetings with A.M. Gorky

I first met Gorky on the eve of the 1905 Revolution when I was invited to his home with some of my fellow painters (Serov and others) to discuss the publication of a new satirical magazine along the lines of *Simplizissimus*[99] in Munich. When I was still only starting out as an artist, I contributed to the comic journal in Odessa called *Pchelka* ('Little Bee'). Besides topical portraits, caricatures and satirical compositions, I also had to do some genre sketches of a strictly artistic nature on different aspects of life in Odessa – Odessan types, street scenes, characteristic episodes from life in the docks and so on. In one of the issues of *Pchelka* I depicted a typical *Bossiak* (a 'down-and-out') from the Odessan docks, a long time before Gorky wrote about his *Bossiaks* in *The Lower Depths*. I remember once when Gorky was having lunch with us, though I can't recall on which particular occasion, I asked him if he had seen my *Bossiak* in *Pchelka*. 'But of course! Of course! I've got a complete set of the journal for the year. Would you like me to send it?' To my great regret, Alexey Maximovich forgot to send it, or perhaps he did send it and it did not reach me.

When I was staying with my family in Berlin in 1906, I discovered that Gorky was also there. I visited him in the country sanatorium in Zelendorf where he was living at the time and took him, as a memento, an etching which I had just done from the painting of Tolstoy against a tempestuous sky. Gorky pinned it to the wall and gazed at it for a long time as if unable to tear himself away from the image of Tolstoy coming through the stormy elements. Then, clenching his fist to emphasize his words, he moved his right hand upwards and said: 'Gosh, how he has wedged himself into all literature!'

107

During this particular visit to Gorky in Zelendorf we discussed 1905 and the seditious, anarchic elements in the Russian people. Gorky remarked that the humility of the people was just a front: 'Of course they doff their hats to the landowning gentry but there are little flashes in their eyes which say, "Just you wait – you'll have to reckon with us by and by." '

I once did a little pencil sketch of Gorky reading an excerpt from one of his new works at a charitable literary evening in Berlin in 1906. This was before my visit to see Gorky in Zelendorf. I did an etching from this sketch but it was never completed: there were only two or three impressions of it and one is apparently in the Gorky Museum in Moscow. Later, I did a study from it in pastel but where it is now I do not know.

Meetings with R.M. Rilke[100]

This was more than forty years ago in Moscow. On one of those lovely spring days which startle with an ecstasy of brilliant sunshine after the long grey winter, a young man appeared in my studio. He was still very youthful, fair-haired and delicate and wore dark-green Tyrolean dress. He carried letters of recommendation from my friends in Germany asking me to help him become acquainted with the language and affairs of the country and its inhabitants. As far as I recall, I was also asked to introduce him to Tolstoy if that could be arranged.

The name of this unknown poet, Rainer Maria Rilke, meant nothing to me. The whole outward appearance of this young German, with his soft little beard and large, inquiring, pale-blue eyes – clear as a child's – and the way he stood surveying the room, reminded me rather of a Russian intellectual. His noble bearing, *joie de vivre*, liveliness and unbridled enthusiasm for everything he had already seen in Russia – a country which was, as he put it, 'sacred' for him – all this I found immediately charming. And already, after our first short discussion, we felt like very good old friends (which indeed we later became).

Rilke had come to Moscow with his friends the poet Lou Andreas-Sâlomé[101] and her husband.[102] They planned to stay for Holy Week and the Easter holiday. A fairy-tale beauty emanated from Moscow at that time, with its countless monasteries, towers, gold-capped churches and the pale-gold Kremlin, radiant in the sunshine, towering over the city. It is not difficult to imagine how

Moscow's uniquely picturesque appearance influenced such a sensitive artist as Rilke. But during Holy Week and Easter, it presented an even more interesting world especially for a foreigner like Rilke, who had set himself to study the historical-religious ceremonies and customs of the country, and to acquaint himself with the authentic, unvarnished life of its people. How distinctive were those nights during Passion Week with processions through dark narrow lanes and parishioners returning from church on Maundy Thursday with their lighted candles. And what an original, fascinating picture must have been presented to the student of Russian traditions by the indescribable and unforgettable Holy Week Bazaar on the grand, historic, beautiful Red Square! There was such a multicoloured mixture of the Old Russian with the oriental, such a wonderful happy hustle and bustle at the fair with all its whistling, shouting, pushing and squeezing.

But at the same time the elegance and splendour of the scene suggested present-day Europe. There was a magnificent turn-out – like something on the Corso – of graceful high-society carriages and rich merchants' beautiful horses in splendid Russian harness.

The silence preceding matins in the Kremlin was charged with reverent expectation, despite the press of the crowd. What a profound and tremendous impression this night must have made on Rilke's keen, receptive soul when the first chime of Ivan the Great's bell drifted over the whole of Moscow.

When he returned to Germany full of his Russian impressions, Rilke wrote to me from Berlin – Schmargendorf (sending me his first collection of poems at the same time): 'I must tell you now that, just as I had anticipated, Russia was no transient experience for me. Ever since last August I have been studying Russian art, history and culture and of course your splendid, unforgettable language, and this is practically my exclusive occupation now . . . And what a pleasure it is to read Lermontov's verse or Tolstoy's prose in the original. How I delight in this! The direct consequence of these activities is that I yearn for Moscow and provided nothing unforeseen happens, I'll be with you on the first of April.' And further: 'This time I'm thinking of going to Kiev or the Crimea as well . . . In anticipating this trip to Russia I feel like a child before opening the Christmas presents!' The letter closed with the request: 'Please send me a few lines – and you can even write them in Russian now.' And sure enough, from the time that we began to correspond with each other, he learned to speak Russian quite fluently.

My next meeting with Rilke, in the summer of 1900, was short

and fleeting. In coming to Russia this time, he had planned a major trip. We met quite by chance on a railway station between Moscow and Tula. I was travelling south with my family and when I got out of the carriage at some station or other I suddenly caught sight of Rilke. After exchanging joyous greetings I asked him where he was going. It turned out that he was bound for Yasnaya Polyana, though, as he began to complain, he had not managed to establish whether Tolstoy was at home in Yasnaya Polyana just then or whether he had gone away somewhere. I was in a good position to resolve his difficulty at once since there was a close friend of Tolstoy's travelling in the same train. He immediately notified Tolstoy by telegram and thus Rilke's visit to Yasnaya Polyana and his meeting with Leo Nikolaevich were arranged. It was in this chance way that my son Boris (still only a ten-year-old schoolboy) who had come out of the carriage and onto the platform with me saw Rilke for the first and last time in his life. Neither he nor I dreamed at the time of the enormous influence the great German poet would have on him in the future.

In the summer of 1904, I went to Italy for the first time. Everyone knows what significance there is in a painter's first visit to Italy. After looking round Venice, Verona and Florence, I arrived in Rome. The weather was hot. I was utterly exhausted from all the impressions and feelings I had accumulated during my sightseeing. I suddenly felt that I couldn't take any more; I just couldn't go on. I felt I had to find someone, a fellow-spirit, a friend to whom I could communicate my impressions and unburden my soul; but I was surrounded by strangers. In such a state I went out onto the streets, and suddenly, whom did I see but Rilke coming towards me! What a miracle! My dear, beloved, radiant Rilke! What a joy to have such a completely unexpected encounter! And after so many years we had so much that we wanted to tell one another. Our conversation started spouting like the jets of the nearby fountains of Neptune. As we were saying goodbye he invited me to spend the evening at his house in Rome where he was then living.

In the still, warm darkness of a blue-black night in Rome, it was difficult to find the villa where he lived (I don't remember well but I think it was near the Villa Borghese). He was already married by then and he introduced me to his delightful young wife[103] who was a talented sculptor and a pupil of Rodin.

Everything was so comfortable and so interesting at their house and the hours spent in animated conversation were unforgettable. This time the main topics besides art were Russia and Russian literature which he worshipped and studied avidly. I was struck by

the knowledge and fervour with which he spoke about the beauty and idiosyncrasies of old Russian poetry, especially 'The Song of Igor's Campaign' which he had read in the original Old Church Slavonic, which is extremely difficult for a foreigner.

Yet another brief chance meeting with Rilke, which was also to be the last, took place in Switzerland. After this we seldom wrote to each other during the 1914 war when correspondence with friends in Germany was temporarily stopped. It was rumoured in Moscow several times that Rilke was dead, but it was impossible to verify these rumours. It was not until 1921 when I went abroad with my family that we heard to our very great joy that Rilke was alive and well and working in Switzerland. I wrote to him straight away.

I received a long letter in reply – his last before his very sudden death. True, the letter begins in Russian, but after the first few lines he confesses that he's forgotten how to write in Russian now; further on he confirms that Russia – 'this unforgettable fairy-tale' – remained for him 'intimate, dear and sacred, having penetrated the very basis of his existence'. He writes about his stay in Paris during recent years and about his little house in Switzerland where he has now settled 'working in complete solitude among the roses in his little garden'. He writes of old and new Parisian friends and suddenly I hear for the first time '. . . in many ways I have been touched by the youthful fame of your son Boris'. He goes on to inform me that he had heard a reading of 'his wonderful verse' and adds as postscript, 'some splendid poems by Boris Pasternak have just appeared in a French translation in the winter edition of the very good Parisian journal *Commerce* published by Paul Valéry'. These lines were the last I received from Rilke.

A Comic Jupiter

'But you don't know, Leonid Osipovich, that it was you who saved me, and that it was largely thanks to you that I became an artist.' 'What? How? Tell me!' This was the beginning of a conversation that I had with the painter H. Krymov at one of the fraternal dinners organized by the Union of Russian Artists. The friendly atmosphere which prevailed on those traditional occasions together with an abundance of wine transformed customary restraint and reticence into cordial frankness and sincerity. This is what Krymov told me. 'It happened at one of the

entrance examinations for the School of Painting, Sculpture and Architecture, where I wanted to secure a place. You know, of course, that when the candidates are allowed into the rooms where the objects to be painted are displayed, all the best places are taken by the strong and vigorous, and I was actually the smallest and weakest boy of all. I therefore got a window place behind a column. I could scarcely see the plaster cast head of Jupiter which we were supposed to draw.

'Long before the end of the examination, I noticed that my rivals, well trained at private schools in every hackneyed device, seemed to have outstripped me by far, and there was no doubt in my mind that my pathetic Jupiter would fail.'

When Krymov reached this point in his story, I suddenly remembered the following: the rules governing entrance examinations dictated that teachers should invigilate in turn to prevent any cheating and to stop outsiders from slipping into the room. As I was walking past the various candidates, I happened to stop somewhat longer than usual near Krymov. Although his Jupiter was awkward and comical, it nevertheless had a certain something, and certainly more than the efforts produced by those self-confident, deft and gallant young men straight from the crammer's, who spent their breaks flirting with the female candidates. There was something spontaneous and talented about Krymov's work – and it was precisely such pupils as he, gifted and not spoiled by stereotypes, whom we were seeking. His curious Jupiter pleased me, and when I turned round to look at Krymov again as I was leaving, he hadn't taken his eyes off me and seemed to glimpse the expression of some satisfaction on my face.

'When you looked and smiled at me as you were leaving,' Krymov continued, 'I came back to life. I felt that perhaps I hadn't started off too badly after all and that I could carry on in the same way – so I began to work with greater confidence and speed. By the time the bell rang I had finished the drawing and was accepted into the School! You see, it was the approval which I read in your eyes and smile which saved me. Before you appeared, I had already given up hope of success, you know, and I hadn't the energy to carry on. You probably didn't think that you'd played such a part in my life, Leonid Osipovich!'

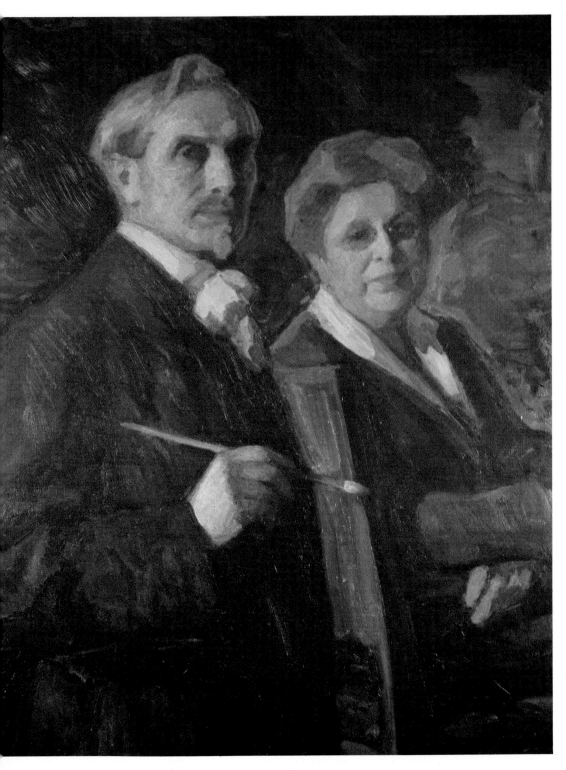

DOUBLE PORTRAIT OF THE ARTIST AND HIS WIFE
Oils Coll: Helen Ramsay and Charles Pasternak, New York & London

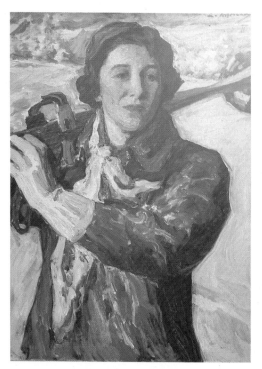

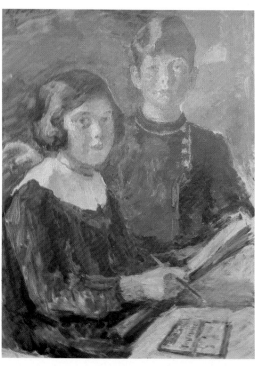

LYDIA WITH SKIS
Oils Coll: Lydia Pasternak Slater, Oxford

THE ARTIST'S GRANDCHILDREN AT A TABLE
Oils Coll: Helen Ramsay and Charles Pasternak,
New York & London

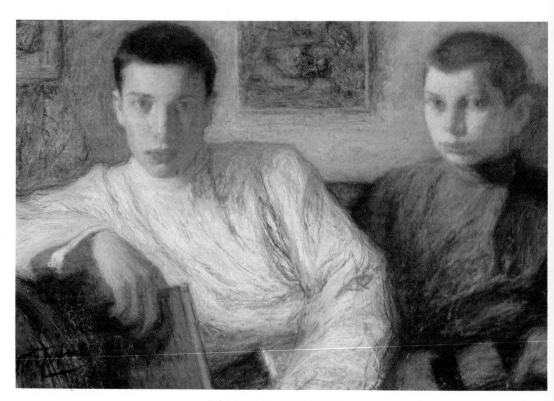

BORIS AND ALEXANDER
Pastel Coll: The Ashmolean Museum, Oxford

STREET IN JERUSALEM
Water-colours, body colours and pastels on grey-green paper Private collection, London

GOING FOR A DRIVE IN THE COUNTRY, NEAR MOSCOW
Oils Coll: A.Gale, London

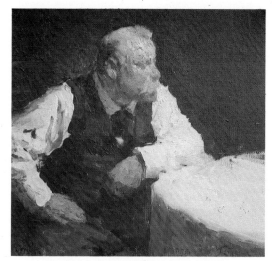

MAN IN SHIRTSLEEVES AT A TABLE
Oils Coll: M. Geiringer, Oxford

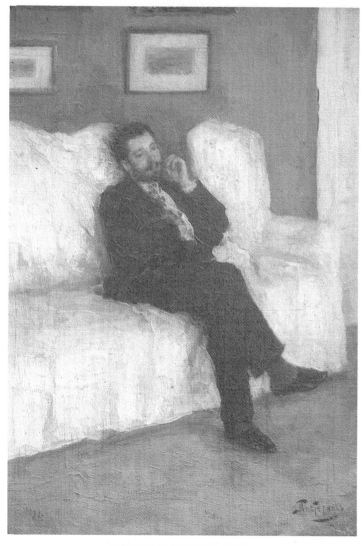

YOUNG MAN ON A SOFA
Oils Coll: Lydia Pasternak Slater, Oxford

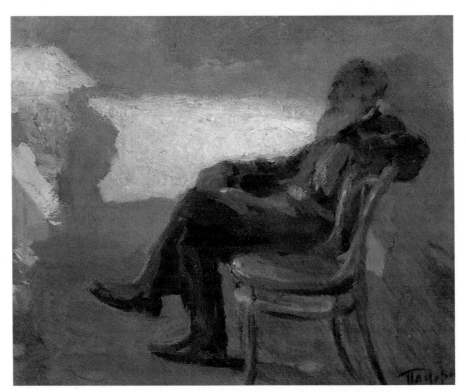

L. V. TOLSTOY
Oils Coll: Louvre, Paris

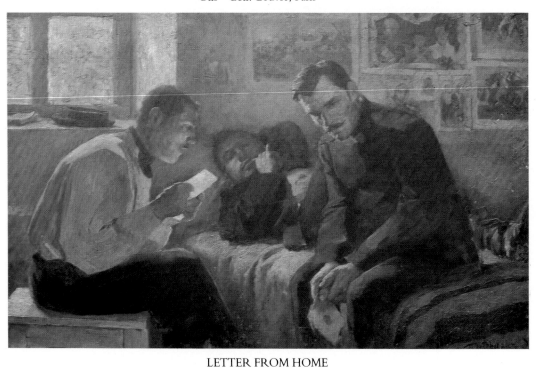

LETTER FROM HOME
Oils Coll: Helen Ramsay and Charles Pasternak, New York & London

Note: This is a replica of Pasternak's first large oil composition which was bought by Pavel Tretyakov, the great Moscow collector, in 1889.
This acquisition established Pasternak's reputation as a distinguished painter.

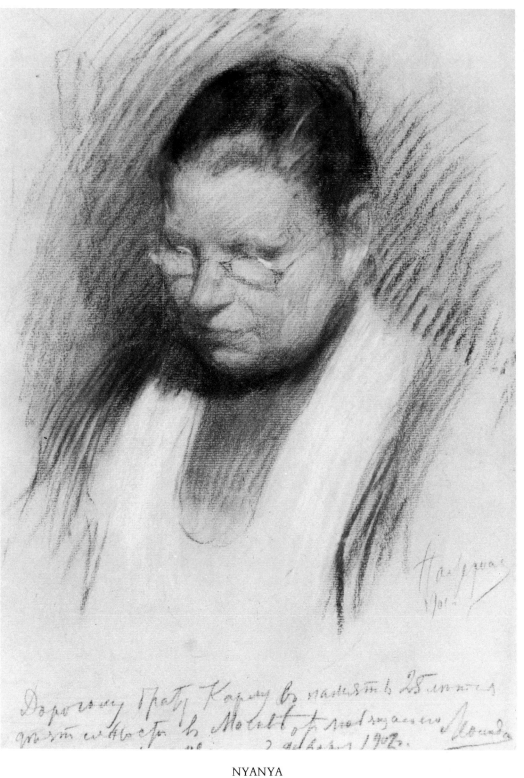

NYANYA

Charcoal, red and white chalks Coll: Helen Ramsay and Charles Pasternak, New York and London

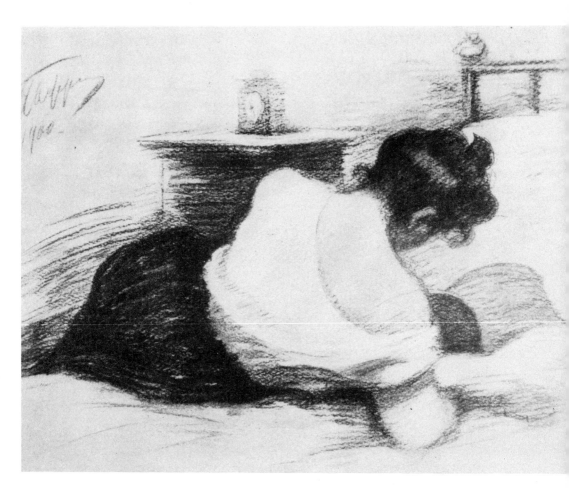

MOTHERHOOD: ROSALIA PASTERNAK RECLINING ON A BED NURSING HER NEWLY BORN
DAUGHTER JOSEPHINE
Charcoal, White and blue pastel on grey paper Coll: Lydia Pasternak Slater, Oxford
Note: A very close replica of this drawing is in the Brodsky Museum in Leningrad. It bears the date April 1900.

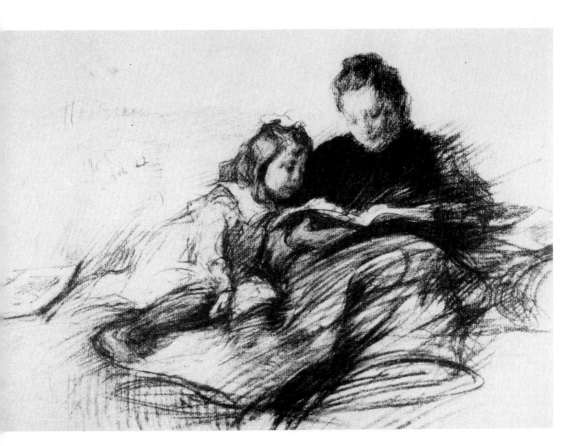

MOTHER AND CHILD
Coloured pencil Private Collection, Moscow

LYDIA IN A CHAIR
Charcoal Coll: Mr and Mrs J. Bentley, Oxford

LYDIA WRITING AT THE TABLE
Charcoal Coll: Lydia Pasternak Slater, Oxford

ON THE SOFA
Water-colour Coll: Tate Gallery, London

TWO SISTERS BESIDE A STOVE
Black and red chalks Coll: Tate Gallery, London

THE ARTIST'S WIFE
Pencil drawing Coll: Helen Ramsay and Charles Pasternak, New York and London

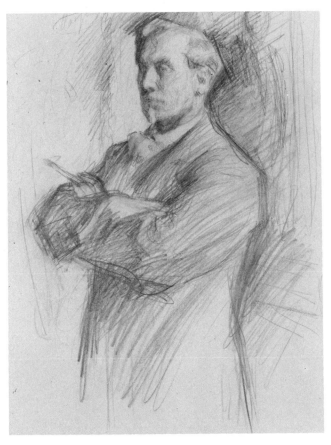

SELF-PORTRAIT
Pencil Coll: Ashmolean Museum, Oxford

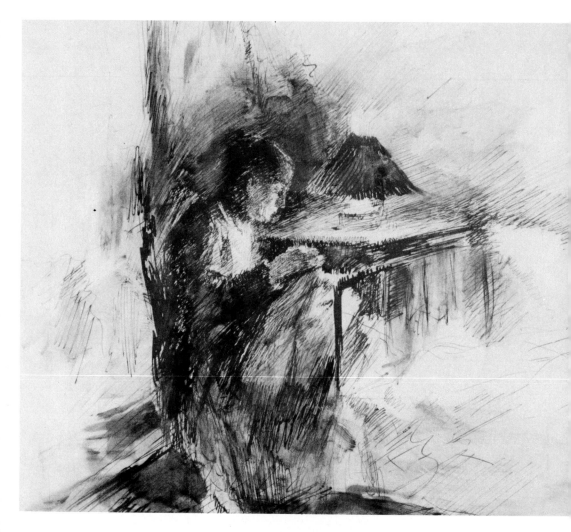

MENDING BY LAMPLIGHT
Pen and brush with Indian ink Coll: Helen Ramsay and Charles Pasternak, New York and London
Note: The sitter was the mother of the artist's cousin, Karl Pasternak.

JOSEPHINE AND LYDIA IN THE NURSERY
Black and red chalks Coll: Lydia Pasternak Slater, Oxford

THE PRINCESSES GORTCHAKOV

Pastel Coll: Prince Gortchakov, Moscow

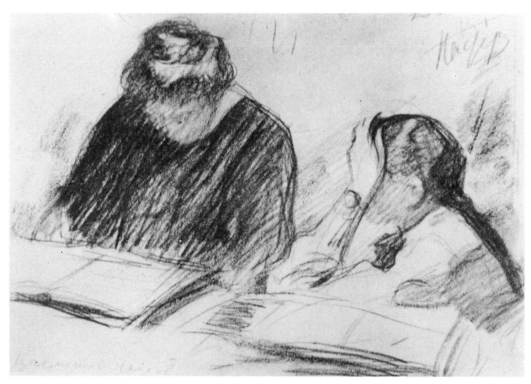

HOMEWORK: ROSALIA PASTERNAK HELPING HER DAUGHTER LYDIA WITH HER LESSONS
Black chalk with traces of red chalk in the faces Coll: Lydia Pasternak Slater, Oxford
Note: This drawing can be dated on grounds of style to the 1900 s.

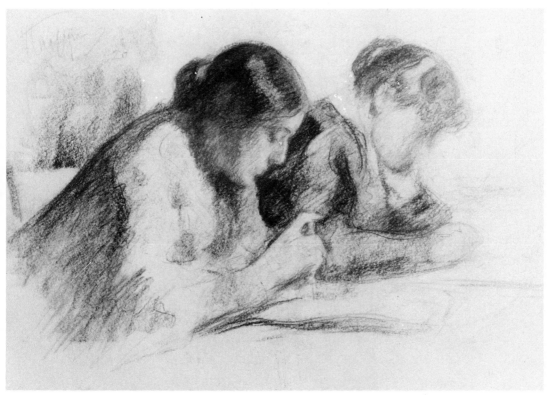

JOSEPHINE AND LYDIA AT THE TABLE
Black and red chalks Coll: Helen Ramsay and Charles Pasternak, New York and London

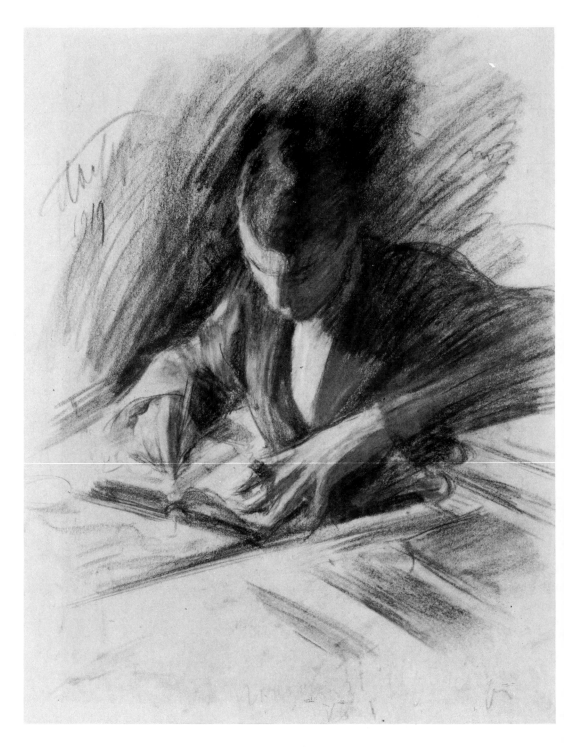

BORIS PASTERNAK

Drawing Coll: Tate Gallery, London

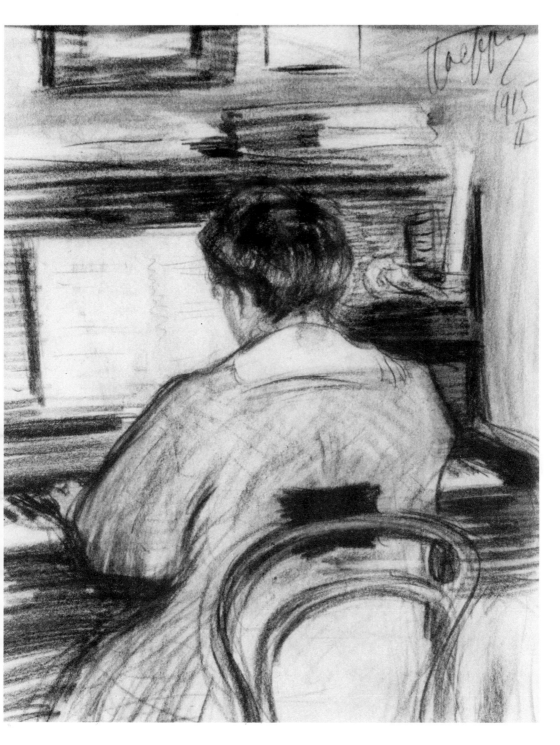

ROSALIA PASTERNAK AT THE PIANO
Charcoal Coll: Helen Ramsay and Charles Pasternak, New York and London

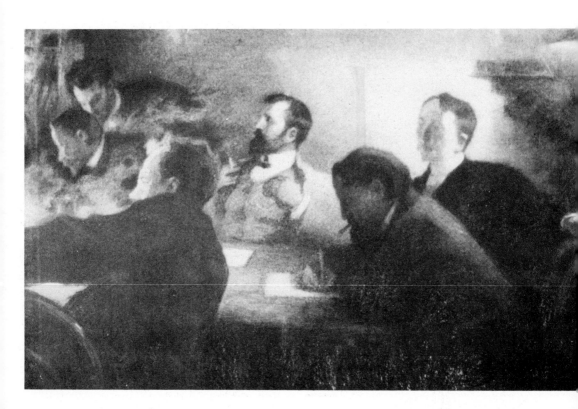

STAFF MEETING AT THE MOSCOW SCHOOL OF PAINTING, SCULPTURE AND ARCHITECTURE
Pastel Coll: Russian State Museum, Leningrad

Note: Portrayed are A. Arkhipov, N. Kasatkin, S. Ivanov, K. Korovin, V. Serov and A. Vasnetsov.

AUTUMNAL ORCHARD NEAR MOSCOW
Pastel Coll: Helen Ramsay and Charles Pasternak, New York & London

YELLOW TREE IN A GARDEN AT SUNSET
Oils Coll: E. Lee, Hobart, Australia

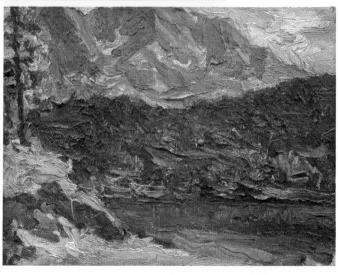

LANDSCAPE: LAKE IN THE BAVARIAN ALPS
Oils Coll: Helen Ramsay and Charles Pasternak, New York & London

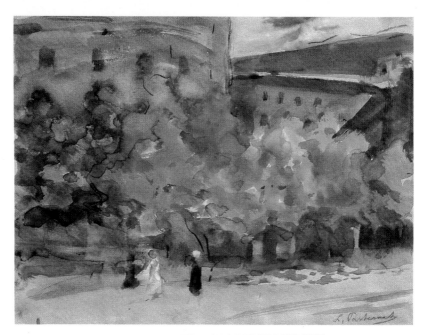

PINK GASOMETER IN A BERLIN STREET

Water-colour Coll: Helen Ramsay and Charles Pasternak, New York & London

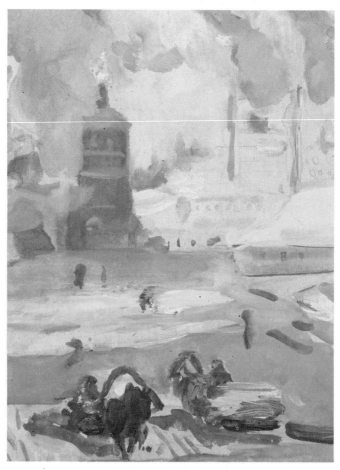

WINTER MORNING, MOSCOW

Water-colour Coll: Lydia Pasternak Slater, Oxford

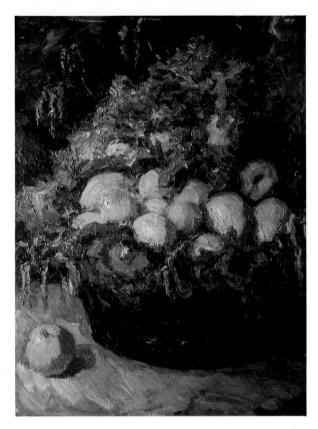

APPLES AND VIOLETS
Oils Coll: Helen Ramsay and Charles Pasternak, New York & London

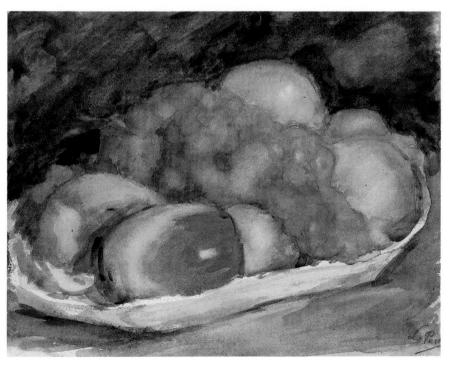

BOWL OF FRUIT
Water-colour Col: Victoria and Albert Museum, London

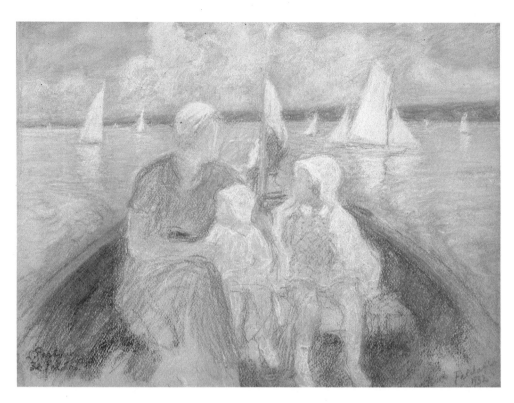

LADY WITH TWO CHILDREN IN A BOAT
Pastel Coll: Helen Ramsay and Charles Pasternak, New York & London

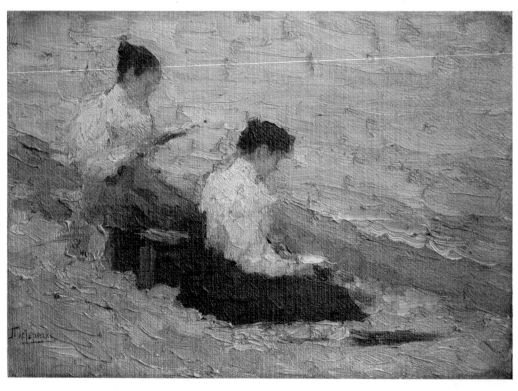

TWO WOMEN ON A BEACH BY THE BLACK SEA
Oils Coll: M. Geiringer, Oxford

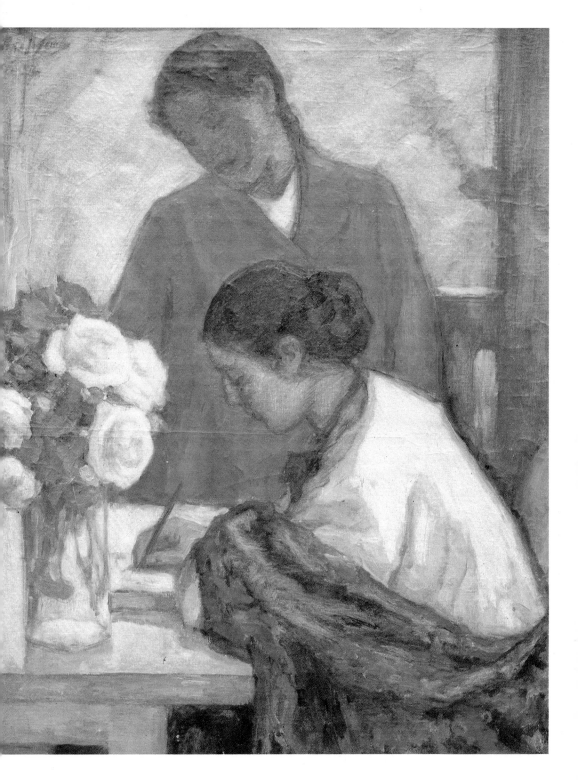

THE SISTERS ON THE VERANDAH IN MOLODI
Oils Private Collection, Stockholm
Note: This is a later replica of a picture painted in Molodi where the Pasternaks spent their summer holidays between 1914 and 1916.

ARTIST'S WIFE WITH BORIS AS A CHILD
Oils Coll: Ann Pasternak Slater, Oxford

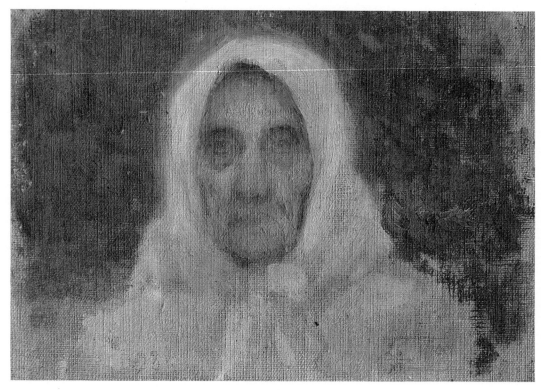

THE ARTIST'S MOTHER
Oil study Coll: Lydia Pasternak Slater, Oxford

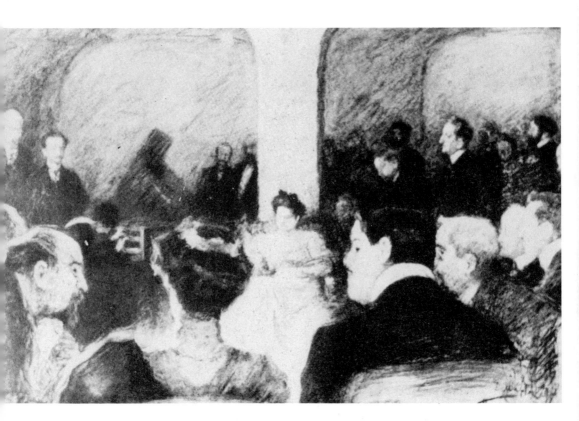

RECITAL BY MADAME VANDA LANDOVSKA
Pastel Coll: Tretyakov Gallery, Moscow

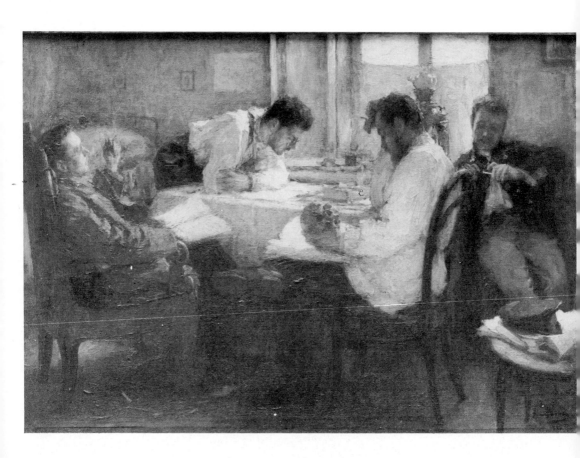

THE EVE OF THE EXAMINATION
Oils Coll: Louvre, Paris

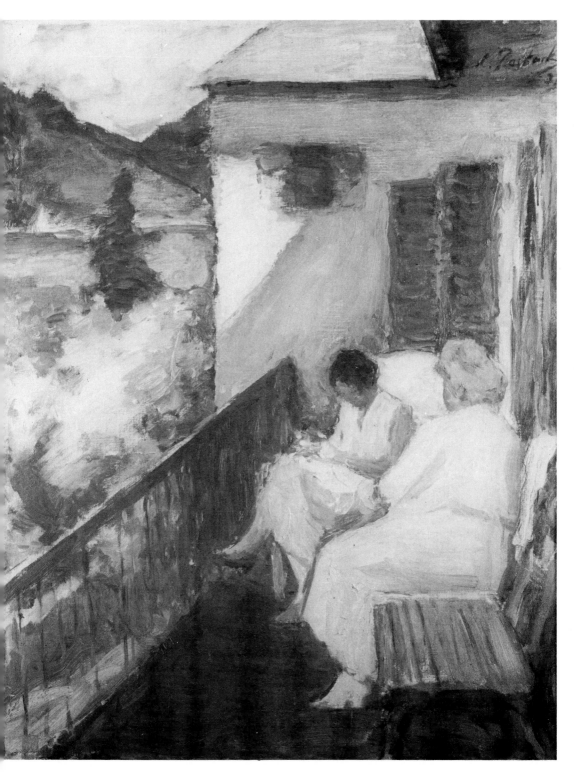

ON A BALCONY IN SCHLIERSEE, BAVARIA: ROSALIA PASTERNAK WITH JOSEPHINE
Oils Coll: Helen Ramsay and Charles Pasternak, New York and London

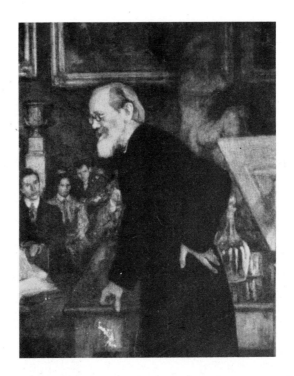

PROFESSOR V. O. KLYUCHEVSKY
Coll: State Gallery, Moscow

ROAD WITH TOMB OF RACHEL: ARABS WITH DONKEY AND CAMEL
Charcoal Private Collection

INTERIOR WITH SAMOVAR ON THE TABLE
Water-colour Coll: Grand-Duke Michael, Leningrad

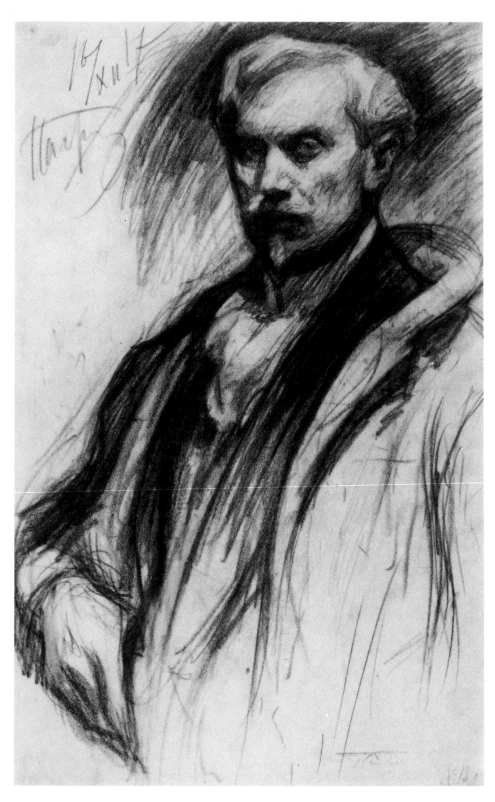

SELF-PORTRAIT
Charcoal Coll: British Museum, London

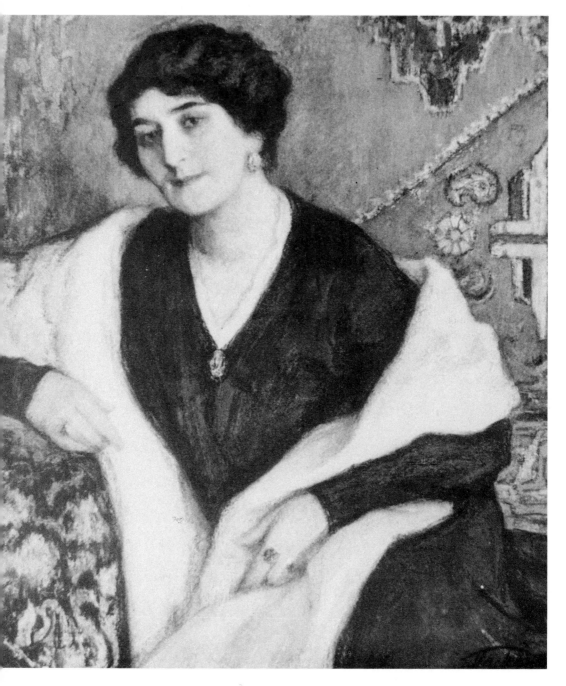

MADAME ALELOVA
Tempera and pastel Coll: Alelov, Moscow

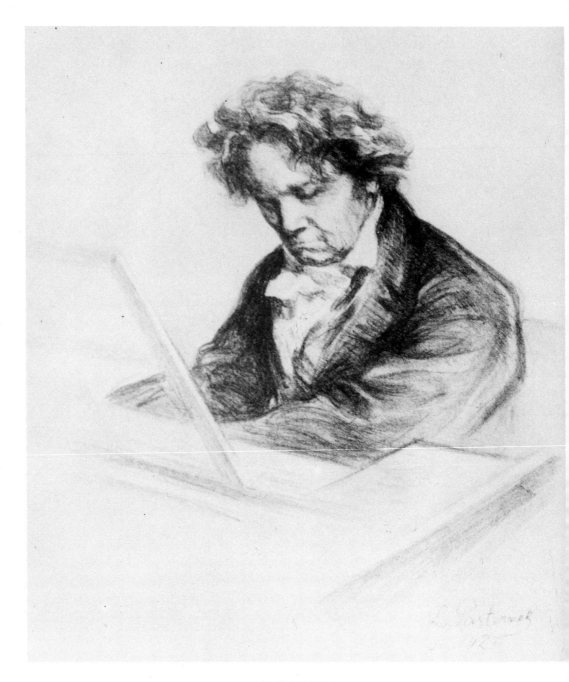

BEETHOVEN

Autolithograph engraving Coll: British Museum, London

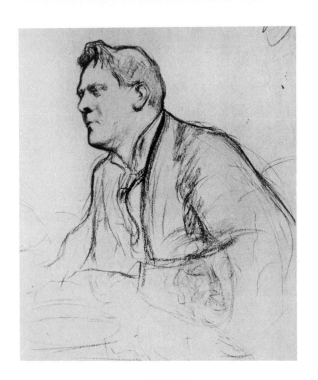

CHALIAPIN
Black chalk Private Collection, Oxford

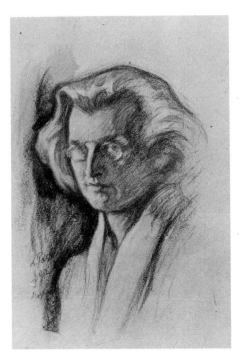

EDWARD GORDON CRAIG
Black chalk Coll: Sheffield City Art Gallery

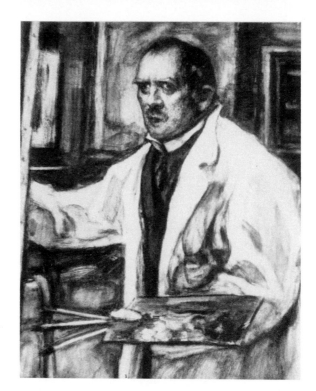

THE GERMAN PAINTER LOVIS CORINTH
Gouache, Pastel Coll: Borinsky, Berlin

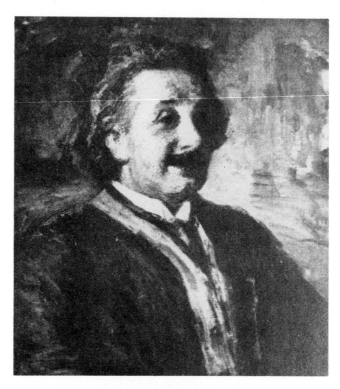

ALBERT EINSTEIN 1924
Oil Coll: The Hebrew University of Jerusalem
Note: This was painted in Berlin.

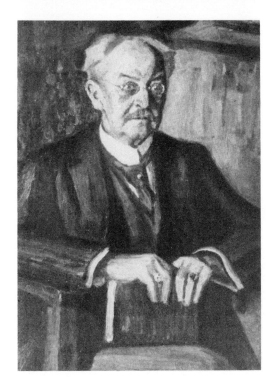

A. VON HARNACK
Oils Coll: Harnack House, Berlin

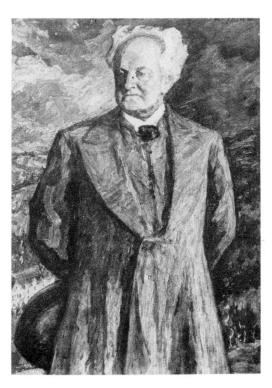

GERART HAUPTMAN N
Oils Coll: Schiller Museum, Marbach

PORTRAIT OF THE PIANIST JOSEPH HOFFMANN
Black and coloured chalks Private Collection, Moscow

OLGA HAUSER

Oils Coll: Hauser, New York

MADAME KAPTSOVA AND DAUGHTER
Coll: Kaptsov, Moscow

PROFESSOR OSCAR KRAUS
Oils Private Collection, Prague

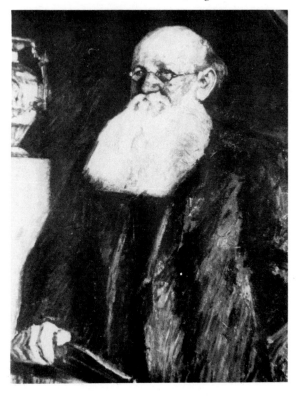

PRINCE P. A. KROPOTKIN
Oils Coll: Kropotkin State Museum, Moscow

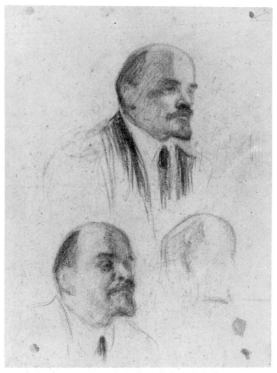

THREE STUDIES OF LENIN
Black chalk and stump Coll: Ashmolean Museum, Oxford
Note: This was drawn from life at a meeting of the Third International in Moscow.

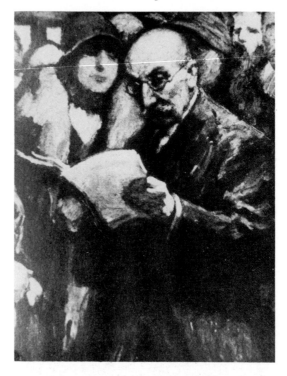

PROFESSOR MAX LIEBERMANN
Oils Coll: Tel-Aviv Museum
Note: This was done from sketches made during Liebermann's speech for the opening of the annual exhibition at the Academy of Berlin.

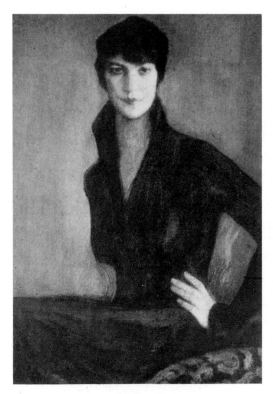

MADAME E. LEVINA
Pastel Coll: Fürstenberg, Paris

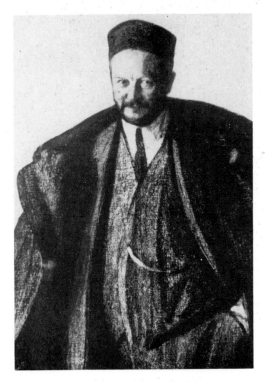

V. A. MAKLAKOV (MEMBER OF THE STATE DUMA)
Charcoal and chalks Coll: Solovyov, Moscow

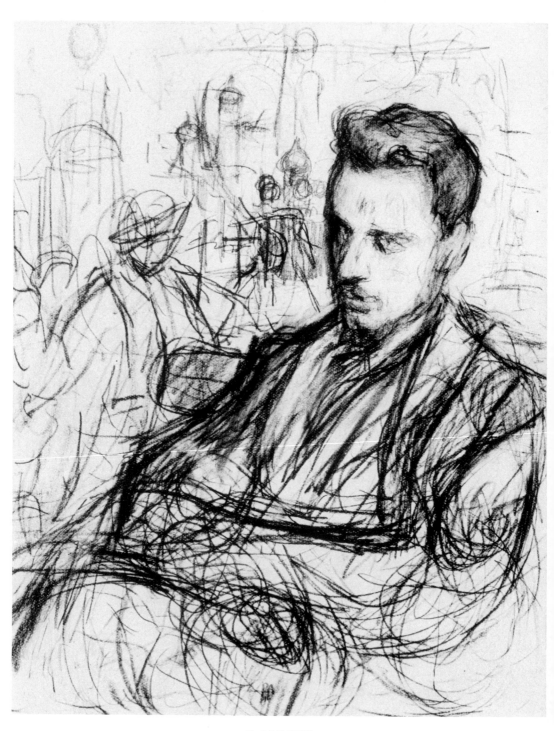

R. M. RILKE
Black chalk Coll: Schiller Museum, Marbach

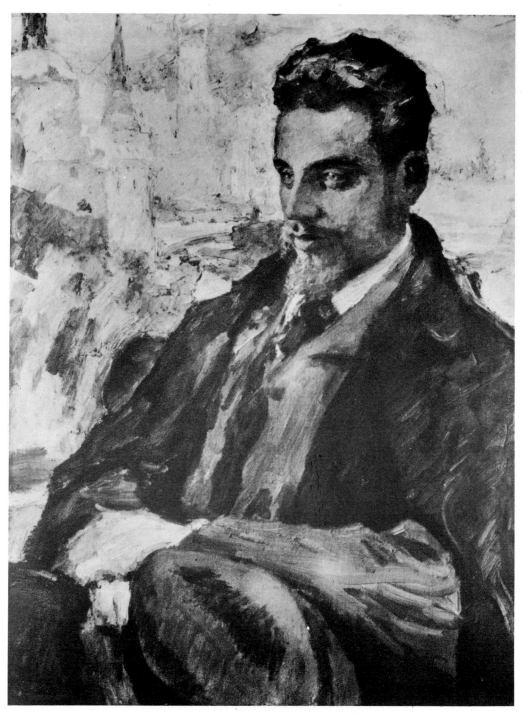

R. M. RILKE

Oils Coll: Neue Pinakothek, Munich

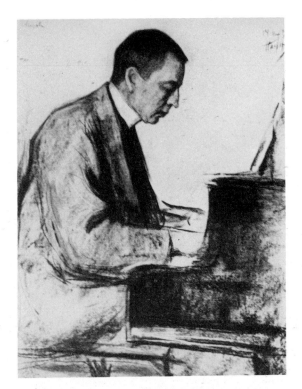

RACHMANINOV AT THE PIANO 1913
Charcoal and chalks Coll: Tretyakov State Gallery, Moscow

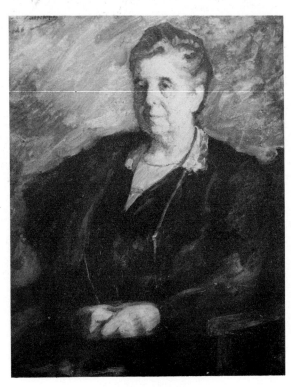

MRS SANDER
Oils Coll: A. Gale, London

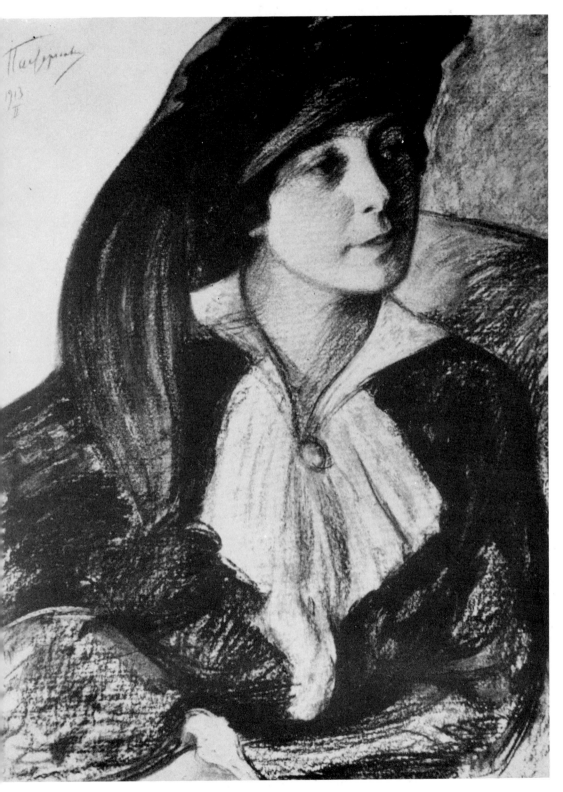

MADAME SOLDATENKOVA
Pastel Coll: Soldatenkov, Moscow

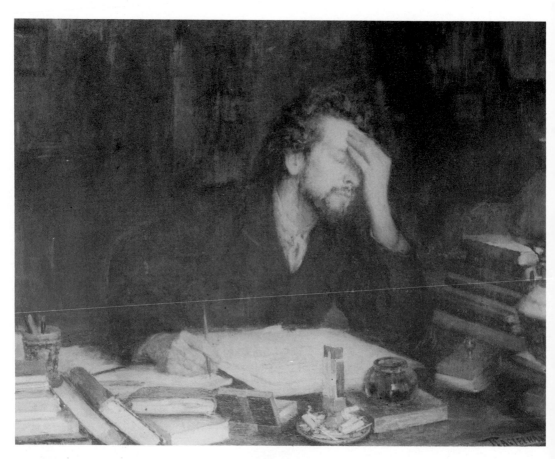

THE POET
Oils Coll: Helen Ramsay and Charles Pasternak, New York and London

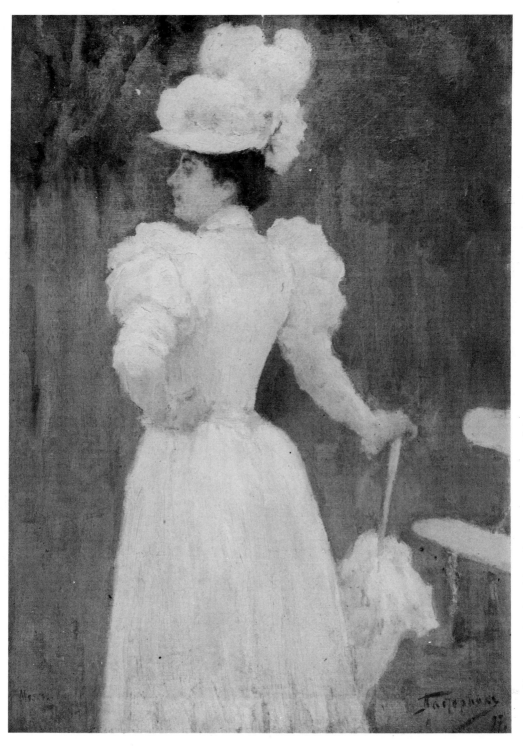

LADY IN WHITE

Oils Coll: Helen Ramsay and Charles Pasternak, New York and London

Note: This is a portrait of the artist's niece Augusta, a daughter of his sister Ekaterina.

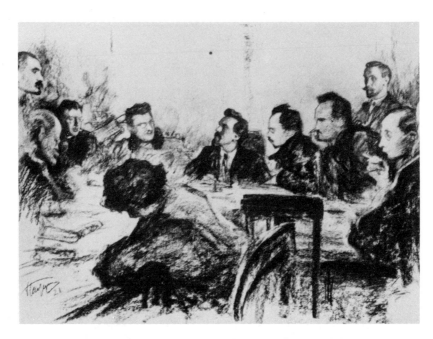

COUNCIL OF THE SOVNARKHOS (COUNCIL FOR NATIONAL ECONOMY) IN THE KREMLIN
Coll: The Soviet Government, Moscow

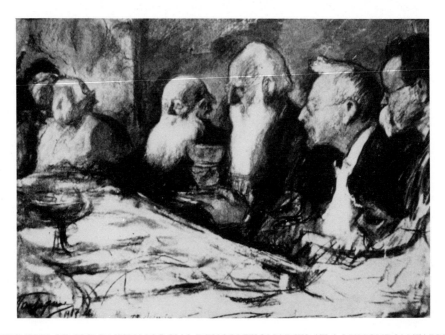

REUNION OF OLD RUSSIAN SOCIAL REVOLUTIONARIES AT A LUNCHEON TABLE
Charcoal, pastel and body colours Coll: Sir Isaiah Berlin, Oxford

Note: From left to right Lebedeva in black talking to Breshko-Breshkovskaya, Kropotkin, Tchaikovsky, Burzev and Morozov. Among Pasternak's group portraits this pastel is of quite exceptional historical interest since it represents a luncheon party which turned out to be the last reunion of a group of old members of the Russian Social Revolutionary Party following their attendance at a meeting of the Government on 14 August 1917.

COACHMAN
Pastel Coll: British Museum, London

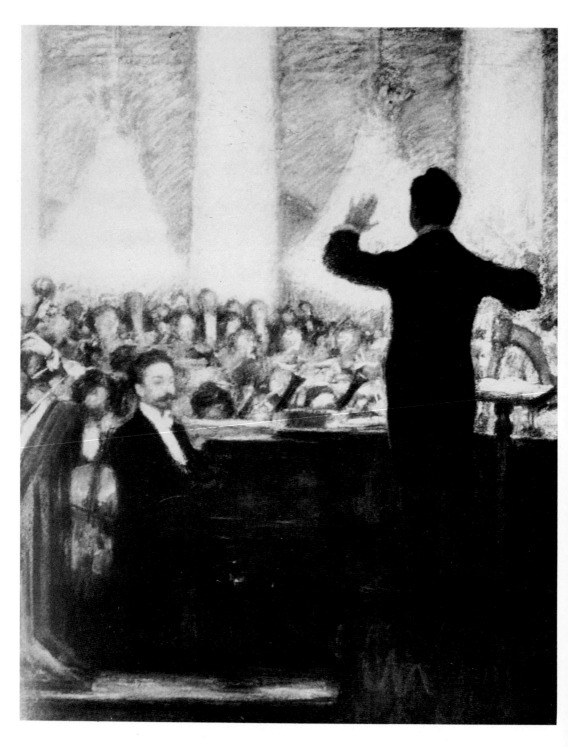

S. KUSSEVITSKY CONDUCTING WITH A. SCRIABIN AT THE PIANO
Pastel Coll: Kussevitsky, U.S.A.

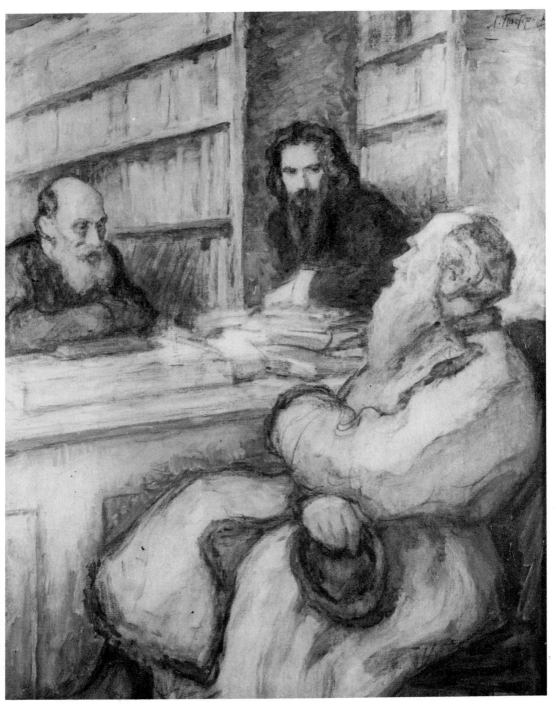

THE THREE PHILOSOPHERS
(Tolstoy, Solovyov and Fyodorov)
Oils Coll: Lydia Pasternak Slater, Oxford

Note: The idea of this group portrait of three Russian philosophers came to Pasternak after the posthumous publication of Fyodorov's philosophical essays in 1906 (he died in 1904). For the composition he used the original sketches of Fyodorov done in the Rumyantsev Library where Fyodorov was librarian. The original is now in the Tolstoy Museum in Moscow and this is a replica painted in Berlin in the 1920s.

AFTER THE FLOGGING
Coll: Tolstoy State Museum, Moscow
Note: From the series of colour illustrations to Tolstoy's *Resurrection.*

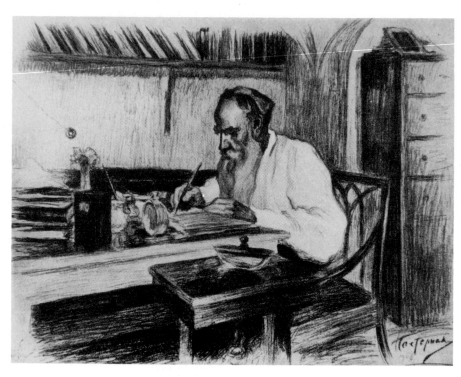

L. N. TOLSTOY AT HIS DESK
Coll: Tolstoy State Museum, Moscow

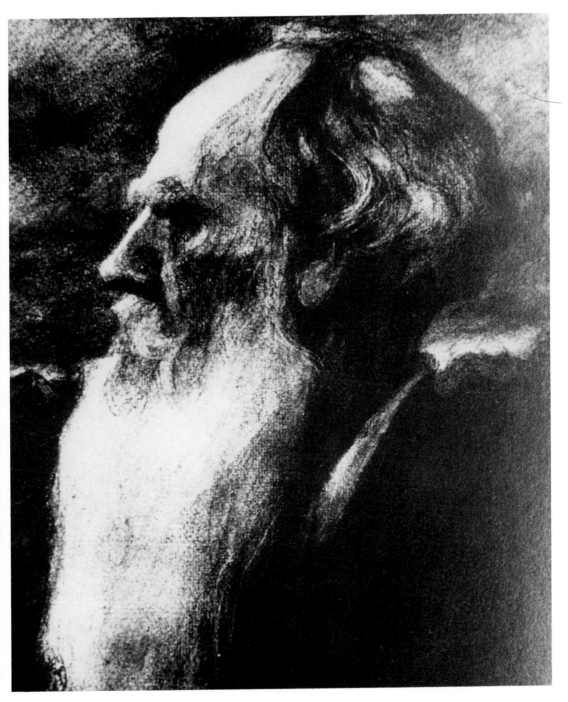

L. N. TOLSTOY

Oils Coll: Lydia Pasternak Slater, Oxford

STUDY FOR PORTRAIT OF L. N. TOLSTOY
Black chalk Coll: Ashmolean Museum, Oxford

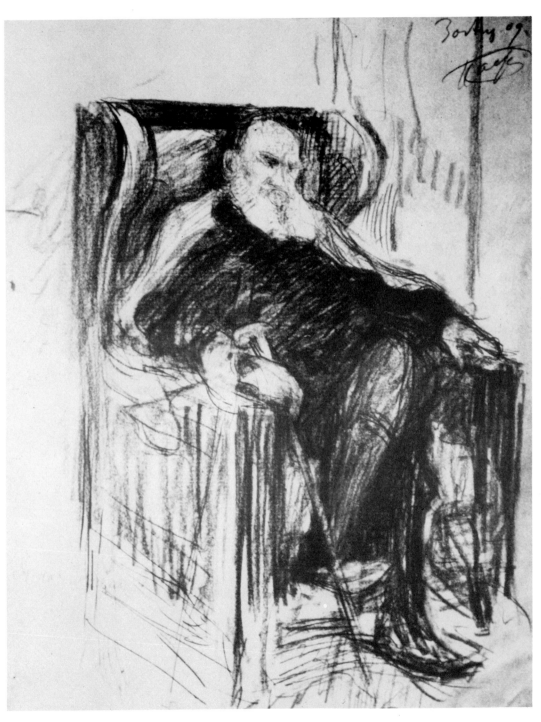

TOLSTOY IN AN ARMCHAIR, 1909
Drawing Coll: Tolstoy State Museum, Moscow

Note: This was executed at Yasnaya Polyana when Tolstoy was recovering from illness.

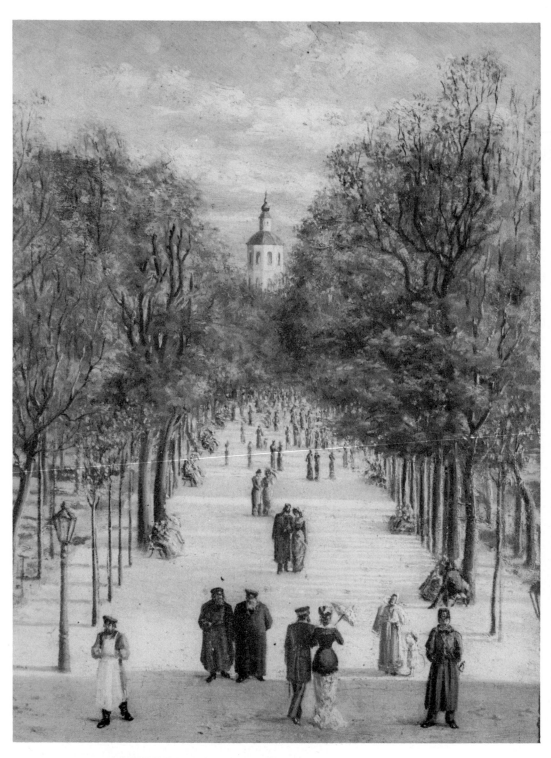

A BOULEVARD IN LATE NINETEENTH-CENTURY MOSCOW
Canvas oils Coll: Helen Ramsay and Charles Pasternak, New York and London

Note: This picture, which is unusual among Pasternak's early works, shows that he was aware of various trends in contemporary French painting. The view on 'Chisti Prudi' was painted from the apartment of the artist's cousin in the 1890s.

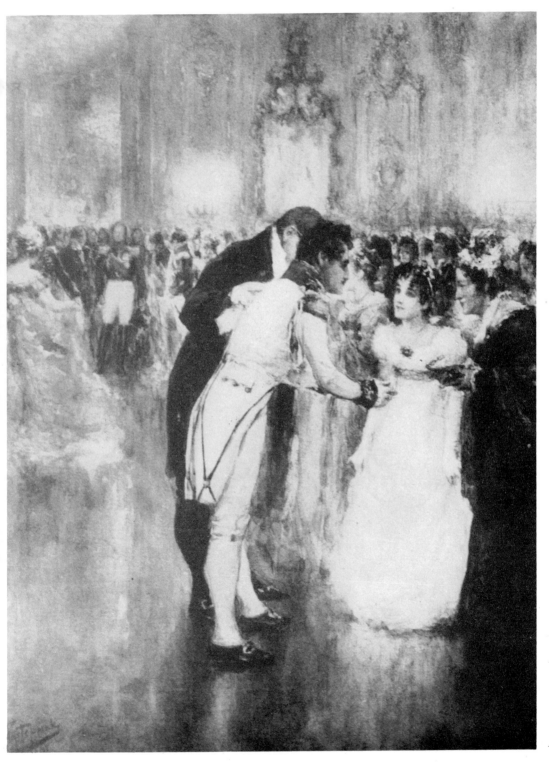

NATASHA'S FIRST BALL
Coll: Tolstoy State Museum, Moscow

Note: From the series of colour illustrations to Tolstoy's *War and Peace*.

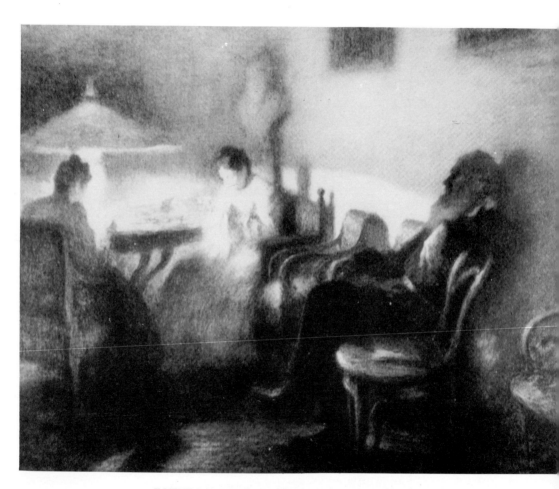

IN THE LAMPLIGHT: TOLSTOY AND FAMILY 1902
Pastel Coll: Russian State Museum, Leningrad

V.O. Klyuchevsky

Having entered the Medical Faculty of Moscow University to please my parents, a year's study convinced me that I could not become a doctor; it was not in my power to overcome my aversion for dead bodies. I therefore decided to transfer to the Faculty of Law where there was ample opportunity to devote myself to painting. The lectures were of little interest to me and, to be truthful, I hardly ever attended them and completed University only for my parents' sake. Of all the professors, only two made an indelible impression on me – Klyuchevsky and Chuprov. By the time I started in the Faculty of Law, Klyuchevsky's reputation as a professor and scholar, and as the most outstanding Russian hitorian of his time had already been firmly established.

As I set out for his first lecture, I must admit that I had in no way anticipated the difficulty I would have in fighting my way through the crowd of students who had come, 'to hear Klyuchevsky'. The enormous Law Faculty lecture-hall quickly filled up with students who had come from other Faculties as well, until it was absolutely crammed full of people. At Chuprov's lectures the hall was also crowded out and here too, students from other Faculties attended. But at Klyuchevsky's lectures, there was literally no space to stick a pin: they sat on the embrasures, on the window-sills, on the steps to the circle, in front of and behind the rostrum – absolutely everywhere was packed with students from practically the whole University.

The solid wall of students standing and sitting in front of me obscured the front part of the lecture-hall and it was not until Klyuchevsky went on to the rostrum that I eventually saw him for the first time. How can I describe this first impression? However much one either says or tries to give an account of it – the effect is still vague. It seems to me that only a portrait – and not a verbal representation – can give some idea of the man. From that very first moment Klyuchevsky fascinated me.

When I try to remember him as he appeared to me on that very first occasion, I cannot help seeing Chuprov beside him. Although quite unalike, they complemented each other perfectly, and a comparison of their distinctive qualities makes them both easier to describe. Both were professors – Klyuchevsky in Russian History and Chuprov in Political Economy – and in their time they were both very typical representatives of the Russian intelligentsia at its best.

As the most prominent writer on Russian history Klyuchevsky

significantly outshone Chuprov in the enormous powers of his creative talent and his artistic imagination. (Chuprov, on the other hand, was able to charm with his noble nature and his ability to captivate his audience with his lively rendering of what was an interesting and in those days fashionable subject.) How can I convey the impression which Klyuchevsky made on me when, during a lecture, he would pounce like a hunter on some historical character or event and hold it up to the enormous audience still alive and quivering and subject it without mercy to the most brutal and searching analysis? How can I describe his posture, or his speech – somewhat gutteral and breathy, yet light, affectionate and melodic when he recited Slavonic quotations and plunged the lecture-hall back into the sixteenth century? A rare and ingenious historian, he knew how to electrify his audience with a colourful and scintillating story. When I sat enthralled and fascinated in the packed lecture-hall listening to his graphic account of Russian life, character and events in ancient times, I never dreamed that in some ten or twelve years we would be colleagues at the Moscow School of Painting, Sculpture and Architecture, that we would both teach in the School or that we would both love the School as we did. I certainly never dreamed that I would be able to paint his portrait in the artistic environs of the School.

During the nineties the School was improved and reformed and new rules were adopted which made it possible to change and increase the teaching staff. Indeed the Director, Prince Lvov, managed to attract Professor Klyuchevsky to give a lecture on Russian History. Klyuchevsky relished the atmosphere of the School. As a great artist and master of the word himself, he fell in love with his new pupils – the young artists. Evidently he did not like the University very much; I gathered this from the fact that after he had given up lecturing there he continued with great enthusiasm, and practically to the end of his days, to give lectures at our School and in the Troytza-Sergiev monastery. When Klyuchevsky lectured in our red circular assembly-hall, it was packed with pupils, teachers and artists from all the studios and classrooms, and also those outsiders who had received permission to attend from the Director or Klyuchevsky himself.

As he spoke he would walk round the table, stooping a little, his left hand supporting his back (he probably suffered from lumbago); he would come to a halt, pause and lean on the table with his right hand. And suddenly he would fire off some teasing riddle at his audience, and then just as suddenly, he would provide the unexpected twist in his own answer. This man, so much the Old Russian, with his luminous gaze, his pure Russian speech, seemed the very personification of Russian educated society as it

had evolved from the seventeenth century. But in actual fact, as his closest relatives told me, he was a non-Russian. His father was a Christian and later became an Orthodox priest.

I painted Klyuchevsky's portrait in the winter of 1909. Unfortunately I cannot find his letter about it. As far as I remember I was the only one who painted him, and I am very happy that I was able to commemorate the features of this brilliant Russian historian for the nation. I portrayed Klyuchevsky giving a lecture in our splendid hall among the statues and pictures. Next to the hall was the school office which doubled as a common room where the teachers would go during the break to have a smoke. It was very strange to see this 'Old Russian' – more than ever in winter in his bear-like fur coat with the 'Boyar' style collar – holding a modern cigarette in his distinctive way. Once during the break after Klyuchevsky's lecture on Peter I, I began talking to him about Peter, whom I was then intending to depict in my series of portraits of great Russian people. Since I had the general public in mind I wanted to produce three cheap life-size lithographs, depicting characters of national genius: Peter I, Pushkin and Tolstoy. I distinctly remember how Klyuchevsky, cigarette in hand, screwed up his eyes and paused for a moment as if to collect his thoughts. Then came something typically original and unexpected, delivered as usual in his somewhat sing-song voice: 'You would need to do Lomonosov. . .' I do not know if there are any gramophone records of his voice (I hope there are!). It sounded somehow modest and shy but at the same time insinuating. The affectionate expression and barely perceptible smile never left his face. On this occasion, too, he spoke slowly, deliberately and with peculiar emphasis so that his observation immediately conveyed the tone and slant of his attitude towards Lomonosov and the peasant people – for they were after all of the same stock – and once again his burning love of the simple Russian people was evident.

Painting Klyuchevsky's portrait was greatly facilitated by the fact that my flat was in the same building as the School and I could freely observe him both in the assembly-hall and at home where the portrait was actually painted. During the sittings Vasily Osipovich told a great many interesting stories but unfortunately I was too tired to write down what he said either during the sittings or after them. And then of course they were gradually forgotten.

As I conclude these reminiscences of Klyuchevsky, I am naturally reminded of the Moscow of those days and I see in front of me three original old men of genius – Tolstoy, Fyodorov and Klyuchevsky. How kind Providence has been to have given me the opportunity to meet each of them in my lifetime.

Korovin's Birthday Party

A propos of my frequent encounters with the problems of artificial light (*The Débutante,* 1893, *Tolstoy with his Family,* 1901, *The Rabbit,* 1901, *Nikish on the Conductor's Stand,* 1908, *Prometheus – Scriabin and Kusevitsky,* 1910, *At the Samovar,* 1914) I had become preoccupied with a new project – a group portrait composition which I called *An Evening Party.*

In this picture I depicted Chaliapin at the table with a group of artists. A very colourful figure was Tuchkov with his guitar and this composition probably affords a unique glimpse of Moscow life (with a touch of the gypsy) in bygone days.

On the evening of his birthday, which was in December, the artist K.A. Korovin would always have a sort of bachelors' party for his friends (in fact practically all of them were married). There was always much wining, dining and merrymaking with gypsy songs.

The chief performer was usually Chaliapin. Tuchkov, the well-known guitarist, would accompany him and sometimes join in the song. Tuchkov was a fast liver and had been the district representative of the nobility before squandering nearly two of his estates on the gypsies. In my painting I depicted Tuchkov and Chaliapin at the centre with the host himself, Prince Shcherbatov, the artists Vinogradov, Archipov and myself grouped in the background.

Tuchkov was absolutely besotted with Chaliapin, mainly because of the way in which the latter could sing gypsy romances. Chaliapin was aware of this and on these occasions he would play tricks on Tuchkov. At the point where Tuchkov had become quite ecstatic in his passionate accompaniment, Chaliapin would quite deliberately sing a note slightly off-key. Tuchkov would immediately snap out of his reverie and become fierce with anger, cursing and swearing until the assembled company was reduced to helpless laughter and the episode ended in noise and uproar.

During Tuchkov's solo number when he used to work himself up into a passion with his own singing, his face all the while becoming more purple and ludicrous, Chaliapin would whisper in my ear, 'Just look at him! Those eyes of his! Draw him! For God's sake, draw him!'

Chaliapin also sang quite a serious repertoire on these occasions. It was wonderful to hear him sing in the intimate circle of his artist friends. But he devoted the main part of such evenings to funny

stories, anecdotes or imitations. He was a marvellous mimic and we all practically died of laughter.

These evenings went on until three or four o'clock in the morning after which it was expected that everyone apart from those abstemious stay-at-homes like myself would go off to drink more in the apartment of a famous rich barrister. There they enjoyed themselves till ten in the morning, after which they dispersed homewards.

I saw Chaliapin for the last time in 1924 in the Hotel Bristol in Berlin when I did a sketch of him in his room for the subsequent autolithograph *At the Rehearsal*.[104] Chaliapin was sitting in his flowery dressing-gown at the piano. Suddenly he leapt up, took a match, dipped it in ink and with two or three strokes he drew on hotel notepaper a caricature of himself singing. On one side he wrote with the match: 'To my very dear friend, Leonid Osipovich Pasternak. F. Chaliapin, 1924.' I have kept this little sketch as a dear memento of him.

The Origin of the Russian Word for Artist (Khudozhnik)

I can't stand painting from photographs. What nonsense it is, and how difficult it becomes to try and restore in pigment the appearance of long-dead people, when you only have old photographs to go by. How can you make them live when you have no idea of the colour of the face and hair and hands, when you don't know their habitual poses, gestures etc.? But anything can happen in life and several times I have had to paint portraits from photographs (about five in all, I think), either yielding to the insistent requests and persuasion of friends, or when customers had pestered me and I was in serious need of money. So it was that about thirty years ago I was approached by a colleague of the Mayor of Moscow, Mr Gennert, with an official request from the board of the Kiev–Voronezh Railway to paint a portrait of the deceased President of the Company, one Kokovtsev. According to Gennert,[105] the photographs provided were a poor likeness and of inferior quality. Only one of them was of any use, and that was a small one taken on some station platform. Fortunately it hadn't been retouched.

However much I tried to refuse, he would have none of it, although he admitted that you wouldn't get much of a portrait out of the materials he had brought. But he had hopes of getting

another photograph of good quality, and so on. Needless to say, Gennert wasn't able to find any more photographs, but as consolation, he advised me to get a few details (colour of skin, eyes, hair etc.) by travelling to Petersburg where the deceased's brother and sister were living.

It is interesting to note that when I did make the special journey to Petersburg to ascertain at least a few details from the brother and sister, both gave me completely different, and even contradictory, information about their brother's appearance.

I gave that up as a bad job and started to paint according to my own devices. The device I used consisted of painting everything except the face from a suitable model. I got someone to sit and painted his body, arms and legs trying to get the overall colour and harmony right, and to create the impression of a living person. Then, keeping the general consistency in mind, I painted in the face from a photograph so as to give an impression of likeness. Portraits painted like this almost always give the general appearance of having been painted from life.

So it was that I painted a large portrait of Kokovtsev. I painted him with his hand touching his peaked cap and wearing the greatcoat of a military engineer, equivalent to the rank of general, with its green piping and lining. I invited Mr Gennert to look at this picture of a man whom I had never seen. When he entered the studio and looked at the portrait, he didn't even have time to greet me before being struck dumb, able only to boom out a single word: 'Miraculous!' There were even tears in his eyes. 'Miraculous!' he exclaimed time and time again without stopping. Then, when he seemed to have calmed down a little, he turned to me, wiped his eyes and said: 'Now at least I understand where the word *Khudozhnik* came from. In Old Russian, "doing ill" *(khudoe)* meant performing magic. Like a magician you have resurrected the dead Kokovtsev in your painting: that is to say you have made magic, *khudoe,* and this is what it means to be an artist – a *khudozhnik!*'

The visit ended with sincere congratulations, great enthusiasm and enormous happiness.

Lovis Corinth

Excerpts from letters to P.D. Ettinger[106]

Berlin, 18 July 1923

. . . I don't remember whether I've already told you that I received a very friendly letter from Lovis Corinth? The fact is that there has recently been an exhibition of his work here, and I wrote him a few lines about it, full of unfeigned admiration. One rarely hears sincere praise from a colleague these days (there's any amount of insincere praise, of course), and I am always glad when I have the opportunity to give my sincere, heartfelt opinion.

By the way, Corinth writes to me that he would like to paint my portrait and speaks so flatteringly of my appearance that, were I a woman, I would have been proud. He hopes that this work will be an interesting addition to the portraits that he has painted already. Of course, this gives me great pleasure, the more so as it will give me in my turn the opportunity of painting him, which I have been thinking about for a long time.

But for the time being we have postponed all this until he returns to Berlin as any day now he is leaving to spend the summer at his cottage near the Walchensee where, as he writes, he hopes 'to be in contact only with nature'. He ends his letter with the words: 'In August I will take up my work in Berlin again with renewed strength.'

Berlin, 7 September 1923

. . . It turns out that Corinth and I were at the Munich Academy at the same time. But we were working in different studios. It also turned out that we had mutual friends and we started to lapse into memories of the good old days. He is a subtle, keenly observant man. He once said very amusingly: 'We Germans are rude; the Russians are polite; but the Spaniards are more polite still.' He hasn't a trace in him of that arrogant Berlin way of behaving; he proved to be altogether pleasant and seems a good comrade. After the split took place in the 'Secession',[107] which you know about, Corinth became its leader. His colleagues fully appreciated his independent, honest and firm character and gave him the reins many years ago . . .

Berlin, 2 December 1923

. . . Corinth is going through a tremendous drama . . . Serious illness over the last year has partially paralysed him. Once he was a strong, healthy man (he's from peasant stock) but now has difficulty in holding his palette and moving around. There's often an expression of the profoundest sorrow in his eyes . . . And yet it's precisely now that he's working at full intensity, as if he were

119

exploding with the pressure of creative ideas, as if his colossal artistic talent and his unbridled temperament had only now fully developed and blossomed. What a pity you can't see the work which he is doing now. As usual, you can't really picture the originals from reproductions, all the more so as his whole art is in the colours or rather in the general harmony of the works. He has brilliantly succeeded in harmonizing even those dirtyish black tints of his.

If you saw the work he did before the war (after all you often used to talk to me about him), you would be astounded by the incredible change which has come over this man in recent years. Now he mainly paints still-lifes and there are some magnificent masterpieces among those which I have managed to see at the houses of friends. The illness and physical obstacles which he has had to overcome must have increased his colossal spiritual and creative powers still more, they must have called forth a new wave of inspiration. You should see him at work! When he was painting me, the expression in his eyes was almost terrifying! Whether it's the result of his illness or of an intent fixation on his subject, he is beginning to squint; his left arm is paralysed, so he presses the palette convulsively to his body; he stands there bowed down, perhaps trying to overcome superhuman torment. And for three hours at a stretch he stands like this in front of his canvas. That's how I wanted to paint him. But more of this on another occasion, as I have no more time today . . .

Berlin, 28 December 1927
. . . This time I can tell you something more joyful. In my last letter I spoke about the difficulties I was encountering in arranging my own exhibition. Just the question of choosing frames for the innumerable water-colours, drawings and oil-paintings, for example, is a source of torment and furthermore, it all takes up so much time and energy.

I chose a well-known artistic salon which enjoys a particularly good reputation. Although some of my colleagues who had seen my work predicted success, inwardly I felt very uneasy all the same, as I didn't know how the public and press here would react to me. The influence of art criticism here is very great. Just imagine, people go to exhibitions with newspaper clippings and review articles in their hands! And their aesthetic perception of the paintings is immediately and directly influenced by these critical reviews! What do you think of that?

But it turned out that all my fears and innate pessimism were groundless. The moral and material success has quite exceeded my

expectations, thank God! In your reading-room you've already probably seen Dr Max Osborne's brilliant review, which appeared in one of the most important Berlin newspapers, the *Vossische Zeitung*. And there were short stories in all the other Berlin and provincial newspapers. I'll quote the review given in another big Berlin paper, the *Berlin Tageblatt*. It's written by the well-known critic and art historian, F. Stahl, who is considered to be very severe. I liked his article not only because he praises me, but rather because of his quite moving attitude towards the personality of Corinth, and also because he understood correctly what guided me in the painting of Corinth's portrait. Perhaps you will manage to get a copy of this newspaper for 21 December 1927 somewhere. But just in case, I'll quote a few words from what he has to say about the portrait of Corinth. Here's what he writes:

> Pasternak's exhibition (at the Hartberg Gallery) contains his portrait of Lovis Corinth, one of the best contemporary portraits I have seen in the course of my long life. Corinth is standing with palette in hand, working at his easel; he has the appearance of a decrepit old man, not so much the result of old age as of illness. The whole of his life is concentrated in his eyes – his great, sacred, ardent creative will and the ecstasy of his art, so intense (and closer to us than any ecstasy of belief) that it was able to create the miracle of which we have become witness. Nobody would have believed it possible to depict the Corinth of those final years. But here he is before us. This painting is the result of heartfelt, reverential love and it would be sacrilege either to omit or to add or even to emphasize anything in it . . .

The most important thing comes next: 'This painting ought to hang alongside Corinth's later works – it explains them better than the printed word could.' He goes on to speak about me as a portrait artist – a great rarity, in his words. This Mr Stahl is completely unknown to me; I have seen him only once at some exhibition or other. Corinth pointed him out to me, adding that he was a terribly severe and experienced critic. But the most remarkable thing, as people tell me, – and this is why I have taken the liberty of quoting you the review word for word – was that the painting was immediately removed to the National Gallery and hung there for a whole day. The Purchase Commission, however, didn't have sufficient funds to acquire it, as happened once even to Renoir . . .[108]

Max Liebermann

Hermann Struck introduced me to Max Liebermann whom I went to see many years ago. They used to be friends but were subsequently at odds with each other over 'The Secession', and in my view Liebermann treated Struck very ungraciously. I once visited Liebermann when he was working on a group portrait (commissioned by the Hamburg City Council) of the council in session. After showing me the portrait he began to insist that I should expose him to severe criticism and that I must not feel abashed about doing so, and so on. Of course I started declining in every way possible, but he became all the more pressing in his request and so I eventually decided to point out his shortcomings. He recognized that my frank and sincere criticism was very useful to him, so that far from calling a halt, he clamoured for more. I do not remember how long my critical analysis had gone on but I suddenly felt that it was time to break off since he was barely managing to keep his irritation in check. From this moment on, I noticed that his attitude towards me took a turn for the worse. It became almost hostile when he found himself having to paint two portraits for the very same clients whom I had painted when I was still in Moscow and then later in Berlin. But just why he became so unfriendly to me I cannot understand. I was not a rival of his, nor indeed would I have wanted to be; his reputation as the best artist and portrait painter in Germany was already established. He had acquired for himself an extremely rich collection of the best French Impressionists starting with Manet and he was a very clever and sharp character. His muddy-grey portraits, however, were in my view precisely his weak point (with the exception of two or three). He was much stronger as a genre and landscape painter. Nevertheless, being the very intelligent man that he was, he knew exactly how to play the role of genius whenever he was in the public eye, at the exhibitions and especially in front of the critics – in the manner of the European masters like Zorn, Boldini and Sargent. Unfortunately he was terribly spoiled by excessive praise from the critics and the press, which can harm the artist more than anything. He was incidentally very good and skilful at delivering speeches and on the whole he was a gifted and talented man of letters, which is very rarely the case among artists. As President of the Berlin Academy of Arts he used to follow the example of the celebrated English artist Reynolds (the founder of the British Academy of Arts in London) and open the annual spring exhibitions of the Academy with witty, caustic speeches gleaned

from the art world. He would read out his notes in the entrance-hall of the Academy surrounded by the elegant public. These inaugurations by Liebermann became quite a famous occurrence and I used to sketch him reading his speech surrounded in the background by his audience. Since he was already very old I had to prepare the way for my portrait of him by drawing him during his speech and then later, when he had kindly granted a sitting at his villa in Wannsee, I made use of them, and took a picture with me so that I could authenticate everything from life.

Meetings with L.N. Tolstoy

Did it really happen? Twenty years have elapsed since his death, but even now it is still hard to believe that he actually existed. Looking back in time, he broadens and grows in stature with each passing year; he will not fit into an ordinary frame, but reaches stunning dimensions; a legendary genius in his own lifetime, he was marvelled at by two hemispheres; he broadens and grows, and time only enhances his stature. And yet it is not so very long ago since he was among us, and we, who were fortunate enough to be his contemporaries, knew him closely, saw him, chatted and argued with him, and felt the warmth of his handshake. But can all this really be true? Is it really possible that he is not a legend, but actually existed?

The exceptional end which completed Tolstoy's exceptional life was the last grace which Providence granted him. It was a kind Providence, although it was not generally appreciated that his life, which seemed outwardly happy, was a profound tragedy. And from the moment of his departure from Yasnaya Polyana, especially from the moment of his exceptionally beautiful death, the legendary quality of Tolstoy began to be felt.

That same kind Providence saved him from having to witness the senseless slaughter of the First World War. How many times had he warned mankind against such a terrible, irreversible tragedy? He had foreseen it all, and passed the last years of his life preaching against this most terrible of evils, the killing of man by man.

Like all wise men, he knew what gives men happiness and joy and what takes this from them and destroys them. 'What do men

live by?' – by love, brotherhood, work, truth; not by violence, hate and brutish wickedness.

Pushkin died and Tolstoy was born, as if to replace him. For all their dissimilarity, he is Pushkin's direct spiritual descendant.

Tolstoy and Pushkin . . . Of all authors, Russian and foreign, I was from my earliest days most drawn to them, and they were the most dear to me. The high precepts of these two sublime Russian writer-artists stood unshakeably before me during my whole life, and influenced my creative work. But apart from my early liking for Tolstoy and even before I came to know him personally, I was drawn to him not only as a great artist, but also as a man in whom I discerned the presence of spiritual qualities, which condition the basic expression of morality: sympathy, compassion – the principle of love for one's neighbour. The unswerving striving towards moral perfection, so clearly expressed throughout his whole life, particularly attracted me to him. And subsequently, my acquaintance with him and our closeness played a very large part in my life, and the whole of my life was affected to a significant degree by his teaching or rather by this striving towards moral perfection.

To sum up the past: when I remember Tolstoy, I wonder how I deserved the happiness granted me by Providence, not only to be the contemporary of this legendary man but also to know him personally, to visit him, to converse with him, and to paint and draw him. How can I express in words the even greater, incomparable happiness, indeed almost a miracle, that he should have summoned me to him, that he himself wanted my participation and invited me to illustrate *Resurrection* while he was writing it. How can I convey the bliss I experienced (I can speak of it openly now – I'm an old man and have no time to boast, or to flaunt my shyness) when once in conversation with me, a friend of Tolstoy's, N.N. Gué[109], remarked: 'Tolstoy holds you in great affection – that is a great happiness.'

Why did I postpone the memoirs? Why did I not write letters to him (apart from business letters when *Resurrection* was being published)? Why did I not portray him with myself (for that's how it was in fact), but with Gué? Why did I set about doing his portrait only at the insistence of his daughters ('Yes, after all Papa himself would like it')? Why did I not keep a diary and note down his words for my memoirs? It was because I felt for him such reverence, akin to love – a feeling I had had since my childhood and schooldays. I jealously protected the spontaneity of my feelings from being tainted by any extraneous considerations,

whatever they might be, of profit or personal gain; I avoided publicity in every way possible and did not advertise the relationship we enjoyed together; I was much too afraid of troubling him and encroaching upon his precious time. How else, but with a heart which was pure through and through, could one appear before him – the great reader of the human heart! He really was the conscience of the Russian people, and not only of them, but of the whole world.

I do not know why it is – whether because Tolstoy sensed in me a fervent devotion, an anxiety not to trouble or disturb him, but to serve him whenever possible; or whether because he noticed how I loved simplicity and frankness, how I enjoyed a joke and an opportunity for hearty laughter – but, when I remember him, and see before me the giant, the genius, the extremely serious teacher and preacher (as one pictures him in the abstract, not just in my imagination), inaccessible in his greatness and powerful insight into human destiny, I can in no way reconcile this image with the Tolstoy whom I saw in all my meetings and in almost all my contact with him, whose hand I shook no less sincerely than the hand of my own father, whom I embraced and kissed on meeting and parting – that tender, charming old man, so kind, so keen on a joke, witty, possessed of an almost childlike *joie de vivre*.

True, there were occasions when I saw him in a different light. There were moments, brought on by some serious news or other about a violent or villainous act somewhere, when Tolstoy would flare up in anger and be transformed. He was even more beautiful at those times, with his blazing eyes, like those ancient prophets who 'with their words fired the hearts of the people'.

When I was abroad (whether in Paris, or Vienna, in Berlin or London) I was struck by the very great interest foreigners took in him. It's true, they were interested in everything Russian; nevertheless one of the first questions, to be asked whenever the conversation turned on Moscow, or Russia, would be: 'Oh, and have you ever had any occasion to see Tolstoy in the flesh?' One may easily imagine the effect my answers produced: astonishment, exclamations and endless questions. Even the little that I told them out of politeness would enrapture them. Eyes would light up and faces would shine, not only out of curiosity, but also out of a genuine reverence before the great Russian genius.

Often my own friends and the friends and admirers of Tolstoy reproached me for not writing my reminiscences of him. I would usually answer that my memoirs were contained in the portraits and the paintings. But my accusers were right: a paintbrush and a

pencil cannot convey everything. When I visit the Tolstoy museum, and survey my pictures from his life and works, mental images from the distant past come to life and I am gripped with excitement. I see Tolstoy's head bent over my drawings, attentively studying each detail; I hear his soft voice, feel his affectionate glance on me – and how can one convey all that!

If only my works – dumb witnesses of inspired moments spent in Tolstoy's company, the best moments of my life – if only they could talk! I have often felt like sharing with my friends these treasured memories, and now have the irresistible urge to speak and write about Tolstoy.

At one time, when he was alive, my love and devotion prompted me not to intrude, not to pester him with questions, and to refrain from talking and writing about him. Now these same feelings of love and devotion prompt me to resurrect in my mind everything which I remember about him.

In the late autumn of 1893 a representative from the well-known periodical *The North* came to Moscow. He proposed that I should take part in illustrating Tolstoy's *War and Peace,* together with V.V. Vereshchagin, who had been working on his Napoleonic cycle, and Repin, Kivshenko and Karazin, who was in charge of the arts section. It was planned to produce an album of coloured illustrations which were to be given as free supplements to subscribers to the journal. As a young painter at the start of my career, I was naturally very eager to take up this flattering offer.

As far as I remember, Vereshchagin turned down the proposal. We were each to choose four scenes and paint them in water-colour. This proposal was all the more enticing because it gave me my first opportunity to illustrate in colour – a long-cherished dream – and to illustrate a celebrated work by the writer whom I had worshipped since my schooldays.

I set to work joyfully. But it was not easy! To begin with, it was excruciatingly difficult to settle on only four scenes[110] from a whole book containing countless scenes of comparable beauty. After the first intoxicating inspirations had yielded the initial sketches, I reached the stage of having to work out artistic details, and it was then that I encountered unforeseen and insuperable difficulties. It may seem incredible, but in Moscow itself, the setting for most of the action described in the novel, it was then almost impossible to find anything which would help recreate the period at the beginning of the nineteenth century: there were no civilian costumes, no military uniforms, no surviving furnishings and fittings – in short, none of the material which was

indispensable to the artist intent on being true to life and working in accordance with the historical data. Of course there were illustrated books which one could use but a genuine specimen of a dress or costume, any sort of coloured remnant, could suggest an unexpected colour combination and become the point of departure for a vivid and convincing composition.

Among my old colleagues was a splendid painter called K.A. Savitsky, a genial soul whom I knew well and loved. Savitsky knew that I was busy working on the illustrations for *War and Peace,* since I had tried to find out from him some details of the costumes of 1812. An elderly, experienced man, he was very considerate and well disposed towards me. Time and again he reproached me for my shyness: why, he asked, did I not go to Khamovniki and find out from the author himself?

The distinctive quality of Tolstoy's art is that his books are not mere literature but life itself, and one tends to forget about the existence of an author. In reading this or that work, it was as if I had been present as an unseen observer of all that was taking place, so that it was not difficult to produce sketches as if they had been done from life. Besides, Tolstoy's art was somehow so close to me, so direct and immediate, that I was particularly eager to illustrate it: I felt I did not have to confine myself to the words on the page but could reach beyond them to extend the inexplicably familiar material.

Yet as soon as I tried to imagine the author of the written word, Tolstoy assumed fantastic proportions and became something cosmic and elemental. I lacked the daring necessary to approach such a giant. Besides, I ought to mention that by the early nineties Tolstoy's fame had reached its zenith; celebrated throughout the world as 'the great writer of the Russian land' – as Turgenev, himself a Russian genius at the height of his fame, had called him – he was acknowledged indisputably as the greatest of all living literary artists. Painters and writers the world over, and all thinking people turned their gaze on the little house at Khamovniki and, subsequently, the house at Yasnaya Polyana where he led his singular existence.

After a severe spiritual crisis[111], the artist in Tolstoy gave way to the teacher, the thinker, the man in search of life's meaning and the ardent prophet proclaiming religious ideals which might lead to the establishment of heaven on earth. People thronged to him from all over the world, people who were suffering, burdened and tormented by doubts and faintheartedness, people in search of truth. He became humanity's 'burning conscience'. How then

could I approach him with my paltry artistic worries? (I later found out that even the great and famous writers were consumed with reverential fear before meeting Tolstoy.) But as often happens in life, matters are decided for us by some unexpected incident.

It happened in the year 1893. It was a wonderful bright spring day just before Easter in Holy Week. The regular exhibition of the Wanderers[112] had been arranged in the rooms of the Moscow School of Painting, Sculpture and Architecture. Everywhere there was the usual last-minute hustle and bustle before the opening of the exhibition. There was the noise of hammering, the screeching of stubborn nails being pulled from the crates, the banging of planks against the floor, the chatter of workmen, the voices of artists calling to one another: all this combined to make a continuous din. It was dazzlingly bright, as the first days of spring usually are in Moscow. The venerable members of the Wanderers, distinguished Moscow painters and those who had come from Petersburg for the opening, boldly strode about in their fur coats, stepping over the crates, shouting above the other noises and exchanging opinions and advice about the hanging of the paintings. As a novice and as yet little-known painter (to distinguish us from the fully-fledged members, we young painters were called 'exhibitors': we didn't have any rights and were entirely dependent on the jury consisting of seven senior members) I hung timidly somewhere on the sidelines, keeping out of people's way. My picture *The Débutante* was already hanging in its place. I was on the point of leaving when suddenly word spread around the room: 'Tolstoy is about to arrive.' Just at that moment Savitsky, who was talking to his colleagues, the senior members, came up to me and said: 'It's a good thing that you're here, Leonid Osipovich, because Lev Nikolaevich will be here in a minute. He comes every year, you know, before the exhibition is open to the public. I will introduce you. You can ask him about the details of the scenes from *War and Peace* which you're anxious about. But where are you off to?' he cried and caught my arm when he saw me making a dive for the exit. 'Away with your shyness! He's so agreeable and unpretentious. You'll see what I mean. Anyway, do stay around. You know you've always dreamed of seeing him in the flesh, and this is such a convenient opportunity.'

'Konstantin Apollonovich! Please don't introduce me! Still less in front of my colleagues! Please don't! You can do it some other time.'

'Well, all right, let's wait and see.' Meanwhile in the entrance-hall Tolstoy was already taking off his coat. The older artists were beginning to fuss and were rushing forward to meet him as he came in. Suddenly there was a hush. The man himself was coming.

A singular presence was advancing from the doorway into the room. Hidden behind the backs of my colleagues, I fixed my eyes on Tolstoy. Dressed in his shirt with his hands stuffed in his belt, he glided along, hardly lifting his heels from the ground – a gait peculiar to him. With his head slightly raised and chest forward, it was as if he floated along. He walked easily with rapid, sprightly steps, which conveyed a powerful sense of purpose. Only afterwards did I discover that he had really felt extremely awkward and ill at ease, as he always did in a crowd, when he was in the public eye and the centre of attention; that is why he avoided crowded gatherings. After he had greeted the painters politely, Tolstoy suddenly began to look hard at the pictures, as if he were drilling a hole in the air. All of a sudden I had the feeling that his affectionate nature and his simplicity were the result of inner self-discipline and control over his immense personality. I saw the flash and flare of lightning, I saw a thunderstorm with muffled peals of thunder rumbling behind the storm-clouds. This was the Tolstoy whom I later tried to depict in my profile portrait against the stormy sky.

The viewing began. The painter of this or that work would detach himself from the semi-circle surrounding Tolstoy and would explain his work and then listen to Tolstoy's impressions and considered opinion. But they were not getting nearer to my picture. I was choked with excitement. What if he condemns it, and in front of the others too! Where could I then put myself, in my shame and grief! But some force stronger than my fear drew me after the advancing group. At any minute my heart would burst. Another moment, and there they were in front of my picture. 'And this,' said Savitsky, walking alongside Tolstoy, 'this is *The Débutante* by Pasternak, a young painter of ours. . .' But he did not manage to complete his sentence before Tolstoy burst in, 'Yes, yes, I know the name. I have been following his talent.'

I gasped like a condemned man who suddenly learns of his pardon. Overwhelmed by delight and embarrassment, I hardly knew where to put myself. 'In that case, allow me to introduce you to the painter himself. He is here,' said Savitsky; immediately the circle of people opened and I found myself in front of Tolstoy, who looked charming and radiant. I stood there helpless with confusion, and I remember the warmth and tenderness of his large fatherly hand as it shook mine. He said something agreeable to me, but I was so excited by the thought that Tolstoy was giving me his attention, and I felt so ashamed and awkward, especially in front of my elder colleagues, that I could not make out his individual words. It was something to do with the fact that he knew my *Letter from Home* and my drawings.

I am not going to describe in detail the rest of the viewing, the opinions of Tolstoy concerning this or that picture, or his thoughts on the meaning of art and its problems. All this is to be found in his article 'What is Art?'[113] This problem was preoccupying him just at that time and he was writing the article in question. For that reason he was then still visiting exhibitions. Tolstoy regarded certain paintings very seriously and in particular scrutinized those depicting scenes from peasant life. Of his remarks to the artists surrounding him which I managed to overhear (I had gone away again and was standing right at the back), I remember a snatch of one sentence: 'Of course for them art is only an amusement.' This was evidently directed at those who did not take an interest in the pictures reflecting the grim, unhappy peasant way of life, and just walked past them. Then he passed a remark with regard to one big canvas, that its size was disproportionate to its paltry subject. 'It seems to me,' he added, 'that when you paint in life-size you have to depict important things, which are significant as regards content, historical events and so on.'

The viewing ended. When I said goodbye to Tolstoy we were standing a little to the side of the group of painters and I plucked up courage to tell him about my illustrations,[114] and to ask him about various details of the scenes. I also told him about my dream of showing them to him and hearing his judgement as the author of the book. 'But of course. Thank you. That's very interesting. I would be very pleased. Come next Friday.' Even now I remember the day exactly. 'Come to us for tea. And be sure to bring the drawings with you.'

At the appointed hour, Tolstoy's butler led me upstairs into a large white room in the Khamovniki house. It was dusk by then and on a round table in the centre of the room a large kerosene lamp was already burning under a shade. To the left of the entrance there were two white doors, one a little larger than the other. I stood at the table with the portfolio under my arm and looked towards the two white doors with understandable excitement.

My heart beat violently and the minutes of waiting seemed endless. But Lev Nikolaevich suddenly appeared, framed in the smaller doorway which led into his study. Wearing the same grey shirt, he walked into the room with that characteristic gait of his. Cheerful and lively, he greeted me warmly from across the room. When he saw my folio he said to me kindly and with a hint of jocularity: 'Well then, let's have a look. Show me quickly what you've brought.' He moved towards the lamp and took the first water-colour from my hand. I had depicted Natasha's first ball

with Pierre Bezukhov introducing her to Prince Andrey. In the background Emperor Alexander I, surrounded by his brilliant retinue, is making his appearance in the entrance to the ballroom. The ball is in full swing and, in the light of the gleaming chandeliers, everything is resplendent with colour. At first Tolstoy did not utter a word. Then suddenly he turned towards the big white door and called: 'Tatyana! Tatyana! Come here quickly!' And only then did he address me, shaking his head: 'You know, this is such a strange thing. They offer the squirrel nuts when it's lost its teeth! You know, when I wrote *War and Peace* I dreamed of having such illustrations. It's really wonderful, just wonderful!' Then he began repeating this word over and over again in a singularly musical voice, with such tender animation and affection as could come only from him, the most fascinating of men. Many times in my life since than I have heard this word on his lips, and to this day it is fresh in my memory and I can still hear that special Tolstoyan 'Wonderful!'

I think that his acquaintance with my work and the potential which he saw in me then prompted him to allow me at the first suitable opportunity to do the illustrations for whichever new book he might write. He tore himself away from the drawing and looked at me closely. But he became very serious all of a sudden and once more became absorbed in the contemplation of the water-colour. I must admit that the unexpected effect produced by my drawing filled me with inexpressible joy. My shyness and instinctive uneasiness gradually left me and I no longer had the feeling of being confronted by a harsh, forbidding judge. My heart became lighter and I thought, 'He's a lovable, friendly old man who even reminds me slightly of my father. His hair is even combed to the back like my father's with a lock over his ear.'

I had not noticed that his daughter Tatyana Lvovna had come up to the table. 'Here Tatyana, let me introduce you to the painter of whom I spoke after the exhibition. Look how beautiful this is!' At that time I did not know that Tatyana Lvovna was herself a painter and had great natural talent as an artist. Looking at the water-colour, she too began to express her enthusiasm.

Father and daughter examined and discussed each person depicted in the picture and almost vied with each other in heaping praise on me. Tolstoy became more and more excited. 'Please show us the next one!' My apprehension and embarrassment disappeared, I felt my spirits rise, and I began to show the water-colours one after the other. *Napoleon and Lavrushka, Natasha visiting the wounded Prince Andrey, The execution of the Moscow incendiaries by the French.* Their interest grew with each new picture and there was no end to their praise. How charming Tolstoy was! I

remember how he burst into loud and hearty laughter when he saw my water-colour depicting a group of cavalry officers in brightly coloured uniforms, with Napoleon in battle-dress in the foreground looking grim and preoccupied as he listened to the babble of the drunken Lavrushka riding at his side. Tolstoy was amused by the contrast between Napoleon's concentration and the grimaces of the tipsy Lavrushka revelling in the nonsense he was talking.

Tolstoy's interest and good humour encouraged me to ask him various questions which were worrying me. I wanted information regarding some details about various scenes and characters, details about the costumes – everything which I was unable to find out by rummaging in the libraries. I distinctly remember, for example, that I was interested in how precisely Lavrushka was dressed in the scene with Napoleon, the appearance of Pierre at the time of the execution of the incendiaries, and many other things. You can imagine my amazement when it was revealed right from the start that, despite Tolstoy's good intentions to help me, his memories of certain passages and sometimes whole scenes of *War and Peace* were so confused that we both laughed heartily.

All the same Tolstoy did remember various episodes in the book and talked incidentally about his creative work, in particular the extremely interesting moments in his writing of *War and Peace*. 'I remember,' he began, 'that at all costs I wanted to depict the famous meeting at Tilsit between the two Emperors, but it just could not be managed; somehow it always turned out to be on the periphery of events, and I could not connect it with the rest of the text. But as the novel progressed, it turned out that Nikholai Rostov decided to deliver Denissov's petition to the Emperor, who happened to be in Tilsit at the time. So, once having brought Rostov to Tilsit I could describe in detail the Emperors' meeting, without its seeming out of place. A propos of this,' continued Tolstoy, 'I always remember Fet's[115] remarkable words: "If a portrait is a good one, then it will have a mouth; and if you open the mouth you would find a tongue; and under the tongue, there would be a bone, and so on." Fet's incisive graphic expression is relevant to the very essence of each work of art: everything evolves naturally and one thing flows from another with the inevitability of life itself.'

Tolstoy told me incidentally that soon after the appearance of *War and Peace* he was often sent illustrations, but not one satisfied him: they were all very superficial and looked like battle sketches.

There was neither flattery nor exaggeration in Tatyana's

exclamation, 'we've never seen anything like this before'. I was then perhaps the first Russian painter whose illustrations had been considered seriously in their own right as an independent genre of artistic creativity.

That evening I learned from talking to Tatyana Lvovna that she was herself a painter, and whenever time permitted she visited the Moscow School of Art. An amusing coincidence also emerged during our conversation. Tatyana Lvovna had unwittingly been the reason for my receiving artistic training abroad rather than in Russia. The fact is that when I went to Moscow after high school and, to please my parents, signed on in the medical faculty of Moscow University, I decided at the same time to devote myself to art. I submitted an application to the School of Art. But there was only one vacancy and two candidates: Countess Tolstoy and myself, a mere student. Naturally they chose her. But since I did not want to leave the University (which I should have been obliged to do if I had entered the Petersburg Academy) nor to waste time, I decided to go to Munich where I was accepted by the Munich Academy, which in those days was considered to be one of the best European schools of art. 'And you're obliged to me for that!' Tatyana remarked, laughing. This chapter of accidents goes still further. A year later I was invited by Prince Lvov, the Director of the Moscow School to join the School as a teacher in the very class in which Tatyana Lvovna still figured on the list of students. Unfortunately the talented artist very rarely visited the studio in the School, since nearly all her time, like that of her mother and her sister Maria, was devoted to her father – copying his manuscripts, proofreading and helping with his extraordinarily large correspondence from all over the world.

I began to relax a little in Tatyana's company (especially when I found out that she was an artist, that is, one of my own kind, a colleague); my inhibitions began to fade and I began to feel easier and more comfortable, but in spite of all this I prepared to take my leave. 'This is Tolstoy after all,' – the words bored through my consciousness – 'the author of *War and Peace*. How dare I talk to him as if he were an ordinary mortal, how dare I encroach upon his time?'

Yet Tatyana Lvovna did not allow me to leave and I stayed to tea. Gradually the drawing-room filled up with members of the family, friends and guests. I was introduced first of all to Sofya Andreyevna, Tolstoy's wife. At that time she was still a comparatively young and lively woman of the world. She was evidently very nervous, and being extremely shortsighted she kept lifting her lorgnette, which hung on a chain round her neck, and letting it drop again. She also had the habit of jerking her head

rapidly from side to side, after which she welcomed her guests very warmly.

When Tolstoy still lived with his family at Khamovniki during the winter (and this year they were spending the rest of the spring in Moscow) some very mixed society gatherings took place on certain evenings. Who did not dream of visiting Tolstoy – not only among Russians but among his foreign admirers from both hemispheres? In the house you could still sense an atmosphere of the age-old hospitality of high society, of distinguished nobility; this was interspersed with the fashionable society of the day; and then there were Tolstoy's own friends, a special breed of Tolstoyans who somehow managed to mix and get along with those they were sandwiched between, even though they were opposed to this whole tenor of life both in their way of thinking and way of life.

Also present at different times were Moscow's leading artists:[116] musicians, composers and painters; professors and scholars; eminent foreigners not only from Europe but all the way from America or Australia; maids of honour, dignitaries, governors and public procurators from St Petersburg; and the young people who included friends and admirers of the daughters, and friends of the sons. Alongside some general of the Imperial Household, a friend of Tolstoy's youth, there were socialists and revolutionaries, perhaps destined to exile in Siberia, and disciples of Tolstoy, released from prisons where they had suffered for their convictions. Everything that seemed incompatible in life and even in fiction was to be found here sitting peacefully at the big tea-table. Such uniting of the un-unitable was possible only at the Tolstoys'. This even had its own name: 'Le style Tolstoy'.

An agreeable and stimulating atmosphere would be enhanced on the one hand by our charming, gracious hostess, aristocratic in the best sense of the word, and her two delightful, clever, grown-up daughters; on the other, of course, by Lev Nikolaevich himself when he came into tea from that small door in the corner. The true aristocrat at heart, he knew how to speak to each one of his guests – sometimes in a convivial manner, sometimes affectionately, sometimes wittily, sometimes sympathetically, but always compellingly.

On my first evening at Khamovniki, I remember standing in a group with Tatyana Lvovna and Maria Lvovna. We were discussing news from the artistic world when Tolstoy came towards us. In the company of his two beloved daughters, who were closer to him than anyone else, he looked radiant. Infected by their youthful exuberance, he was particularly jovial, witty and captivating: he radiated friendliness, warmth, and joy. 'My

goodness, what an evening!' I thought, 'I must go. I need to be on my own, to sort out the first impressions of my visit to Tolstoy.'

On one of my visits to Khamovniki I asked Tolstoy if I might introduce my wife to him and his family. We arrived at the appointed hour and I presented her; but to my great embarrassment Tolstoy, without a word, suddenly gazed earnestly at me, then at my wife, then again at me, then again at her, and to my horror did this several times. 'No, there's no likeness!' he exclaimed, and burst out laughing. Only then did he welcome us warmly. He explained: 'I was looking at you both like that to see whether or not you looked like each other. It's a popular belief that after some years together, married couples come to resemble each other.' Tolstoy was charming as only he could be; he joked and chatted with my wife about music, questioning her about various composers.

Afterwards, in Moscow, then in Yasnaya Polyana, it gave her particular pleasure to play his favourite composers for him – Bach, Handel, Chopin and others. He loved her playing and often her performance excited him and moved him to tears. I remember that once after a visit to the country we received a very warm letter from Sofya Andreyevna or Tatyana Lvovna (I don't remember which and don't know where these letters are kept); it ended with words something like these: 'for a long time after your departure our house was filled with an atmosphere of sublime art evoked by the playing of Rosaliya Isidorovna. . .'

Among my water-colours in the Tolstoy Museum is a sketch of Tolstoy listening to chamber music in our house. This is how the drawing came about.

In the early nineties, Tchaikovsky wrote a new trio called 'On the death of a great artist'. This trio enjoyed a great success in musical circles. Tolstoy was avoiding large crowds and had stopped going to concerts. We learned from Tatyana Lvovna and Maria Lvovna that he would very much like to hear this new work in an intimate circle, so we suggested that it should be arranged at our house. My wife was at the piano; Professor Grzhimali played the violin, and Professor Brandukov the 'cello. Since our flat was so small, we had invited only two or three people apart from the players, and Tolstoy and his daughters. That evening, which proved particularly successful both in a musical sense and in the pleasure afforded to Tolstoy, is recorded in the water-colour, which I painted from memory. I remember too how Tolstoy dined with us that evening (we had vegetarian food) and how he absolutely adored the olives. However the evening could not pass

without an annoying unforeseen incident. The arrangement of rooms in our modest little flat was such that the door from the nursery led straight into the room in which the trio was being performed. During a pianissimo passage, this door opened and our *nyanya*, without batting an eyelid, walked slowly and with an air of importance across the whole room, empty teacup in hand. 'Squeak! squeak!' went the floorboards. 'Shsh! *Nyanya!* Quiet!' – but she paid no heed and at a leisurely pace proceeded diagonally across the room into the kitchen as if nothing had happened.

Incidentally I remember that I decided that evening for the first time to tell Tatyana Lvovna and Maria Lvovna that it would make me very happy to draw Tolstoy. I could not bring myself to ask him since I knew that he did not like having his portrait done, and I did not want to disturb someone who was so far above our paltry worries and desires. 'No, no! On the contrary! Father would be very pleased! He would be very interested to see how you drew him! He will gladly pose for you!'

From that time I began to draw him (first in Yasnaya Polyana) whenever I had the opportunity. I did not bother with a special pose but drew him while he was walking or working, reading or writing. He was always very pleasant and obliging, and he himself often suggested a sitting when it was convenient.

That spring when I was at Khamovniki I met Nikolai Nikolaevich Gué, to whom I had been introduced earlier at V.D. Polenov's. He was a lively original man of great intellect, quite apart from being one of the greatest artists in the Wanderers group. He had hardly aged at all and was alive to questions of the day.

We were once sitting in the garden listening to Gué tell about his past; the apple trees were in blossom, I remember, and the garden was full of spring fragrance. He turned in the direction of the little window on the upper storey where Tolstoy was working and said: 'Do you see that little window up there? From it, there will eventually emerge a doctrine that will conquer the whole world.' Suddenly Tolstoy appeared at the entrance to the house and walked towards us quickly. He was evidently in a good mood and, being in the habit of saying the most important things first even before greeting, he exclaimed: 'I have just read S——'s 'Reminiscences' in *Sovremenyi Zapisi*. The inimitable Pushkin! Amazing! Wonderful! S—— writes, "Alexander Sergeevich came to see me today and said, 'Do you know my Tatyana has just sent Onegin packing?' " What a genuine creative work this is! Pushkin speaks about his heroes as if they were real people of whom he'd just heard news!'

Several times the Tolstoys invited me with characteristic cordiality to be their summer guest at Yasnaya Polyana. To begin with I could not bring myself to accept the invitation, but I could not for long fight against the genuine desire to see the famous Yasnaya Polyana at last with Lev Nikolaevich in that setting, and to breathe in the whole atmosphere of the place – the nature, the land, the *muzhiks* – in fact, all these elements of real life with which Tolstoy had so identified himself, and out of which had grown this mighty oak. It was extremely tempting for a city dweller like myself who had grown up in his own peculiar surroundings, to see the great Russian country estate, and the great Russian countryside which I had not seen at close quarters; I had only glanced from a distance through train windows; the peasant huts from there were the size of a walnut, small in the distance as though huddled together, crooked and strange. But just to see this landscape was already sufficient to sense that Yasnaya Polyana was somewhere quite near by and that Tolstoy was there in his element.

At daybreak we arrived at the station and I prepared to leave the train. I was extremely embarrassed to announce: 'I want to go to Yasnaya, to Count Tolstoy's.' But where was I going? And why had I come? – I wanted to escape. In short, the same old feeling of apprehension, regret, and fear that I would be intruding, that I'd be wasting his time; had there been a return train I would have gone straight back to Moscow. It was a small station. Day was breaking slowly.

Suddenly the door screeched and a great big strong man burst into the room. This was Ilya Lvovich Tolstoy (he looked a little like his father). Having learned from the station guard that no one had come from Yasnaya yet, he flung himself onto the bench and, without looking at me, immediately went to sleep. After some time, when the jingle of bells could be heard and the horses swung round sharply in front of the station, the guard came into the room and said: 'They've come, gentlemen!' I went towards the door, whereupon Ilya Lvovich said: 'So you're going to Papa's at Yasnaya? Let me introduce myself.' We greeted each other and got into the carriage.

On the way we got talking and Ilya in his good-natured way talked unceremoniously about his family, and continued incessantly until we entered the park. They were still asleep in the house and Ilya Lvovich left me to go and sleep a little more. With understandable curiosity I looked around the former library downstairs where I had been taken. Many times afterwards (when *Resurrection* was being written) I spent the night here, and then the room and the books came alive for me. But even on this early morning when I entered for the first time, the room seemed alive,

as though it was bringing back a past that had already become history. And here, downstairs at this window, as I found out later, Tolstoy had written *War and Peace*. The books still stood here, and papers, representing the source material for the subject of his work, lay on the shelves in folders and in piles. What a lot he must have read to write *War and Peace,* and what mighty canvases must have been uncovered in this little room with only one window!

In Yasnaya Polyana I became more closely acquainted with the Tolstoyan lifestyle and entourage. Here, surrounded by nature and close to the simple peasant life, Tolstoy was transformed both in temperament and appearance; he looked remarkably better, stronger, healthier. What a wonderful figure he cut during his morning outings on horseback! I remember one encounter with him. It was a wonderful sunny summer morning. I was walking home through the grove after bathing. Lev Nikolaevich was riding towards me; he looked lively and strong, and sat on the saddle like a Cossack, as if glued to it. He reined in to greet me, to joke a little and exchange a few words. After saying goodbye he went off quickly in the other direction. A few seconds later I turned round to take a look at him from behind. Horror rooted me to the spot. I saw that Lev Nikolaevich had run into a swarm of bees. Something elemental seemed to break loose in all his contortions to defend his body; he quickly fought them off to left and right with his crop, then galloped ahead and, thank goodness, escaped from the menacing danger (said sometimes to be deadly). Remembering this incident, I could not help thinking that Tolstoy's adversaries, who constantly found fault with him, would have accused him of inconsistency with regard to his non–resistance to evil, in the use of violence in his natural move to defend himself.

In connection with this I remember A.F. Koni's[117] brilliant rejoinder to a remark of one of Tolstoy's antagonists. Once during evening tea at Khamovniki he happened to be among the guests, and I was introduced to him. This former chief procurator was a celebrated public speaker, the best lawyer in Russia and counsel for the defence in the most famous lawsuits; he had the reputation of being completely honourable and incorruptible. He told stories for almost the whole evening, and spoke so beautifully that everyone was rapt in attention; Tolstoy, I was told, was very fond of him and loved listening to him. When the two of us had said goodbye to our hosts, we went outside and it turned out that we were going the same way. He took out a cigar and lit it: 'I usually come to Moscow to visit my mother's grave, and stay at Lev Nikolaevich's to disinfect my soul. You see, I don't allow myself to smoke in

his presence.' We incidentally fell to talking about Tolstoy's adversaries, who accused him of inconsistency in his private life. It was with particular eloquence that Koni related how he answered one high dignitary who made the usual remark of this kind: 'Of course it would be nicer for you if, one fine morning after you have set off for the senate and are lounging in your satin carriage on its soft springs and rubber tyres with a cigar between your teeth, you could unfold your newspaper and read the short paragraph: "Today the writer bearing the name of Count Tolstoy was found frozen to death in a gutter under the bridge."'

I have already referred to the picture, *Reading of the Manuscript*: this is what actually led up to it. On the second or third day of my trip to Yasnaya Polyana I was standing towards evening with Biriukov[118] by 'the tree of the poor' when Tolstoy emerged from his study and came up to us. He had a scythe in his hand and an overcoat was flung over his shoulder. He invited us to take a stroll with him. It was already getting dark. After a day's work at his desk Tolstoy was in the habit of going out towards evening to walk or do a bit of scything, which he called 'loosening up'. When we reached the meadow he threw off his overcoat and, without interrupting the conversation (we were talking about art, I think), began to scythe. For the first time I decided to sketch him from life. He wielded a scythe very skilfully, and, despite his years, cut the grass dexterously with the strong practised movements of a genuine peasant hay-maker. He did it so quickly that it was impossible to catch his pose as a whole, even for a moment, and I hardly had time to sketch him. After working like this for some time, Tolstoy obviously became tired, so he flung his coat over his shoulder again, took up his scythe, and the three of us set off for home. All of a sudden Tolstoy said to me: 'Leonid Osipovich, have you got time to drop in on me?' It's not difficult to imagine how thrilled I was by this invitation. I was extremely curious to see inside Tolstoy's study. Instead of going upstairs to tea we followed Tolstoy who was walking quickly in front of us. As we were making our way along the corridor of the basement, Biriukov just had time to whisper to me: 'Lev Nikolaevich must be wanting to read to you some new thing of his to be illustrated. For him to read to anyone from his own work is a very rare honour.' It's not difficult to imagine what my feelings were when I found myself in this historic semi-basement room (in former times this was a saddle room and still had the rings on the ceiling) which was Tolstoy's study. Biriukov was right. Hardly had we got into the room when Lev Nikolaevich, without taking his coat from his

shoulders (that was just how I'd drawn him) put his scythe in the corner, lit a candle, and addressed me in his usual soft tones: 'Please take a seat. I wanted to read something to you.' I sat opposite Tolstoy with Biriukov on my left. Tolstoy took out the manuscript and began to read.

This was a fragment of a story[119] depicting the departure of the Grand Duke. It happened to be the description of a family's visit to relatives, some aunt's or other (I don't remember exactly). At the same time various scenes from the life of the family were told with such exceptionally vivid artistic sharpness that it was as if the text were actually asking to be illustrated. Some situations, characteristically, were told with such rollicking humour and sarcasm that I roared with laughter. The courtyard scene involving the chase of an unfortunate chicken intended for the dinner guests sticks in my mind. It's not difficult to imagine how Lev Nikolaevich, who was after all a vegetarian, was able to sketch such a scene and strike just the right note. They were hunting the chicken in the servants' quarters and trying to drive it into a corner, but it kept breaking loose, and when finally it was completely exhausted and barely conscious, it nevertheless succeeded in disappearing and escaping the fate they had prepared for it. I listened to the reading yet at the same time made an effort to drink in all the special beauty of the surroundings and commit it to memory. The room was lit by one candle and in the picturesque half-light the shadows were slanting, and in front of me the great author sat reading. This all captivated my artist's eye; I absorbed the impressions, I remembered all the shapes, all the half-tones and all the details of the room. I do not know whether this story was published afterwards or not, but during the time that I'm describing it unfortunately did not appear in print.

But five years later Tolstoy invited me to illustrate not this work but another, more important and significant.

During my first or second visit to Yasnaya Polyana, Tatyana Lvovna asked me to draw as a keepsake something in her elegant little album with the silver clasps. Marya Alexandrovna Schmidt[120] and Pasha were sitting chatting on one of the garden benches. I began to draw them without their noticing. The drawing had the character of a portrait and was a good likeness of both of them. Just as I was finishing it, Tolstoy came up to me. He became warmly enthusiastic. 'What a lovely drawing!' he exclaimed. Suddenly he looked worried and said: 'You must put fixative on it'; and, turning towards Tatyana's studio, he began to call, 'Tatyana! Bring fixative, quickly!' That was more than forty

years ago. Tolstoy not only praised my drawings, he treated them with a sort of touching solicitude and affection which moved me deeply.

If I were in the habit of keeping a diary, I would have written the following – doubtless in great excitement – towards the evening of 28 October 1898. 'Tatyana Lvovna has just been. She informed me that Lev Nikolaevich has written a new story. He requests me to go to Yasnaya Polyana to get to know the contents, and wants to ask me if I will undertake the illustrations.' I hardly dared to believe this good fortune. It can't be! Lev Nikolaevich! Lev Nikolaevich himself inviting me to illustrate his new work! Terrifying! It took my breath away. God help me!

Tatyana Lvovna also told us that Lev Nikolaevich was in a great hurry to publish the story, for the author's fee was to go to help the Dukhobors emigrate to Canada. He asked me to go to Yasnaya Polyana as quickly as possible and to cable my time of arrival so that he could send a carriage to the station.

The next day I hurriedly arranged my affairs and sent a telegram to Tolstoy to say that I was going to Yasnaya Polyana on the night train. In the train I abandoned myself to my thoughts as I was in no condition to sleep. What was this new thing? It was certainly flattering and pleasing, but could I manage it? Would I be capable? It was no trifling matter! What I had dreamed of in the last years from the moment on that memorable evening when I heard those first words of praise for my drawings for *War and Peace* – what I had dreamed of was coming true. So probably Lev Nikolaevich had somehow sensed my passionate desire to illustrate something from his more recent work. And then of course, in Yasnaya, with Biriukov present, there was Tolstoy's reading of those splendid extracts containing so many suitable passages for illustration from the unfinished story 'In the starving year', so perhaps he had read this manuscript to me with this in mind? But would I come up to his expectations? What lay ahead of me?

Despite the early hour, Tolstoy was already waiting for me in the glass porch, and greeted me with his customary affectionate kiss. After asking after my family's health and taking me into the hall, he said: 'Well then, did Tatyana tell you? It's wonderful of you to have come. Thank you.'

While I was taking off my fur coat in the familiar hallway, and as we were going upstairs to the famous white room – the dining-room where usually at this time the samovar was on the go and hot

coffee was being prepared – Tolstoy told me about his plans to help the Dukhobors and said that to this end he had recently started to write an 'artistic' book (the Tolstoys made this distinction between artistic and religio-philosophical works). The household was still asleep. Lev Nikolaevich went to the table and invited me to have breakfast. I sat down, stirring my coffee slowly and absent-mindedly, and, as I now recall, looked round in confusion at the great familiar dining-room with the portraits on its walls. Lev Nikolaevich, with his hands, as usual, in his belt, remained standing at the table while talking and looking now at me, now at my hand stirring the spoon. In the course of our conversation his face became more and more serious. In talking about the details of our prospective work he was somehow nervous, even impatient perhaps. This had already shown itself in the way he had waited for me on the doorstep and in the way he was bustling around the samovar and almost hurrying the breakfast. 'Now then, have your breakfast and we'll go,' he said. I finished. I can see him now, as he stood half-turned away with his chin tucked into his chest and his eyebrows slightly raised, and that singular, unforgettable, penetrating look of his. His bearing, his words, the expression on his face – everything bore witness to the feeling of the great artist who knows that he has done something of great value and importance for himself. Along with the solemnity and grandeur of this creative consciousness I felt his impatience to hear my opinion as an added touch of life and humanity. 'Let's go. I'll give you the manuscript and you can begin reading. I think you will like it.' I was used to the fact that Tolstoy usually spoke very deprecatingly about his own works. For this reason I was amazed both by the unexpectedness of his words and the arresting seriousness of his intonation, when, after a moment's pause, he announced: 'You know, this is perhaps the best thing that I've ever written.'

Here I am downstairs in the familiar room, the former library where I had stayed before. And here it is – the manuscript. At the beginning there was a fair copy, then there followed barely legible large strong handwriting: the hand of Tolstoy which even the author himself sometimes could not read, and which only certain members of his family, used to his manuscripts, were in a position to decipher.

It started at a lively pace with a strong keen tension, like an electric current; as always, the Tolstoyan writing, more than that of any other writer, has something intimate and unequivocal which irresistibly flows into me. My interest grows as I read on. From the very first lines, the artistic images appear in the outlines,

the clearly expressed forms, its contrasts, its reality and its vitality. They begin to live, begin to walk and move. The soldiers and Katyusha and the prison atmosphere are already declaring themselves in bright well-defined images. There is the usual Tolstoyan range: a huge canvas – a vast circle of characters from different social classes. The trial. I see it clearly before me, as if it were real.

And here is the higher Nekhludov circle. The Korchagins. How well I know all this. I can see it. Already fixed in my mind and swaying in my imagination, the images burst onto the paper. I read on without being able to stop myself and every single passage is graphic, as if it were made for drawing – strong, clear, precise, like his own language, exactly delineated as with a nail. Good gracious, how on earth will I convey these riches: everything was valuable and deep-dug – what could I select? My head and heart could hardly contain everything, they were feeling tight with the influx of impressions – when suddenly in walked Tolstoy (I had hardly had time to read more than a few chapters) and asked me quietly: 'I'm not disturbing you, am I? Have you read much? How do you find it?'

I will mention in passing that despite the undoubted confidence of such a great writer in his own powers and technical skill, Tolstoy nevertheless to all appearances gave a ready ear to frank impressions of his work. At least in my case, I don't know whether it was because I was an artist or because of his sympathy towards me which I took pride in all my life, but in any case he always took a very lively interest in my opinion of his writings. Of course he knew that I was never calculating in my dealings with him and that I spoke plainly and simply to him. In my eyes he could read sincere enthusiasm, and a love which at times approached adoration. Sometimes I would sit admiring him for a long time, looking at him, trying to fathom the whole person, and reading in him the whole human range: *Homo sum, humani nihil a me alienum puto* (I am a man, I consider nothing human to be alien to me), from the most basic natural things to the spiritual summits. And perhaps both his flair and his instinctive enthusiasm for the artist caused him to speak to me in a different way; often we could catch each other's meaning at once – sometimes by the glint in his eye, by his interest and desire to demonstrate, (to read what he'd written to me as an artist-illustrator in whom he sensed a fellow-thinker) – in the way we perceived things, in the essentials and methods of artistic creation (observation, working from life, truthfulness).

The unexpected appearance of Tolstoy in my room did not give

me time to collect my thoughts or to formulate the impressions the reading had made on me. So all the more spontaneous was my reaction to his question, and all the more surely my utterances must have shown him how enthralled I was by the reading. And since it was not in my power to hide or repress my emotion, I began to express my enthusiasm, my joy, and with the impressions of what I had read still fresh in my mind, I immediately began telling him about the first scenes I had selected.

In accordance with the length of the book, I considered how much work it would involve, how much time it would take for the technical execution, turned over in my imagination the possibilities of illustrating it, and made a note, however approximately, of the characters and scenes for my future drawings. I never imagined that in adding a fairly short ending to the story (for that was how Tolstoy proposed to complete the work) he would get so carried away, that in the course of writing, the story would begin to grow, to spread and to assume ever wider horizons.

Being extremely self-critical, Tolstoy would often be dissatisfied with this or that part of his work. Unable to leave it alone, he would rework it, often throwing out whole chapters and changing them for new ones.

To begin with, this was the approximate state of affairs as far as I remember: in order to help the Dukhobors emigrate, Tolstoy had decided to give his story for a certain sum of money to some foreign journals of which the most important was the French journal *Illustration*.[121] My illustrations were at first intended for this journal, and it was with them that I had to negotiate about the technical side of the work. But even these original superficial terms for the publication of *Resurrection* were changed. Thus, if my memory does not deceive me, when the publisher of the journal *Illustration* got to know the text of the story he refused to print it. The journal was, he said, widely read in the provinces by young ladies, and the content of the story was 'unseemly' for them; the story might arouse displeasure among the provincial bourgeois subscribers, etc., etc. I do not now remember the outcome of these negotiations, but in any case both *Resurrection* and my illustrations for it appeared in France. I do not remember exactly the names of the English, American and other European journals in which, at the same time as in the French journals, the novel with my illustrations appeared chapter by chapter as it was written.

The fact of the matter was that the appearance of *Resurrection* in print was preceded both at home and abroad with the sensational news that Tolstoy, after many years of abstaining from purely artistic work, and having apparently renounced it forever, was

writing a new novel, and that all the fees would be given to help resettle the religious sect of the Dukhobors in Canada.

Tolstoy writing a new novel! One may easily imagine the effect this news produced. Immediately the more prominent publishers of periodicals both in Russia and abroad began to offer large sums of money for the right to print the first weekly instalments. *Niva* was of course also aware that the new work was to appear abroad first of all, and since at that time there was no greater attraction in the whole world than the appearance of a new creative work by Tolstoy, *Niva* naturally hastened to enter into negotiations with Tolstoy and succeeded in obtaining for itself the first publishing rights on *Resurrection*. Of course there was immediately an unprecedented increase in the number of subscribers to the journal. Incidentally, I must mention that the publishers of *Niva,* which was in its day a very well-known and widely-read journal, played no small part in promoting the development of Russian culture by publishing the best works in almost the whole of Russian literature.

This was one of the best periods in my acquaintance with Tolstoy. He was engrossed in his work, and the deeper he delved into it, the greater his *joie de vivre* and his youthfulness. The living flame of artistic creation was rekindled. How mighty he was then, what power and inner beauty there were in him! His family used to say: 'Papa is always like this when he gets started on any artistic work.'

I saw Tolstoy at different periods of his life. And, more often than not, I would meet him in bright and happy mood. But I never afterwards saw him looking so joyful, radiant and young as at the time when he was writing *Resurrection*. Apart from the absorption in his work which is natural for an artist, one could see that this novel had a special significance for him. It gave him a special energy, and one could feel in him a surge of creative power. His negative view of *belles-lettres* as 'superfluous' in the period before he wrote this novel was well known to everyone. But for *Resurrection* he evidently made a special exception, I think in view of the importance of the theme, and he considered it, as he told me on the morning of my arrival, the best thing he had ever written.

I must admit that it was only after many years, when looking back, recalling and reconstructing our conversations, that I understood the full significance of the seriousness which suddenly transfigured Tolstoy on that early morning when he first spoke to me about *Resurrection*.

147

My days were taken up with reading and taking notes, and the whole household gathered upstairs in the white room for dinner and evening tea. After tea Tolstoy had the habit of walking diagonally up and down the room with me, asking me about my impressions. During these walks we had extremely interesting discussions and exchanges of thoughts and observations, both of real life and with regard to my day's reading. I often managed to arouse his interest in my personal impressions and my outline of the features I had noticed in the appearance and character of his personae, and how I imagined I would depict them. Tolstoy told me in passing about some very interesting episodes in his life and made observations which unfortunately I did not record; there was much that was extremely fascinating, especially in Tolstoy's graphic narratives. He could also recount amusing stories with astonishing humour. I remember telling him of my desire to pick out as an epitome of the whole class of rowdy young good-timers a cabbie, a rough show-off in his funny absurd coat with quilted lining on the backside – a typical phenomenon not so much of the Russian, as of your pure Moscow mercantile and noble classes. When I began to tell him about my observations – their physiognomy, dress, hairstyles, and especially the insolent expression on their clean-shaven faces – Tolstoy exclaimed: 'I was once dealt a blow by one of those! It happened one winter night; my wife was not well, she had gone into labour. I rushed out to fetch the doctor. I hastily threw on my sheepskin coat, changed my boots (I was wearing felt boots at the time), took some sort of round peasant cloth-cap which happened to be at hand, and went out into the street. Not a soul was about, not a single cab. I ran on, and finally saw one at the corner of Prechistenka. I dashed up to him: "Now then, brother, take me quickly to. . .", and I began to tell him the address. But I didn't have time to finish what I was saying before he – without budging from his seat – slowly moved his head in my direction' – and here Tolstoy demonstrated this movement and looked over his shoulder haughtily like the cab-driver – 'disdainfully looked me up and down and, concluding from my peasant attire that I was not gentry, sternly grated: "You should learn to know your station." '

But it also happened that in our walks together, we touched on very painful questions as I understood only later. While I was still under the influence of one of the most powerful scenes from *Resurrection,* in which Nekhlyudov sneaks up on Katyusha on that memorable night, I remember how I began to say to Lev Nikolaevich that I wanted to depict Nekhlyudov in the most

humiliating way possible: how he, like a thief and criminal, steals up to his unfortunate victim in order to destroy her. With obvious agitation in my voice I began sincerely and at the same time naïvely to develop my views on this question. At a time when the theft of a handkerchief was considered disgraceful, and the law and society stigmatized the one who had committed the theft, a crime like Nekhlyudov's, which was graver than ordinary theft, the theft of a life and of the honour of the seduced victim, was not only not punished but was not even considered reprehensible. . . On the contrary, after committing the crime he becomes more 'interesting', almost a romantic hero, especially in the higher Nekhlyudov society, particularly to the ladies – and that, it would seem, is even more senseless. Apparently I was clumsily expressing something of this sort in an agitated, heated way, while Tolstoy, becoming ever more serious and gloomy, continued to pace up and down the room with me; and without taking his eyes off me he looked from under his beetling eyebrows with that special knowing gaze which, as it were, pierced and looked straight through you. 'You know, I look at you,' he said, 'and I greatly admire the high moral stand you take!' I was so embarrassed that I did not even catch what he went on to say. I began to feel awkward; I sensed that I had somehow touched on something which I should not have, and I changed the subject.

As I said before, Tolstoy wished to help the Dukhobors and decided to depart for once from his principles of the last years[122] (namely not to take a fee) and to try on the contrary to enter into a more advantageous arrangement with his publishers in order to obtain the greatest possible sum for his charitable aim.

I happened to be in Yasnaya when the head of the Petersburg illustrated journal *Niva,* in which *Resurrection* was first to appear, arrived to arrange terms with Tolstoy. Tolstoy immediately suggested that I should join in the discussion. The managing director of the journal, a Mr Grünberg[123] (so far as I can remember) suggested to me that I should illustrate the weekly instalments in *Niva* as they were being printed. He also proposed that I should give to his journal the exclusive rights of reproduction and printing of my prospective original illustrations for *Resurrection* in Russia, leaving me the right of ownership and freedom to print abroad. Since I had no clear idea of how my illustrations would turn out, and was completely taken up with my anxiety about the artistic merit of my prospective work, I hardly paid attention to him. Mr Grünberg drew up a contract there and then. I scarcely looked at the text of the contract before scrawling

my signature in thoughtless excitement. The contract turned out to be so disadvantageous that I ever afterwards regretted it. But I no way reproach Grünberg: the blame was entirely mine. Whilst he was explaining the details of the agreement to me I was completely preoccupied with my own thoughts. A feeling of bliss and at the same time overwhelming responsibility and reverent awe at the thought of my appearing together with Tolstoy before the whole world – all this possessed me to the exclusion of any other thoughts. What were they to me, these exclusive and non-exclusive rights (I did not even understand the meaning of these expressions) and these material advantages. Only let me prove myself worthy of Tolstoy's confidence, only let me create a distinguished work of art, I thought, as I signed the agreement.

When Grünberg left, Tolstoy, having realized my stupidity, reproached me for being so impractical. He also scolded me for not having consulted him; he said that as a general rule one should not sign contracts. 'They are usually written in such a way that one side inevitably swindles the other,' he said (I don't remember his exact words, only their sense). 'A contract, as a matter of fact, is an act in which one of the parties ensures the deception of the other.'

However Tolstoy had a very high opinion of Grünberg, and of the head publisher of *Niva,* a Mr Marx, [124] whom he valued both as a man and as a publisher. Marx, a Russified German from the Baltic, was very fond of parading popular Russian sayings. Telling me about him, Tolstoy, with his kindly humour, imitated the 'pure Russian' speech of Marx and quoted some examples. 'If you call yourself a mushroom – then crawl into the belly.'* Or: 'Don't carry your own joints' (instead of 'rules') – 'into a monastery', and so on. Tolstoy laughed good-naturedly as he recounted this. Marx considered it extremely important to 'obtain the exclusive rights of ownership'. Tolstoy then told me how a young writer who was very bad and very hard up came to him and started to ask him for his assistance in getting one of his stories published and obtaining a fee for it. 'I didn't have the heart to refuse him,' Tolstoy said, 'so I promised to carry out his request. After several unsuccessful attempts I went to Marx who is a very good chap, and asked him to print it if it were at all possible and to pay the young man for it. And sure enough after a short time, back came the author from St Petersburg and radiantly reported his success: his story had been accepted! But the first condition Marx made was that he would put at the disposal of *Niva* the "exclusive rights" and he sent the appropriate agreement to the author for his signature. Meanwhile

*The actual Russian saying is 'If you call yourself a mushroom, then crawl into the basket.' – Tr.

no one would have agreed to print the story even for nothing!' concluded Tolstoy, and burst into hearty laughter.

· Marx had another bee in his bonnet, but this one in the artistic realm: every drawing had to have a 'pupil' and he judged the quality of a picture by this alone. If a portrait had a 'Pupille' (for some reason Marx used the German word 'Pupille' for 'pupil') then according to him such a drawing was good, however bad it was in fact. And, conversely, the absence of a 'pupil' on the face of the person depicted in the drawing robbed it of its value in Marx's view, however successful it might be in all other respects. This more or less limited his understanding and his ventures in the artistic field. I found this out only later when for a time I suffered not a little grief on account of these 'pupils' – of which more anon.

And so some of the most memorable and happiest days of my life were spent reading the manuscript in the daytime and conversing with Tolstoy in the evenings. My enthusiasm for what I had read was so great, and I could so vividly imagine the artistic work which lay ahead of me (I was brimming over with the desire to make a start as soon as possible at home) that, before I had read to the end of the story (what remained being only what Tolstoy had to add) and without further consideration of the difficulties ahead and the enormous responsibility, I impetuously resolved to get down to it at once. What will be, will be. . . I decided to go home to get the first sketches ready, and intended to return to Yasnaya Polyana as quickly as possible. The story, when I began to read it, was not very long, and no more than a third of what it grew to later: there was enough time to produce something sizeable and significant.

I went away to Moscow to think over the individual scenes, to make sketches, studies from life, to collect artistic material, and to visit prisons, the court, gambling dens, and so on. Incidentally Tolstoy had not been given permission to visit the prisons, but I managed to obtain a pass. They did not know that I was gathering material for the illustrations for *Resurrection*. In the meantime, further discussions and a vast, tiresome correspondence with foreign publishers were going on (my wife was extremely helpful in this) and announcements about Tolstoy's forthcoming new work with my illustrations were appearing everywhere. Since I had the foreign reader in mind I used the contents of the story sometimes only as a basis for a series of large, independent drawings; and I set myself the aim of giving as clear a presentation as possible of the peculiar Russian reality and of its types, which were unfamiliar to the foreigner and represented the range of

classes – from the very lowest to the highest strata of society – with which *Resurrection* is so richly endowed. This was the first attempt to look at illustrations not merely as the graphic adornment of a book, but also an independent monumental entity.

The artist who works in the field of the graphic arts is concerned with the concrete outward forms of the subject. His work is difficult and dangerous in that his incarnations give well-defined portrait images, whereas the characters of the literary artist, with however much precision, detail and clarity he might try to describe them, remain, when compared with the plastic portrayals, indeterminate in some way – and, within limits, the opportunity of adding in various ways to what is incompletely stated is given to the reader, depending on his personal conception.

Hence the enormous responsibility of the artist-illustrator; and it is not hard to imagine my mental state and the apprehension which preceded my début with Tolstoy. I was in collaboration with him before the whole of Russia, and not only Russia but also Europe and America, since my drawings were to appear everywhere simultaneously with the text. I would never have risked, never have decided upon such an unparalleled artistic feat, if Lev Nikolaevich himself had not wanted it, and if from beginning to end he had not sustained me like a real artist with a sincere interest in my drawings and with a sympathetic, I might even say fatherly or brotherly, attitude to my work.

Before me, there had never really been such a case, if you discount the far from analogous case of the appearance of *Faust,* which Delacroix illustrated in Goethe's lifetime. It is known from memoirs what delight was caused in Weimar when the author of *Faust* unexpectedly received Delacroix's lithograph illustrations (which, however, were executed on the artist's own initiative) for the edition of *Faust* which had just been brought out in France. If so great an artist as Delacroix was more than a little nervous when he sent his drawings off to such an author, it's not difficult to imagine me before an incomparably more difficult task – the execution of the illustrations simultaneously with the process of writing the text, and, what is more, in the immediate vicinity of the author himself, as if under his very nose!

As I mentioned already in my introduction, each one of the drawings could relate how Tolstoy held it in his hands; how he would examine it; what thoughts this or that detail would engender; what discussions, often of an artistic or philosophical character, would commence between us. Alas! I did not write down his words, but I remember something of them and I shall relate this in the appropriate place.

In Moscow I started work on the illustrations. It was a quite gigantic task, indescribably fascinating and alluring, but its seriousness and boundless possibilities depressed me at the same time.

How was I to start? I decided first of all to make sketches of the main characters in the story, and as contrasting scenes from the text I selected 'Katyusha's Morning' and 'Nekhlyudov's Morning'. I made some portrait studies, giving a graphic expression of how I imagined them, and then took my sketches to Yasnaya Polyana. What anxiety I felt before I finally resolved to show them to Lev Nikolaevich! But the awful moment came and went and was behind me, and there I was drinking in his praises, inspired by the exclamations of both Tolstoy and Tatyana Lvovna. They claimed that my Katyusha and Nekhlyudov were almost portraits of the people on whom Tolstoy had based them, people I had never seen and about whom I knew nothing. Subsequently Tatyana Lvovna did tell me who they were. In retrospect I am not altogether surprised that I managed instinctively to capture these unsuspected likenesses: Tolstoy had such an ability to paint from real life, he was such a master of real life, that it was quite easy for me to picture his heroes as though they were alive, and to produce portraits of them.

As on my previous visit to Yasnaya Polyana, I would spend the afternoons reading, and in the evenings I would walk up and down the hall with Tolstoy, discussing what I had read during the day. I told him of the things that had most caught my attention, and I described in detail my various impressions. And again we would exchange views and opinions on the various occurrences, and the human types and situations which he had depicted in *Resurrection*. Lev Nikolaevich was very interested to hear the outline sketches I gave and my 'plastic definitions', (the expressions I borrowed from the field of figurative art in order to characterize certain figures). But Tolstoy would often question me in the middle of the day, when we met either in the house or on a walk, and I would tell him my thoughts and views on some scene or other. At that time, when his work was going especially well, he was particularly cheerful and in an excellent mood. He was busy writing new chapters, and when he asked me at our meetings about what I had just read, his usual question: 'Well, how do you find it?' had a certain note of charm.

In describing Tolstoy's buoyancy and exuberance at the time of writing *Resurrection*, I would like once again to emphasize what I mentioned earlier: namely the intolerable difficulty he must have

had in renouncing his artistic creativity. The pure artist remained alive in him to the end of his days, and it was a superhuman task for him to suppress within himself that artistic instinct, that unquenchable interest in artistic creation. Tolstoy committed this act of asceticism at the height of his worldwide fame and the consequence of his renunciation was that any new line of artistic literature written by him now began literally to be worth its weight in gold. I was told that publishers in various countries, especially America, competed in their offers of fabulous fees in an attempt to procure anything whatsoever from him; they promised payment in pure gold – a substantial amount per line – in an endeavour to persuade him to write some new work of fiction for their publishing house. But of course Tolstoy turned a deaf ear to all this.

When I had made a thorough study of the available text of the still uncompleted story, I prepared several of the first illustrations on quite a large scale and sent them off to *Niva* for reproduction. In the editorial office the originals produced such a sensation that I immediately received some congratulatory telegrams: 'Never yet had anything like this', 'Exceeded all our expectations', etc. Of course I was happy and flattered, but how would the reproductions turn out? I still fretted over this question, since the public never sees the originals and they can judge only by the reproductions. The editors promised to make every effort and so on. But when at last the first pulls came through – O horror! There was nothing left of my Katyusha. Nothing remained of the expression on her face, and particularly of the look in her eyes. In these first prints from my drawings, in which I had treasured every feature of expression, there was hardly any sign of the artistry I had striven so hard to achieve. I had tried to provide not mere illustrations of some passage in some chapter or other, but powerful artistic depictions of the real life of Russia, such as Tolstoy had shown in his various portraits of Russian society – but I had laboured in vain. I was in despair. Everyone who had seen the originals was horrified by these reproductions. And those who had not seen them failed to understand how I could be dissatisfied with such splendid illustrations as had never hitherto been published.

My despair was all the greater since there was no way out of my situation. It might have seemed simple to refuse to allow them to print reproductions which so distorted my devoted workmanship, but that was the one thing I was quite unable to do. I was bound hand and foot. On the one hand I was tied down in law by the contract, and on the other hand, most important, I was morally

bound: I seemed to have some obligation to the huge masses of the reading public who were so impatiently waiting (especially in the provinces, as I later discovered) for each issue of *Niva* to appear with Tolstoy's new novel and the promised illustrations. But there was yet another consideration which restrained me from finally deciding to stop the illustrations, namely, that none of my justifications and explanations why I had backed down would have been heeded or understood by anyone. And if one recalls that for a long time before the appearance of the novel in print, *Niva* had been distributing everywhere its announcements and adverts of my participation, one can easily imagine that the journal's appearance without my drawings would have been explained simply 'because the artist was not up to the task'. Thus, willy-nilly, I had to go on bearing the agony of my public crucifixion without grumbling. However, I should say that in the first bout of despair and indignation I did send off to the editors the appropriate letter, stating my refusal to take part.

It later turned out that my sorrows were caused largely – and especially in the drawing of Katyusha – by the so-called 'pupils' of Marx. Following his normal habit and Marx's requirement that there should be a black dot for the pupils of the eyes (thus immediately changing the whole face – prominent and frightened eyes distort any soft, clouded expression), the master printer had inserted these black dots in the ready printing blocks! The editors were ready to meet any of my demands, but however much they tried, the technical shortcomings and traditions of reproduction in the journal were still noticeable in the ensuing publications. And although everyone praised and enthused over my illustrations, I alone suffered because of their poor reproduction. But how could one tell the public about those idiotic 'pupils' and the other incongruities?

I recounted these gloomy thoughts to Tolstoy. He tried every way of consoling me. He tried persuading me that I should not attach so much importance to technical failings and not pay attention to all this: 'You see, you can then show your drawings at an exhibition, and there everyone will see and appreciate them, and they will realize what a difference there is between your originals and the reproductions. And then they can be seen in a separate edition with proper reproductions.'

I can see him there now. He tried every means of comforting me, urging me not to give up but continue working. He ended with the following important words – beautiful, inspired and deeply felt (only a great artist can have this faith in his achievement which is not the work of human hands): 'Remember, Leonid Osipovich, everything will pass away. . . everything. Kingdoms

and thrones, and wealth and millions will perish. Everything will change. Neither we nor our grandsons will remain, and there will be nothing left of our bones. But if our works contain even a grain of real art, they will live for ever.'

I continued working. I decided not to withdraw – especially since new blocks had been prepared which had not been touched up at all, and were closer to the originals, so it was possible to console oneself. Meanwhile, I had completed negotiations with foreign publishers who were to print the novel and illustrations abroad, in various European countries and also in New York.

The procedure by which the illustrations were delivered was as follows: I showed the completed illustration – the original – to Tolstoy; then it was photographed; the photographic prints were sent abroad, and the originals went to *Niva*. When it had copied them, *Niva* returned the originals to me. This was a complicated procedure since the text with its illustrations had to appear everywhere simultaneously. I had an enormous correspondence with St Petersburg and abroad, and my wife's help in this was indispensable. While the text of the novel was being prepared, I was producing the requisite illustrations, and the chapter by chapter printing in *Niva* and the foreign journals began and continued without interruption. But, as I mentioned at the outset, in view of the fact that Lev Nikolaevich began adding to it, the original story of *Resurrection* grew into a large novel. In his usual way, once having started, Tolstoy could not stop, he wrote and wrote, correcting, improving, altering, inserting new passages and crossing out entire chapters that were all ready for the printers. He would send off the amended text to the editors, and the new variants would be sent in galley proof (sometimes even before they were finally approved) for me to read through and for Lev Nikolaevich to give his approval.

The weeks went by, and often there was no material ready. If there was no text there were consequently no drawings, and interruptions began to occur. The difficulties increased as the story expanded. But *Niva* kept hurrying us on – the wheels of the printing press relentlessly demanded more and more!

I hardly had time to read hastily through the proofs of the different variants and still had no idea what was yet to come, and naturally, when once the text was finally established and I could use it as a guide, there was scarcely time to produce the pictures I had planned. The performance of my task was made indescribably arduous and painful because of the journalistic haste together with the technical considerations, *Niva's* impatient demands, and

especially the exalted mood of the reading public who impatiently and with rapt attention awaited my artistic realizations of the text. I performed almost incredible tours de force, and I can hardly believe that some of the scenes, and actually the best drawings, were executed within a matter of hours. As I worked I still managed to discover suitable types and draw from nature. Then I still had to hand in my original illustrations (on very large scale – they are now kept in the Tolstoy Museum); from these a photograph was made which immediately had to be 'proofread', and the photographs had to be dispatched abroad – to London, Paris, etc. And all this time one had to hurry, hurry, hurry!

These arduous conditions, which I had not reckoned with and could never have foreseen, quite exhausted me. Doubtless, Tolstoy must have experienced the same, and the rush to make the next issue was even more irritating for him. Lev Nikolaevich became so engrossed in and dedicated to his work, so caught up by the greatness of its theme, that he could not suppress the flow of creative fantasy – it was his usual way of writing. The conditions under which such writing was done would, I repeat, have tormented any true artist – but especially such an unsurpassed master as Tolstoy, with his particularly sensitive and exacting approach to artistic work, and especially at those moments when he was dealing with the most vital questions that deeply affected him.

Understandably, my own work at times became intolerable in view of the uncertainty as to what would be left of the text the following day, or what new variants there would be, or how things were eventually planned to develop. I sometimes had the feeling that I could not survive, that there would be no end to this torment, and that I had not strength to keep pace with everything. 'I'll simply fall dead,' I thought. 'I'll not make it to the end.' I worked so hard and spent the time in such a state of constant nervous tension that I really did fall ill when the work was completed.

So far as my own work was concerned, I subsequently met some prominent people who told me that in the provinces where they had been living at the time, the arrival of each new issue of *Niva* was like the dawning of a new era – so impatiently did they await my drawings, quite apart from the actual text. 'That was what we were educated on at the time,' I was told. It does not befit me to quote here what was said about my illustrations in the press. Let me say only that the greatest satisfaction to me was when they said that I had succeeded in showing myself adequate to the author's

own artistic understanding and ideas in *Resurrection*.

In these notes I have not given a complete picture of how *Resurrection* was written – that is a task for the literary historian. Nor has it been my aim to give an exact factual account of my meetings with Tolstoy at the time when I was illustrating his novel. This would take up too much time and space. Another time, maybe, if I am still alive. . . These notes are the result of those sleepless nights when a succession of memories arose from the depths of my mind, seeking some release and evoking some long-forgotten, precious images which once seemed to have vanished for ever into the past and were now resurrected in my imagination. . . such precious images. . . dear Lev Nikolaevich. . . One memory either brought another in its wake, or else it pointed to the preceding one – they alternated like causes and effects. And in the centre of everything stands Tolstoy, immense and inaccessible, and at the same time so close and so human. It is now difficult for me to reconstruct the start of any particular conversation, but how well I remember the essence of them! How well I remember the significance and profundity of those conversations which touched on religious and philosophical questions, or on problems of art, or at other times on the insoluble conflicts of humanity at large.

Despite the frequent, unexpected, similarity of our views and tastes there were times when our opinions differed, but this only made our talks more lively and more interesting. Our discussion of scenes and characters from *Resurrection* often stimulated Lev Nikolaevich and led on to conversations and stories, sometimes in serious, sometimes in anecdotal vein. I have already mentioned that, knowing how much I enjoyed a good laugh, Lev Nikolaevich often amused me with his inimitable humour. But I also managed to cheer him too. I remember how amused he was by some of my illustrations – for instance, the one where the inspector is beseeching his daughter to stop practising some piece on the piano. He laughed quite heartily at this picture, and also at my drawing *Zakuska at the Korchagins'*, where the General is gobbling oysters. But most vividly of all I recall the impression produced on him by my illustration of *The Judge*. The benign smile which appeared on his face at first sight of the drawing gradually turned into genial laughter which I can hear ringing in my ears now. His laughter increased, the more he studied the features of the characters – especially the fat judge on the right hand side. 'Oh, how splendid! And the expression of this man, good heavens, how. . .' and the phrase was drowned in his irrepressible, genial laughter, and the drawing shook in his hands. 'Well, Leonid Osipovich, you have mocked him even more, much more cruelly than I have. That is

really cruel! Ha–ha–ha!' And then he would come out with an affectionate 'Splendid!' and lavish praise on me.

In view of the complications in his work on *Resurrection,* Tolstoy did not always manage to send the continuation in time for the regular issue of *Niva,* and there were occasions when for several weeks the journal appeared without any instalments of the novel. On the other hand, as soon as the manuscript pages were ready, they were quickly sent off to St Petersburg. There they were rapidly set up in type and the proofs were immediately sent off simultaneously for Tolstoy to correct and for me to familiarize myself with them. There were occasions when I received from the editors the proofs of new chapters in which scenes were depicted with a mastery unique to Tolstoy, and which made such an impact on me that it was difficult for me to resist illustrating them there and then, even though these were only printers' trial proofs and had not been finally approved by the author. An example worth mentioning is the text which resulted in an illustration called *After the Flogging.* It happened as follows. Having received the proofs of some new chapters of *Resurrection,* I was so struck by one of the most powerful scenes that I could not help dwelling on it and became completely absorbed in making an artistic reconstruction of it. This was the description of the flogging in prison which Tolstoy depicted with fascinating artistry and sense of tragedy. Of course, I did not draw the actual flogging, but the scene that immediately followed it, (in general I rarely made literal illustrations of particular passages, but freely selected some moment – the most interesting and most suitable for graphic depiction – some intermediate situation, preceding some scene, or else something independent but prompted by that scene). I took the original to Khamovniki (with the coming of winter the Tolstoys had moved back to Moscow again) and showed it to Lev Nikolaevich. There were the usual repeated words of praise. 'Splendid! Splendid!. . .' His voice quavered as it always did when his throat was gripped by excitement. He gazed and gazed at the picture, and there were tears in his eyes. Then, as if coming to himself and taking himself in hand, he suddenly slapped himself on the forehead and exclaimed, 'Now what have I gone and done! You know, I have sent *Niva* a request to leave this chapter out completely. Oh dear, what have I done!' The flogging in the prison was in fact one of Tolstoy's most powerful descriptions. However, the artist's rigorous aesthetic sense and his acute moral sense of love and all-forgiveness which he experienced while writing *Resurrection* had forced Tolstoy to leave out this chapter. As though

by some insight I had resisted depicting the actual flogging – this would have been counter to my artistic and human instincts – and instead I had drawn the scene which followed immediately afterwards.

'Lev Nikolaevich, please don't worry about that. It's nothing, not worth bothering about.' I tried to calm him and told him to forget the drawing which it would cost me nothing to discard. 'No, no,' he went on. 'Not for anything! We can put that right. I'll send a telegram to the *Niva* editors right away and tell them to restore the chapter I rejected.' 'For heaven's sake, don't do that, Lev Nikolaevich!' I implored him. It would have been outrageous to allow him to disrupt his artistic plans. But Tolstoy insisted. 'Oh no. We must definitely include that drawing. How splendid it is!. . . Here is my idea: I will send them a short addition to the chapter preceding the one I rejected, and in it I'll mention the forthcoming flogging. And that will justify the inclusion of this illustration in the story. But you must, you absolutely must send it to *Niva*. It is one of your best. How marvellous it is! How marvellous!' And as he said this his face bore a painfully serious expression.

Tolstoy's attitude to his own personal achievements was amazingly dispassionate and objective. Once I was showing him one of my illustrations during a session with Trubetskoi,[125] who was then teaching sculpture at the School of Painting, Sculpture and Architecture where I myself taught. Trubetskoi was modelling a statuette of Tolstoy on horseback in the School's special sculpture studio. Lev Nikolaevich came here for the sittings, riding up each time from Khamovniki and posing splendidly – all the time on horseback. I once called in at the studio. Since the novel was growing and being changed and altered, and *Niva* was sometimes late in sending me the text, I was afraid I might not have time to produce the necessary illustrations. I tried slightly to ease the difficulty by making preliminary plans for the work I would have to do, and I began asking Tolstoy, 'Will you be banishing me to Siberia soon, Lev Nikolaevich? I heard you were planning some further scenes in Siberia?' 'Soon, soon,' Tolstoy answered, 'not much remains now. You know,' he said, looking at Trubetskoi and me, 'I am now dealing with what I have written like this. . . How is it you artists call it?. . . Generally paring away. Briefly, I am discarding everything inessential, any accumulations' (as he said this, Lev Nikolaevich swept his arms away to right and left as though cutting away something unwanted, as though hacking something off). 'I am leaving it out,

leaving out everything inessential. . . Yes – soon, soon.'

Much has been written about Tolstoy's creative methods and his manner of writing. Now I remember one winter. We had met near Devichye Pole. Lev Nikolaevich was wearing a sheepskin and boots. The snow squeaked beneath his brisk steps. He was altogether lively. 'Tell me how your work is going. The same as mine? I am making very slow progress.' I do not recall what sort of answer I gave, but I do remember him complaining how difficult the creative process could sometimes be. And what struck me then as a still quite young artist was the fact that such a great writer of world renown would condescend to hold such a conversation with a beginner, putting him on a level with himself and asking, 'Are you having the same trouble as I am?'

Or there was the occasion when I arrived at Khamovniki and Lev Nikolaevich met me with the words, 'My work is going badly at the moment. I simply can't find the uplift I need – that uplift which makes creative work come easily. You must know this from your own experience as well. And in this third part I have written a lot that is completely unnecessary, quite superfluous. And then, you know, I have begun throwing out what was redundant and inessential – a few details, in order to obtain the general impression' (and again, as in Trubetskoi's studio, Lev Nikolaevich used his arms to demonstrate the act of hacking away), 'and that has improved it. Read this now. . .'

Finally the printing of *Resurrection* in the periodicals came to an end. The anxiety, the ordeal and the fears were over. But something else also ended. And it is possible that my illness was not only the consequence of physical and nervous exhaustion. It may have been a reaction to the sudden arrival of peace and quiet and to the devastating end of that blessed state which I perhaps unconsciously enjoyed through the sense of closeness to Tolstoy while he was writing *Resurrection*, during the period of our direct and constant association prompted by my work on the illustrations for his novel.

I need say nothing of the success of *Resurrection* and of the sensation produced by Tolstoy's work. But my own personal success surpassed all my expectations, and there were ample signs of it at the time in the endless flow of articles and appreciations in the Russian and foreign press.

Recently I discovered the rough draft of my letter to Valentin Fyodorivich Bulgakov, [126] and it contains the following remarks: 'I don't recall whether I ever told you that Lev Nikolaevich once

made a live drawing of me? His original drawing – a most intriguing, rare, and perhaps the only, example of what strikes me as his undoubted artistic talent (I don't seem to recall having seen any other portraits by him) – I have kept until this day as a treasured relic and memento of him. Though originally intended as a joke, this scrap of paper on which dear Lev Nikolaevich once in happy mood tried to record my features, is now a priceless object not only for me and my family; it is also certainly of interest to all who loved him and who value the slightest record of his personality. I have decided that this drawing, which was crossed out by the exacting artist's own hand, shall be a gift to you for the Museum, to celebrate its opening.'

The drawing which I gave to Bulgakov was made on the grey cover of some booklet or brochure. At the top there is an inscription in my writing: 'Yasnaya Polyana, 8th October, 1898. Drawing by Tolstoy of me (in the evening)' and also my signature. The lower half of the sheet is torn off. On it is a drawing of a woman's head with my annotation: 'Drawing by Lev Lvovich Tolstoy'. This was Lev Lvovich's portrait sketch of Tatyana Lvovna. It all happened as follows. During my visit to Yasnaya Polyana to read the manuscript of *Resurrection* we all used to gather upstairs in the white room after our day's work and would exchange our impressions of the day, chat and sometimes draw. On one such evening, after an apparently successful day's work, Lev Nikolaevich was in particularly excellent humour, he told jolly stories and was generally, as the saying goes, in top form. In addition to him, Tatyana Lvovna and myself, there was also Lev Lvovich who was staying at Yasnaya Polyana with us. Sofya Andreyevna was in Moscow. I believe I was busy drawing Tatyana Lvovna when suddenly Tolstoy exclaimed, 'Let's all draw one another!' and on the cover of the first book within reach he began to draw me. As he drew in the contours he keenly studied my facial features, and pressing down hard with his pencil, tried to convey them with swift and energetic strokes. I drew Tatyana Lvovna while she drew her father. And on the torn–off lower half of the book cover Lev Lvovich also drew his sister. Tolstoy's smile gradually changed to an expression of serious concentration. I was frightfully interested to see how it would turn out and how he would cope with the task. A few mintues later Tolstoy exclaimed, 'No, that won't do!' laughed and, before I had time to get up and look, he began crossing out his drawing of my profile since it had evidently failed to turn out as he intended. I must confess, I had not expected it – I think he must at some time have done some drawing. Of course, there was no question of it being a portrait likeness, but the drawing in itself was interesting, especially in

Tolstoy's execution. And I also treasure it because in it Lev Nikolaevich tried to make a picture of me. I decided to preserve it, so I tore off the book cover with the crossed-out drawing and took it with me as a memento.[127] Together with it I also kept two sheets with the drawings by Tatyana Lvovna. One of these, incidentally, is a very successful, splendid portrait of her father; the other is of myself and someone else made on the following evening of 9 October. These sheets and also my sketch of Tatyana Lvovna are probably preserved in the Museum, since I no longer have them. On that evening, when I studied Tolstoy as he drew, it seemed to me that I was seeing him as he must have been in his youth.

The three of us sat together – Lev Nikolaevich, Tatyana Lvovna and myself – in one of the rooms in the lower storey of the house at Yasnaya Polyana whose windows looked out into the park. It was evening. Outside there was a dull, autumn landscape with drizzle falling. Inside the room was that special atmosphere which is peculiar to the approaching twilight hours and conducive to reminiscences. We were going over the details of what I had read of *Resurrection* during the day, and as usual we were exchanging remarks about something or other I had read. Tolstoy was in wonderful spirits and kept making witty remarks and jokes, which was a sign that his writing had gone well that day. Sofya Andreyevna had gone to Moscow on business for a few days, and Tatyana Lvovna was running the household. When Sofya Andreyevna was there two types of meal were served: for some of the family they prepared exclusively vegetarian dishes, and for the rest, including Sofya Andreyevna and the guests, there was the normal meat menu. As she was about to go and see to various domestic matters, Tatyana Lvovna turned to me and asked, 'What shall I order for your dinner tomorrow, Leonid Osipovich?' I did not want them to make special dishes just for me and willingly agreed to join those who were having a vegetarian dinner. 'Tanya, you tell them to roast a young pheasant for Leonid Osipovich,' said Lev Nikolaevich with good-humoured irony. We all laughed. With his elbow on one knee and his leg propped up on a low table, he gazed through the window at the park and the wood. He screwed up his eyes as though looking into the dim and distant past, and smiled as he drawled out, 'Ah, when I was young . . . and when the Caucasus was young . . . and when the pheasants were young . . .' Then he got up from his chair and stood for a minute. He looked at us and, as though returning to reality, he gave a laugh and we all went our ways. Lev Nikolaevich pronounced those words in an unusual tone of voice, with an echo

of some bygone, splendid and distant past, and a picture of southern sunshine and colour brought to life by his memory suddenly filled the room. All this was so remarkable by its unexpectedness, so unusual and expressive, that I have always remembered both the general atmosphere that transformed the room, the particular expression on his face and his engaging words.

While in Yasnaya Polyana to familiarize myself with the contents of *Resurrection*, I was forced to break off reading for several days since I was about to go to Moscow on some business. Tolstoy apparently knew of this since he came into my room just before I left. He was in a good mood and carrying a letter. 'Here, Leonid Osipovich, if it is no trouble to you, please hand this to Sonya at the house,' (the Countess happened to be in Moscow on business). The tone in which he said this, the particular soft expression of his face and the tender sincerity in his voice – and his reference not to Sofya Andreyevna, but to 'Sonya' – were so elequent that I have always remembered them. I was flattered and moved by the fact that in handing me the letter Lev Nikolaevich considered me worthy to be, as it were, a witness to the expression of his deep and genuine feelings, and all my life I have remembered that inner light radiating from his face as he pronounced the name of his wife.

Having touched on this theme, I cannot leave unmentioned the tragedies in Lev Nikolaevich's and Sofya Andreyevna's family life, the tragedies of two people who loved one another so fully and deeply, with such perfect understanding. Outwardly, to anybody who happened to spend a short time at Yasnaya Polyana, it might have seemed that their family life right up to their old age was one of rare harmony. Both parents and children lived in mutual love and agreement, and there were – both outwardly and inwardly – all the prerequisites for a happy life. Yet both of them were involved in a serious drama. Sometimes neither of them could cope with the tragic roles which had been imposed not by fate, and not by outward circumstances; these roles were created with fatal inevitability within themselves from the totally contradictory elements in their personal make-up. I do not intend to talk about Lev Nikolevich's inner development – that is all quite well known. But how barbarously indifferent our contemporaries have been towards the extreme sufferings of that woman, arising from her complex nature, full of conflicts, and from the incredibly difficult task of being the wife of a genius who had an even more complex character with its exclusive combination of contradictory

elements. But what can one say of the so-called friends of Tolstoy who knew how dear to him Sofya Andreyevna was and how much he loved her (this nobody who knew Tolstoy would try and deny)? . . . What can one say of those people close to Tolstoy who respected and supposedly loved him, and yet who publicly abused her while Lev Nikolaevich was still alive, and thereby caused him indescribable suffering? With complete lack of tact and with the bluntness of boorish low-brows they kept invading Tolstoy's family life. And what hurt they inflicted on the relationship between man and wife! And how could these short-sighted 'disciples' follow the flight of Tolstoy's thoughts? How could they understand his volcanic temperament? How could they comprehend the immense range of his feelings for his wife and the complexity of their relationship? To describe those people who played such a disgraceful part in exacerbating the friction in the relations between Tolstoy and his wife, one must inevitably resort to a term which someone once invented, namely 'deflaters'. They strove so uncompromisingly to 'inflate' the teaching of Tolstoy that they turned it into its direct opposite and antithesis. I was told, though I have never seen it written, that there were people who at one time enjoyed the Tolstoys' cordial hospitality and were certainly not just friends of the house, but particular friends of Tolstoy's, yet later, after Sofya Andreyevna's death, they were disloyal enough to attack her in the press. Disciples of Tolstoy! It is my view that if these people, whose behaviour cannot be excused as mere stupidity, had in the slightest measure absorbed the main essence of his doctrine of love and all-forgiveness, they would have ceased trying to settle scores with her, they would have forgotten their differences with her during her lifetime, and they would have brought more joy and peace to the soul of Tolstoy in the next world than they have done with their ruthless 'discipleship' and the insults they have heaped on Sofya Andreyevna's memory.

From my own observations during my acquaintance with the Tolstoy household I must say that for all her outward similarity to hundreds of other women, especially women from aristocratic circles with their vices and virtues, she was in many respects a remarkable and prominent person – a match for Lev Nikolaevich thanks to the critical ability which she brought to her judgements about works of art, and which enabled her to help him in his literary work. She also helped him literally, as for instance, when she copied out *War and Peace* for him almost ten times. She bore and nursed thirteen children, and how much sorrow and despair she endured when they died in infancy! How much anxiety and alarm, how many sleepless nights when they were ill! How much worry, trouble and work bringing up and educating them! What

other woman of society would have renounced society's allurements as she did, when her celebrated husband occupied such a brilliant position?

Sofya Andreyevna was an outstanding personality in her own right. But women generally are more conservative, and the daily life and habits of the milieu in which she was brought up were so strong, they did not allow her to rise above certain conventions. Not only these outward fetters hindered her from reaching the heights to which Lev Nikolaevich was drawn, but something more powerful – her maternal instinct – did not allow her to abandon life's day-to-day concerns, her attachment to her children and her concern for them and their needs.

To understand this tragedy, one would have to write a complete book. One is bound to pity not only Lev Nikolaevich but also her – unstable though she was, she was also an outstanding partner and helper. Exacerbated by the complexity of relations with Lev Nikolaevich, Sofya Andreyevna's nervous and sensitive mental state often brought her to the verge of psychosis. I even believe that if treatment by psychoanalysis had existed at that time, this method would have been most successful in her case, and that it would have been possible to restore her mental balance and her broken health and in this way make life easier for Lev Nikolaevich, for the family, and for her too.

In the late 1890s I was once approached by the representative of some American religious sect. He had come on someone's recommendation and he asked me to help him collect material – he was going to write a book about Tolstoy, his life, religious aspirations, doctrine, etc. He had been sent by the monthly illustrated magazine published by his religious sect. As far as I recall, the magazine was called *Outlook*. He himself was a pastor and a writer. So on the surface it seemed fair enough. But his 'religiosity' and his status as a 'pastor' seemed slightly suspicious. The fiery colour of his hair and beard made one think of the saying: '*Rufus rare bonus, sed si bonus – valde bonus*'. When he spoke, it was just like St Francis of Assisi, especially when he talked about Tolstoy and his teaching. However, the talking was really not done by him, but by myself – he only kept on asking questions. Since I did not know him at all, I could not bring myself to give him any recommendation to Tolstoy. Moreover Lev Nikolaevich was not altogether well at that time, and this man's initial visit to Khamovniki had been unsuccessful – they would not receive him or let him see Lev Nikolaevich. Sofya Andreyevna, who protected Lev Nikolaevich, especially when he was unwell, had thought the

man looked suspicious, unsympathetic and pushing. But he was not put off by this. He 'sat on me', so to speak, and thoroughly irritated me with his interviewing. Meanwhile my water-colours of scenes from Tolstoy's life were ready, and my interviewer was thrilled with them, and before leaving for America he took them with him to send to *Outlook* for reproducing. He assured me that my fee would be sent to me immediately, and the original water-colours would straight away be returned to me. As a farewell gift he gave me his pocket Kodak camera (at that time a new one cost about thirty roubles), and that was the end of the affair. So I never saw the handsome fee which he promised for my pictures. However, I did receive from him one copy of the book. 'His' book (with my illustrations) had been put together almost entirely from my stories, impression and observations about the life and work of Tolstoy. True, at the end of the preface he did not fail to thank me for the use he had made of my assistance in compiling the text, and so on. I gave the book to the Tolstoy Museum (I believe it was called *Tolstoy's Life and Work*) and the Kodak camera I gave to my younger son. When I recall this incident, I invariably think of it as a stupid episode deserving the title 'How to Write Books About Tolstoy'!

The following incident must have taken place in 1900. I once was at Khamovniki for tea with Lev Nikolaevich, and, as always, there were several guests there. We were sitting at the table. Lev Nikolaevich was in a very good mood, and he brought from his study and gave to me the series of my illustrations for *Resurrection* which had now for the first time been beautifully reproduced. Tolstoy told me he had only just received this set from Chertkov in London. This was Henderson's London edition of 1900.

Of course I was very pleased by the illustrations – they were incomparably better reproduced than in St Petersburg or anywhere else to date (and none of the subsequent illustrated editions of *Resurrection* contained such impeccable reproductions).

'Well, let's examine you,' said Lev Nikolaevich. 'Let's award marks for each drawing! Alpha plus for this one . . . and for this one too. For this one, perhaps alpha,' and so on. And he immediately began pencilling in on each reproduction how many marks he thought it deserved. To my delight, with few exceptions almost all the drawings received highest marks. All these reproductions with Lev Nikolaevich's marks on them are now in the Tolstoy Museum in Moscow.[128]

I was at the Tolstoys' in Khamovniki and was already preparing to leave when it turned out that Lev Nikolaevich also needed to go into town, so we left together. Walking along past the two or three buildings in the lane where the Tolstoys lived (one of them, I believe, was a factory or a brewery), I failed to notice that Lev Nikolaevich had stopped behind while I went on talking, thinking he was still walking alongside me. Suddenly he gave out a strange noise, as though exclaiming in surprise. I immediately looked round and saw that Tolstoy had stopped by the window of a house which we had just passed. I went up to him. Lev Nikolaevich was standing in front of a window, beaming and engrossed in the spectacle before him. It turned out to be two monkeys in the window and Lev Nikolaevich was exchanging glances with them, just like we all used to do when we were children. His eyes lit up in a smile. 'There they are – our ancestors! How splendid they are!' he said, and for a long time we could not tear ourselves away from the curious spectacle of the monkeys somersaulting in the window. Then we went on, continuing the interrupted conversation. But for some reason I have vividly remembered that insignificant incident. It is one link in a chain of observations which have led me to conclude that all remarkable, outstanding, creative people have one feature in common – an almost childlike view of the world, as though encountering its phenomena for the first time; combined with this eternally youthful readiness to react to one new revelation after another there is also what I would call a merry, childish gleeful curiosity that reaches out to make contact with all living things. Surely this is a true sign of the sensitivity of a creative spirit that takes an interest in all phenomena in the world about us!

Only this constant attraction towards the slightest manifestation of the world's vitality can explain the fact that Tolstoy, whom we all picture as serious and concentrated, harsh and severe, and removed from anything petty – that this forbidding figure was charmed with such childlike immediacy by anything touching or comical.

Tolstoy had a natural love of humour and jokes, and he was a splendid reader of humorous stories. I remember how one evening at tea he read something by Aleksei Tolstoy (I forget the exact title of the work – I thing it was *The Manager's Reception*) and he read the amusing passages with such a sense of comedy that we were all rolling with laughter. Knowing that I will react to anything funny, Lev Nikolaevich often used to amuse me with anecdotes, comical stories, and amazed me with his superb gift of imitation. But this

always had a certain note of geniality, and his witty or ironic remarks never turned into the poisonous sarcasm of people who 'are cold or cruel.

During our walks up and down the white room, we used to talk about the most varied subjects. I once remember we touched on the art of Charles Dickens. How I regret now that I did not know him better at that time! Some twenty years later my son Boris gave me Dickens's *Tale of Two Cities*. As I read it I relived those unforgettable hours at Yasnaya Polyana and Tolstoy's enthusiam when he talked about Dickens was revived in my memory by the images in *A Tale of Two Cities*. However, I do not even know whether he had actually read this work – I remember vaguely that he talked about *Little Dorritt* and his other books. If only I could then have shared with him my enthusiasm for Dickens's immortal masterpiece!

Sometimes our discussions had a more professional character. We talked about the different possible ways of depicting the qualities of various human types. Thus, I recall that on the subject of Katyusha we both remarked in unison that one peculiarity of hardened drinkers like Katyusha is their swollen eyes, and there were other similar observations of this sort.

Naturally, from time to time we would discuss art. In general Tolstoy seemed to have a great love for the representational arts. And he not only loved them, but also expressed such understanding and refined taste that it was a pleasure to hear his opinions on the subject. Tolstoy's preference was for drawings, and painting did not interest him so much: 'such rich, broad and heavy gold frames'. Yet I recall that when we were once looking through a book on the history of art with monochrome reproductions, we both thought there was something missing. The splendid photographs of the pictures did not completely satisfy us. Tolstoy remarked that 'there is something absent, something essential . . .' 'And that is the colour that complements the form!' I added. Without the colours even those splendid reproductions struck us as somehow lifeless.

I will say some more about Tolstoy's views on art elsewhere in connection with one of his stories which I illustrated in the year 1904.

In 1901 the Musée Luxembourg[129] in Paris commissioned five Russian artists – Repin, Serov, Korovin, Malyavin and myself – each to paint a picture showing Russian life for the museum. As

the most interesting Russian subject I chose Tolstoy in family surroundings, and I executed the picture in pastel by artificial light in the evening. Before its dispatch to Paris the picture was exhibited at the 'World of Art' exhibition in St Petersburg, where Grand Duke George saw it and tried to acquire it for the museum of Alexander III. Flattering though it was for me to be associated with the best Russian artists selected by the Musée Luxembourg, I preferred the picture to stay in Russia, and I consoled myself with the thought that one of my pictures, *On the Eve of the Examinations*, was already in the Musée Luxembourg, for which it had been acquired by the French government at the Paris World Exhibition of 1900. Incidentally, so far as I recall, the commission to the other four artists was not carried out either, but I have no idea why.

So I started doing the studies and sketches for my picture *Tolstoy in His Family Circle* whenever an opportunity presented itself – on walks, at work, or when we were gathered in the drawing-room after tea in the evening – in order not to bother Lev Nikolaevich with having to pose specially. He was always very kind and considerate, and he himself suggested sitting whenever he was free, and came up to the white room after work: 'Well, how would you like me? How do you want it? Like this, I think? . . .' and he would sit down, taking up roughly the same position as when I had sketched him the day before. His exclamations such as 'How cunningly he's managed the back of my neck!' etc., were highly amusing, but unfortunately I did not note down all his live comments while he was looking at my sketches.

I was so absorbed in my work and observed Lev Nikolaevich and his surroundings so intently from an artistic standpoint, from the plastic, compositional point of view, that the incidentals only spring to mind now as isolated fragments. Here are a few scenes relating to that period, set mainly in Yasnaya Polyana.

In my monograph there is reproduced a sketch with *two* Tolstoys. This happened in the following way. In the evening Lev Nikolaevich had the habit of coming upstairs to the white room to look at his post. He had only just entered the room and gone over to the table where Tatyana Lvovna was sitting sorting out the mail into piles. Sofya Andreyevna usually sat working at the round table by lamplight – she would be sewing something. It was a picturesque group and I sketched it down. But I had hardly time to finish when, without noticing that I was drawing him (only then does a sketch have that natural, 'unposed' appearance), Lev Nikolaevich left the table and sat down as usual on the opposite side of the table to listen to letters from all over the world which

Tatyana Lvovna always read to him. I immediately drew Lev Nikolaevich again, as he usually sat. I liked this intimate group very much, and I took the sketch as the basis for the picture which I planned for the Musée Luxembourg. I gave this live drawing, the first sketch with the 'two Tolstoys', to Sofya Andreyevna, and it is now probably kept in the Tolstoy Museum. [130]

One fine sunny morning Lev Nikolaevich was sitting with me on the balcony while I finished my breakfast. I was in a bright and happy mood, matching that sunny morning. My joyful mood was all the greater because of our forthcoming – and what I believe was our first – session of painting Tolstoy's portrait from life. Lev Nikolaevich was also in good spirits and we were talking peacefully. Suddenly from the direction of the entrance to Yasnaya Polyana we heard the bells of a troika which, instead of drawing up to the house, stopped half-way. Through the small birches we saw an elegantly dressed gentleman get out of the hired carriage. Apart from the fashionable suit which contrasted quaintly with the natural beauty and the peace of that morning, the top hat perched on his head produced a particularly comic and outrageous impression. From afar I saw clearly by the whole silhouette that this 'Parisian'[131] was in fact my compatriot. Before reaching the house he greeted us, taking off his top hat and bowing in our direction. But from the way he was holding a sealed envelope in his hand I knew already that I was in for some unpleasantness and my spirits fell immediately.

It turned out that a close friend of mine had found out, obviously from the papers, that I was a guest at Yasnaya Polyana. When the 'Parisian' learned of this, since he evidently knew him, he decided that a rare opportunity had presented itself and pestered my friend for a letter which he would then give me – 'And everything can be fixed when I'm acutally there . . .'

When he handed me the letter I hastily read it and reproached the newcomer for his lack of tact in turning up without first asking the owners whether he might come to Yasnaya Polyana and without enquiring whether Lev Nikolaevich would be willing to pose for the bust which he apparently wished to make. And the worst thing was that it all looked as if the 'Parisian' and I had agreed in advance craftily to exploit my presence in Yasnaya Polyana (whereas I did not even know him) and so on and so forth. Moreover, one would have to find out whether there was room to put him up in the house. He said 'I'm already fixed up with some peasant in the village and . . . Well, I've clearly failed . . . *Qui ne risque, ne gagne pas.*' He was speculating on the likelihood that Tolstoy's good breeding and kind-heartedness would eventually cause him to give in. But for the time being he began modelling a bust of Sofya

Andreyevna. On the second or third day after his arrival, Lev Nikolaevich was going to his room after breakfast when he said, 'I'm going to my room now to work, and Leonid Osipovich is drawing me in profile from the side – perhaps you can arrange things somehow so that you can use the opportunity as well.' In short, no matter how inconvenient this was for Lev Nikolaevich and myself, '*qui ne risque . . .*' His idea was that 'if chased from the door, you go in at the window'. However, the final result was in fact one of those quite good busts of Tolstoy which are now in the Tolstoy Museum.

Incidentally, it is perhaps worth mentioning here that an artist should never listen to the advice of other people. I remember that when he was modelling the bust of Sofya Andreyevna, people from the household kept coming up and saying, 'Oh, the nose is too large.' The sculptor took note and reduced the nose. But then another member of the family came up and said, 'The nose is too short.' So he lengthened the nose – and the bust would simply not turn out right.

Once before dinner we were in the garden, sitting in the shade at the ready laid table. Among the guests I remember there was Tsinger. It was a heat wave. Lev Nikolaevich arrived from his walk, carrying his stick and wearing a white shirt. His summer smock was slung over his shoulder and on his head was a curious straw hat. 'It's amazing the hypnotic effect that Shakespeare man has!' he exclaimed, and came out with a merciless criticism of Shakespeare (unfortunately, I cannot now recall his exact words). Sofya Andreyevna said, 'Lyovushka, you're only saying that in order to be contrary and for something new to say in the face of world opinion!' And in this vein she quite frankly and candidly expressed her own ideas and opinions, as usual, without any shyness in front of the onlookers.

A few years after the appearance of *Resurrection*, the Commission for the Procurement of State Papers approached me with a request to contribute to a series of popular illustrated editions. This Commission was famous for its splendid reproduction studios – the best in the country for art reproduction and printing – and starting with Repin, Serov, Benois, etc., the best Russian artists had contributed to their series.

I cannot help smiling when I recall this 'cultural enterprise' by the Ministry of Finance, which was based on the state vodka monopoly! It was planned to bring out a cheap mass edition of popular stories by our greatest authors with beautifully reproduced illustrations. This was conceived with the aim of campaign-

ing against drunkenness. Founded on a priceless contradiction, the whole venture consisted in the following: anyone buying a bottle of vodka from the 'Official Monopoly Shop', or vodka store, could also obtain there for two or three kopecks a splendid story with lovely illustrations. This was intended as a 'cultural weapon' in the campaign against nationwide drunkenness; and in this way the vodka drinker was thus assisting the campaign against vodka drinking!

The edition was prepared and it probably cost a lot of money, but for some reason it never appeared.

I chose to illustrate what I considered as the best of Tolstoy's folk stories, 'What Men Live By', and I made several drawings to fit the text. These are perhaps the best of my illustrations. Here is a list of them:[132]

1) *The Freezing Naked Angel and the Cobbler*;
2) *Supper at the Cobbler's*;
3) *Mikhailo and the Merchant*;
4) *The Russian Madonna (the Young Woman and the Orphans)*;
5) *General Scene* – Landscape (believed lost).

The originals were later bought by Sveshnikov for his collection. Then they went to the Rumyantsev Museum, and later to the Tolstoy Museum. I naturally wanted to show them to Tolstoy and hear his opinion. But in order not to take up too much of his time writing a reply, I sent him some very good reproductions of them (the originals were with the printer) and I asked him to use his normal method of assessment, to award marks and write them on the drawings. In general, throughout the period of my acquaintance with him, I avoided correspondence in order not to bother him with having to reply, and also so that outsiders could not accuse me of collecting autographs. Imagine my joy, however, when I received from him not a 'silent' set of marks, but a very warm letter in which among other things he wrote the following:

'Thank you for the drawings you have sent. I particularly like two of them: *At Supper*, and especially the face of the woman – that is worth an alpha plus. Full marks too for the last drawing of the *Woman with the Two Little Girls*. The *barin* is also good – what difficulty he is having pulling out his foot! I was less satisfied with the first one because the body of the angel is too physical. It is true, it is an impossible task to draw an angel in the flesh. Similarly, in the drawing of the cobbler – too physical. But altogether it is splendid, as all your drawings are, and I am grateful to you for them.'

Of course Lev Nikolaevich was right when in 1904 he found it an impossible task to depict an angel 'in the flesh'. Nevertheless (the story was written in 1881), Tolstoy did depict an angel 'in the flesh', just as in general he liked depicting the body wherever opportunity allowed before his spiritual crisis. In this case Lev Nikolaevich showed the angel in human form in a very artistic and realistic manner which inspired me as an artist. At first the cobbler sees in the distance: 'It's like a man, but it's slightly white . . .' – but in the language of the painter a body does 'glow' in the air, precisely what Tolstoy tried to express in the words 'it's slightly white!' Later, moving nearer to look closer, the cobbler sees 'a *young* man, *powerful*, not a mark on his body . . . He leans as he sits. Semyon takes him by the arm and he sees – he has a *fine pure body* . . .' etc. In short, despite the miraculous, supernatural element in the story, Tolstoy as a great artist depicted the angel not in the way people normally draw angels – little wings and no body. He showed it in such relief and so close to nature ('pure', 'not a mark' and 'white') that I was quite enthralled by this treatment of the angel and by the possibility of drawing the naked, young body realistically, plastically and 'physically', with strong general form.

During my talks with Lev Nikolaevich about art I spoke with complete candour and disguised none of my views on the plastic arts, especially painting. I talked of my enthusiasm and veneration for ancient art – the arts of Egypt and Greece, for the drawing, painting and sculpture of the Renaissance, and for the divine beauty embodied with such perfection in human forms by such as Raphael, Titian and Michelangelo. I remember there were several of us once sitting with Tolstoy in the garden. We were having an argument about art, and Lev Nikolaevich turned in my direction, waved his hand and smiled, saying, 'But you, I know, are a heathen . . .' Sometimes he would also jokingly reprove me because of some artist or other. In our conversations about modern art I recall his disapproving remarks about some of them – 'You and your Puvis de Chavannes!' he said.

Problems of representative art always interested Lev Nikolaevich, especially in the period when he was engaged on his article called 'What Is Art?'

One day I came to see the Tolstoys at Khamovniki after lunch (I don't recall on what matter). Lev Nikolaevich was sitting at the table, and opposite him was Mathé, the well-known engraver and professor at the engraving studios of the Petersburg Academy of Arts. He was a very kindly and benign man, and I knew him already, having met him earlier at Serov's. Sitting between them,

to one side by the window, was S–[133] with his big white beard, the celebrated art critic who in Petersburg journalist circles had been christened the 'Trumpet of Jericho' because of his loud, rough voice. While Mathé sat there with a pad, silently sketching Tolstoy, an animated conversation was in progress between the two impressive and colourful old men. What a contrast it was – Lev Nikolaevich side by side with S–! The former's soft, almost tender voice and the nobility of his tone, his speech and his whole figure, compared with the 'militant tribune' and his coarse rattling off of sterotyped phrases! I arrived when the conversation was already coming to an end. Apparently S– had been attacking Grigorovich[134] for his official attitude and status (Grigorovich was, I believe, the chairman of the Petersburg Society for the Encouragement of the Arts). He also attacked Grigorovich for depicting in his books not the common people, but 'landscapes' and the like. To this Lev Nikolaevich was objecting (I do not remember his exact words, only the general drift) that he valued Grigorovich highly and loved him precisely for his dedicated promotion of the Russian *muzhik*, and for Lev Nikolaevich this was more important than any of the modern supposed imitations of popular speech and dialect. One sensed no great love for the Russian *muzhik* in the latter.

But Lev Nikolaevich gained even more, and an aura of sympathy and love for mankind almost glowed about him when he began to talk in his penetrating, melodious voice about one particular story by Maupassant which had evidently struck him by its profundity. In the story two friends are playing billiards, then they begin to talk and one of them tells the other about his love. Lev Nikolaevich's voice began to crack, he could not finish what he wanted to say, and tear after tear began pouring down his face. Now, I know that opponents of Tolstoy have spoken rather ironically of his propensity for weeping. But I must say that I, on the other hand, was gripped and deeply moved by the genuineness of his pity, his fear of causing hurt and by his sympathy. I felt that his weeping was the sign of an aching heart.

The remarkable thing about Tolstoy was that his exceptional gift of sympathy and constant readiness to share other men's sorrow never degenerated into superficial sentimentality. His compassion and sensitivity never hindered him from showing his natural *joie de vivre*. I have already mentioned his childlike capacity to rejoice and the occasional youthful spontaneity of his reaction to various things that occurred. But he was not only young in heart. Despite his age, he was also physically a powerful, healthy and robust man. I remember, for instance, that during our walks, despite the fact that he was more than thirty years my

senior, he sometimes strode on merrily when I was already feeling tired. And I have also mentioned the fact that it was impossible in one's imagination to associate the colossal stature of Tolstoy's figure with the kind and charming old man who was always ready for a joke. And only the reality convinced those of us who witnessed it that this rare harmony was indeed possible – that the genius and dedicated teacher of mankind were identical with this sincere, witty and charming man. He was so sociable, so unpretentious with me that I had an immediate sense of being included in his entourage, and I was filled with tenderness and gratitude for this. No doubt, Lev Nikolaevich also sensed this. He could read my heart as he could everybody else's, and my heart was full of rapture and love for him.

Among some old letters and papers I have found a note which I made while under the immediate impact of what I had experienced, and I am going to reproduce it below:
'Saturday, September 19th, 1909.

Today I have experienced some moments of deepest bliss, and feelings of spiritual happiness and pride. Today I have seen an indescribably touching, sincere, spontaneous and rapturous welcome and farewell shown to the greatest writer alive in the world today.[135] I have witnessed the surge of popular affection for him, and the people's own spiritual glory and pride. A wave of heartfelt excitment welling up within me constricts my throat and I cannot restrain my tears.

This fascinating spectacle was an historical moment in the cultural life of our country that is repeated perhaps only once in a century. What nobility of bearing, what beauty and purity of soul radiated from this splendid, white-bearded old sage! How sudden this flash of greatness and importance against the dark background of the many thousands crowding to greet him! . . .

I have seen a spectacle of rare and noble beauty, the impulsive manifestation of love and the rapture of masses of young people thronging to meet him. I have seen thousands with shining eyes and hearts a–flutter waiting for Tolstoy with feverish impatience, as for a great spiritual guiding light – thousands of people who, perhaps for the first time in a grey, monotonous existence, were granted a few moments of transforming human joy and soaring spirits. The crowd waited, gazing intently into the distance. But then Tolstoy appeared in the approaching carriage. Gazes filled with joy and pride were directed at him as though towards some source of light. And the crowd gave a start and moved towards the light, and a powerful wave of rapture swept over those waiting and

raised them to a state of ecstasy that united them as one. Cries of delight and love and shouts of welcome escaped from breasts no longer able to restrain the overwhelming happiness. The wonderful, shining white head was bared and gracefully responded with several deep bows. He was visibly moved and the tears glistened on his face.'

(Leonid Pasternak's notes on Tolstoy break off at this point. However, his rough notebooks were found to contain several lines which suggested that he intended writing a conclusion to his memoirs. But either he never had time for this, or else he found it too painful to write of that dreadful twentieth day of November, when a telegram summoned him to see Tolstoy for the last time, to draw him as he lay on his deathbed. These lines, which are so full of meaning and suggest how Pasternak intended to complete his notes, are printed below – *Josephine Pasternak*.)

Must write here about Sonya and the tragedy of Lev Nikolaevich. Death, death–mask, Mikhailo. Trip with Borya to Astapovo.

Astapovo. Morning. Sofya Andreyevna at his bedside. The people's farewell. Finale of a family tragedy.

Commentary

Meetings with Lev Tolstoy . . . In accordance with Leonid Pasternak's frequently expressed wish, the account of his meetings with Tolstoy has been put in a separate section. The author intended these notes as material worked out by himself for special publication as a separate book of 'Reminiscences about Lev Tolstoy'. Tolstoy had many friends among Russian artists. Kramskoi, Gué and Repin visited Yasnaya Polyana, corresponded with Tolstoy and left their own reminiscences of meetings with the great writer. Tolstoy's friends and admirers also included Leonid Pasternak. The young artist was introduced to him in 1893 at a Wanderers exhibition in Moscow. On that occasion Tolstoy invited Pasternak to Khamovniki (this was the name of Tolstoy's house in Moscow in Dolgokhamovnichesky Lane). In autumn of 1898, Tatyana Lvovna Tolstoya passed on to Pasternak an invitation to go to Yasnaya Polyana to discuss the illustrating of

Resurrection. In November of that year Pasternak took to Yasnaya Polyana the first sketches for the drawings, which Tolstoy found to be splendid. Pasternak stayed as a guest at Yasnaya Polyana in 1901, 1903 and 1909, and there produced the sketches of Tolstoy and members of his family. On the basis of these he created a series of portraits of Tolstoy. On 7 November 1910, having received news of Tolstoy's death, Pasternak went to Astapovo together with his son Boris. There he made his last drawing of Tolstoy on his deathbed. Extracts of Leonid Pasternak's memoirs of his meetings with Tolstoy have several times been published. See: L.O. Pasternak, 'Kak sozdavalos' "Voskresenie" ', pub. N.N. Gusev, in *Literaturnoe nasledstvo*, Nos. 37–38, vol.II, Moscow 1939; also in the book *L.N. Tolstoi v vospominaniyakh sovremennikov*, vol.II, Moscow 1960; 'Moi vstrechi s Tolstym', pub. E.G. Babaev, *Literaturnaya Rossiya*, 19 November 1964; 'Dve vstrechi s Tolstym', pub. E.G. Babaev, *Uchitel 'skaya gazeta*, 19 January 1965; 'Moi vstrechi s Tolstym', pub. E.G. Babaev, in *Yasnopolyansky sbornik*, Tula, 1968. Concerning Pasternak's visit to Astapovo with his son Boris, see: Boris Pasternak, 'Lyudi i polozyeniya', *Novyi mir*, 1967, No.1. The State Tolstoy Museum has a large collection of pictures and drawings by Leonid Pasternak: twenty-eight portraits of Tolstoy, eight portraits of members of Tolstoy's family and persons close to him, five illustrations for *War and Peace*, forty-four illustrations for *Resurrection*, and six illustrations to the story 'What Men Live By'.

Notes to the Text

1. *Asya* The artist's younger sister who died during the Leningrad blockade.
2. *Grützner E.* German genre-painter. His paintings, particularly those of monastic life, displayed a subtle humour.
3. *Gigout G.F.* French Romantic painer, lithographer, illustrator.
4. *Marzli G.G.* Mayor of Odessa (1878–95). During the 1890s he was vice-president of the Odessa Art Society.
5. *The Beacon* Literary and artistic magazine (supplement to the newspaper *The Odessa Herald* 1881–5). Published by P.A. Zeleny.
6. *The Little Bee* Weekly political and literary newspaper in Odessa, and later humorous literary and political magazine (1881–89). Published by V.K. Kirchner, edited by V.V. Navrotsky.
7. *'Felitsa'* The poet G.R. Derzhavin was the personal secretary to Empress Catherine II. The ode *'Felitsa'* was written in her honour.
8. *The Odessa School of Drawing* Founded in 1865 by the Odessa Fine Arts Society which relied on donations for its existence. From 1886 onwards its pupils were allowed to enter the Academy of Arts without taking exams and the School fell under the jurisdiction of the Academy.
9. *Morandi F.O.* Architect. Commercial director and organizer of the Odessa School of Drawing.
10. *Braz O.E.* Painter and draughtsman. After graduating from the Odessa School of Drawing he studied in I.E. Repin's studio at the Petersburg Academy of Arts and later in Munich and Paris, where he died in 1928.
11. *Ladyzhensky G.A.* Painter (water-colours). Studied at the Petersburg Academy after graduating from the Odessa School of Drawing. Lived and worked in Odessa from 1882 onwards. One of the founders of the 'Society of Southern-Russian Artists'.
12. *Kishinevsky S.Ya.* Ukrainian artist and genre-painter. Studied at the Odessa School of Drawing and the Munich Academy. Member of the 'Society of Southern-Russian Artists'.
13. *Britzzi V.* Artist. Fellow student of Pasternak at the Odessa School of Drawing, thereafter living abroad, mainly in Italy.
14. *Iorini L.D.* Sculptor. Born in Italy, lived and worked in Odessa. One of the first and oldest teachers at the Odessa School of Drawing. Member of the 'Society of Southern-Russian Artists'.

15. *Molinari M.L.* Sculptor. Exhibitor at the 'Society of Southern-Russian Artists' Exhibitions.
16. *Bauer A.* German historical painter, akin to the 'Nazarene School'. One of the first teachers at the Odessa School of Drawing. Honourable member of the Petersburg Academy of Arts (from 1875 onwards).
17. *Nazarene School* Union of German artists (I.F. Overbeck, P. Cornelius, U. Schnoff von Karlsfeld and others) founded on the model of a monastic commune in Rome (1810–20). Its members dreamed of a revival in monumental religious art and painted pictures on biblical themes, imitating Raphael and old German painters. Their work in the areas of portraiture and landscape was more original.
18. *Trutovsky K.A.* Artist and genre-painter. Inspector at the Moscow School of Painting, Sculpture and Architecture (1871–81).
19. *Vipper R.Yu.* Teacher of general history at the Moscow School (1881–94).
20. *Light and Shade* Artistic magazine featuring caricature (1878–84). Published by N.L. Pushkarev.
21. *The Alarm Clock* Moscow satirical magazine featuring caricature. First edited and published by N.A. Stepanov who had previously contributed to the magazine *The Spark*. From the mid-1870s until 1894 it was published by A.P. Sukhov but Stepanov remained editor. During the 1880s, as a result of strict censorship, the magazine lost its former pungency.
22. *Verbel A.* Native of Odessa. Painter. Student at the Munich Academy of Arts. Contributed drawings to the magazine *The Little Bee*.
23. *Herterich I.G.* German genre-painter and painter of historical scenes. From 1884 professor at the Munich Academy.
24. *Piloti K. von* German painter of battle scenes. Studied at the Munich Academy of which he was later director.
25. *Litsenmeyer I.* German artist and draughtsman.
26. *Gizis N.* German artist and genre-painter, towards the end of his life working in the area of monumental art.
27. *Marold L.* Czech artist, genre-painter and draughtsman. Studied at the Munich Academy. Worked in Paris.
28. *Kuznetsov N.D.* Portrait artist, genre-painter and painter of battle scenes. Took part in the Wanderers' exhibitions from 1881. One of the founders of the 'Society of Southern-Russian Artists'. Professor and instructor in battle painting at the Academy of Arts (1885–97).
29. *Blanc et Noir* The name given to three Petersburg exhibitions featuring the different techniques of drawing: pen, pencil, Indian ink, *gouache*, lamp-black, needle and inks, and also oil paints on paper. The first exhibition was organized in 1890 by the famous water-colour painter Albert Benoit. The second and third exhibitions took place in 1892 and 1898 respectively. Artists with different creative aspirations took part in these: Pasternak, V. Vasnetsov, Repin, Surikov, Arkhipov, Ryabushkin, Vrubel, Kustodiev.

30. *Shchukin S.I.* Moscow merchant and collector of new painting, mainly French. Subsequently his collection became part of a museum of New Western Art in Moscow, and then of the Museum of Fine Arts.

31. *Shanks E.Ya. and M.Ya.* Both sisters studied at the Moscow School of Painting, Sculpture and Architecture. E.Ya. Shanks was V.D. Polenov's pupil. During the 1890s she took part in the Wanderers' exhibitions and in 1894 became a member of the Wanderers.

32. *Shcherbinovsky D.A.* Painter. Studied under V.D. Polenov at the Moscow School of Painting, Sculpture and Architecture.

33. *d'Andrade A.* Portuguese opera singer of the Italian repertoire. In the 1880s and 1890s he sang in opera houses in England, Germany, Holland and Russia. Although Leonid Pasternak sat for Repin, it was actually L.F. Verevkin who posed for the picture *Don Juan and Donna Anna*. There are also indications in literature dedicated to the artist that the model for Anna was M.F. Andreyeva.

34. *Tenisheva M.K.* Princess. Patron, interested in ornamental and applied arts. Collector of drawings by old and contemporary artists. Dabbled in painting, taking lessons from Repin. She founded schools of art in Smolensk and Petersburg (Repin taught at the latter for a short time).

35. *Slevogt M.* German painter and draughtsman, one of the last exponents of Impressionism. He was also an illustrator and painted portraits and landscapes.

36. *. . . dear cousin* The author has in mind K.E. Pasternak who was normally resident in Vienna, though at the time referred to, he was spending a few years in Moscow. Took part in various philanthropic societies in Moscow where he also had business connections.

37. *The Cricket* Literary and artistic magazine, published by M. Freudenberg.

38. *The Artist* Monthly magazine, featuring theatre, music and art. Published in Moscow by F.A. Kumanin from 1889–94.

39. *Storozhenko N.I.* Literary historian. Professor at Moscow University. Chairman of the Society for Lovers of Russian Literature.

40. *Veselovsky, A.N.* Literary historian. Author of a series of articles on music. Professor at Moscow University and the Lazarevsky Institute of East European Languages.

41. *Sollogub F.L.* Amateur artist, water-colour painter and illustrator. Close to Stanislavsky and the 'Society of Lovers of Literature and Fine Arts'. Formed the original company of the Moscow Arts Theatre. Amateur artist and theatrical artist.

42. *Baltrushaitis Yu. K.* Poet and translator, associated with the Moscow Symbolist group, the magazine *Scales*, the literary miscellany *Northern Colours* and the publishing house *Scorpion*.

43. *. . . Museum* The State Theatrical Museum named after A.A. Bakhrushin.

44. *Garkavi V.O.* Moscow barrister with whom Pasternak became acquainted after moving to Moscow. His daughter studied drawing in

Pasternak's private school.

45. *Shaikevich S.S.* Barrister, amateur artist, collector of works of art, mainly engraving from abroad. During the 1880s he settled in Paris where he later died. The drawings from his collection were acquired by I.E. Tsvetkov.

46. *Shtember V.K.* Painter. Day-boy at the Petersburg Academy of Arts. Took part in exhibitions of the 'Society of Russian Water-Colour Painters', the 'Petersburg Society of Artists', the 'Moscow Society of Artists' and the Wanderers.

47. . . . *Yuon, Mashkov.* K.F. Yuon's School was founded in 1900 (with I.O.Dudin) and continued until 1917, and I.I. Mashkov's functioned between 1908 and 1917.

48. *Serov V.A.* He taught in the Moscow School from 1897 until 1909; I.I. Levitan – from 1898 to 1900; A.M. Vasnetsov – from 1901 to 1912; A.S. Stepanov – from 1899 to 1914; K.A. Korovin – from 1901 to 1918.

49. *D. Burlyuk . . . his Petersburg lecture* Lecture entitled 'Pushkin and Khlebnikov', delivered 3 November, 1913.

50. *Schulté* Exhibiting salon and picture gallery in Berlin.

51. *Galen Kalela Axel Voldemar* Finnish painter, poster-artist, illustrator and engraver.

52. *Dead Bruges* After Rodenbach's novel of the same name, very popular at the end of the nineteenth century.

53. *Struck H.* Painter, engraver, illustrator, art critic. Studied at the Berlin Academy of Arts. He travelled widely in Europe in the interests of self-education. After the First World War he settled in Palestine.

54. *Lenbach F.* German high-society portrait-artist.

55. *Constant G.G.B.* French portrait-artist whose work enjoyed considerable success.

56. *Sargent J.S.* American painter, mainly of portraits. Also did some genre and monumental painting and sculpting. Lived in England for a long time.

57. *Triumph of Death* (Trionfo della Morte) It was probably the plague which swept central Italy in 1348 which provided the inspiration for this fresco in Campo Santo (covered cemetery in Pisa). Nowadays it is considered to have been completed around 1360 by artists from Bologna.

58. *Cohen H.* German idealist philosopher, head of the Marburg School.

59. *Karpov L.Ya.* Academic, chemist. One of the organizers of the Soviet chemical industry. Prominent agent of the Bolshevik Party.

60. *Harnack A.* German historiographer of Christianity. Professor in Leipzig, Berlin, Giessen, Magdeburg. Harnack's writings were centred mainly on the history of early Christianity and the early Christian Church.

61. *Corinth L.* German painter and draughtsman, belonging to the late Impressionists. Studied at the same time as Pasternak at the Munich Academy of Arts. In 1927 they painted each other's portraits.

62. *Liebermann M.* German Impressionist painter and draughtsman.

Founder of the Berlin 'Secession' in 1899. Professor, president and honorary president of the Berlin Academy of Arts. As a non–Aryan he was removed from his presidency during the Nazi régime and prevented from taking part in exhibitions. His works were also withdrawn from museums.

63. *Hauptmann G.* German dramatist and novelist whose work extended from Naturalism to Symbolism.

64. *Kogan A.E.* Publisher and editor of the monthly artistic magazine *Jar-Ptitsa*, 1921–4. A special issue, dedicated to the work of L.O. Pasternak, was published in 1923. The author of the article was the famous critic and expert in the field of contemporary art, Max Osborn, and there were many colour reproductions (there were also reproductions of Pasternak's work in other issues during the three years of the magazine's publication).

65. *Suritz Ya. Z.* Soviet diplomat from 1918 onwards. Ambassador to Germany 1934–7; ambassador to France 1937–40.

66. *Stybel A.* Cultured Polish businessman, publisher and collector. Close friend of the Pasternak family. Pasternak is referring here to Max Osborn's monograph *Leonid Pasternak* published in Warsaw in 1932 by the Stybel Press in which four autobiographical fragments appeared together with about 150 illustrations.

67. *Sitin I.D.* Moscow book-dealer, founder of the largest publishing association in pre-revolutionary Russia.

68. *Vidgoff D.O.* Native of Odessa, studied in Munich, lived and worked in France. Landscape and still-life painter.

69. *. . .it was in Odessa* The author is mistaken. The family Simonovich in which O.F. Trubnikova grew up lived in Petersburg. At the end of the 1880s O.F. Trubnikova and M.Ya. Simonovich (the artist's cousin) went to Odessa for a change of climate since they both suffered from weak lungs. The girls worked as teachers in Odessa.

70. *Serov G.B.* The artist's son who started his career in the Moscow Art Theatre Company. After the revolution he lived abroad and worked in cinematography.

71. *Konchalovsky P.P.* Father of the artist Konchalovsky.

72. *The 'Thirty-Six'* A society organized in 1901 by the Moscow artists A.M. Vasnetsov, S.A. Vinogradov, Pasternak, V.V. Perepletchikov, N.V. Dosekin and others. Many of the Wanderers group and also the majority of the World of Art exhibitors joined the 'Thirty-Six'.

73. *Arkhipov A.E.* Painter of pictures depicting the Russian way of life. Member of the Wanderers, the Union of Russian Artists, an Academician, and subsequently a national artist of the Republic.

74. *Vinogradov S.A.* Landscape and genre-painter. Exhibited at Wanderers and World of Art Exhibitions. Member of the Union of Russian Artists.

75. *Menelik* Menelik II. Emperor of Ethiopia.

76. *. . . group painting* O.V. Serova, daughter of the artist, says in her reminiscences of her father: 'It is my belief that the strongest likeness of my father is in L.O. Pasternak's 'Staff Meeting in the School of

Painting' . . . the brow is a little too prominent but in general it is very faithfully done.' O. Serova – *Reminiscences of my Father*. Iskusstvo, 1947, p.77.

77. *Mamontov S.I.* Industrialist and financier. Proprietor of Abramtsevo, an estate near Moscow which became an important centre of the Russian artistic life from the 1870s till the 1890s. Patron of sculpture, music and singing. Founder of the famous Private Opera in Moscow.

78. . . . *who had once belonged to the Wanderers* Serov took part in the Wanderers exhibitions from 1890, at first purely as an exhibitor, and from 1894 onwards as a member of the group. After the formation of the World of Art he also exhibited his work there.

79. *Beardsley A.* English draughtsman. One of the initiators of the 'modern' style. Thematic and stylistic aspects of Beardsley's work had a strong influence on European and Russian drawing at the beginning of the twentieth century.

80. . . . *on the Neva* Pasternak is thinking here of the great enthusiasm among World of Art adherents for Beardsley's work and the active propaganda in their magazine.

81. . . . *his posthumous exhibition* Pasternak is referring here to the posthumous exhibition of V.A. Serov's work which opened in Petersburg in January 1914 and in February of the same year in Moscow.

82. . . . *portraits of Verusha and Masha* Pasternak is thinking of *Girl with Peaches* (1887) and *Girl in Sunlight* (1888).

83. . . . *the Alexander III Museum* Now Russian State Museum (Leningrad).

84. *Diaghilev S.P.* Theatrical and artistic agent. One of the initiators of World of Art and editor of the magazine of the same name. Organizer of art exhibitions in Petersburg and the Russian opera and ballet seasons in Paris and London.

85. *World of Art* Serov played a busy part in the affairs of World of Art (Mir Iskusstva) from its inception. Despite his reserved nature, he was close to many members of the group, displayed his work at their exhibitions, petitioned for a subsidy for their magazine, and so on. Diaghilev's flair for organization, his tireless energy and sense of purpose were valued particularly highly by Serov, and he thought that the *World of Art* magazine and exhibitions were in many respects indebted to him. The authority of Serov himself, both as an artist and a man, was extremely high among World of Art members and others connected with the group. A.N. Benoit wrote: 'In actual fact Serov was our only arbiter and both we, the artists, and our "boss" bowed before him.' (A. Benoit, *Reminiscences of the Ballet*, Russkie Zapiski, 1939, XV1, April, p.120.)

86. *E. Ysaÿe* Belgian violinist, composer and conductor.

87. *Kuznetsov-Benoit M.N.* Singer (soprano), soloist at the Marinsky Theatre. Lived in France from 1918 where she sang in the Parisian Grand Opera.

88. *Pokhitonov I.P.* Painter, primarily landscape. Studied in Paris. From

1876 onwards lived in France and Belgium; 1903–5 in White Russia; 1913–19 in the Ukraine. Member of the Wanderers.

89. *Razmaritsyn A.P.* Genre-painter who took part in the Wanderers exhibitions.

90. *Kostandi K.K.* Genre-painter, landscape and portrait painter. Member of the Wanderers, Academician, one of the organizers of the 'Society of Southern-Russian Artists' in Odessa, and teacher in the Odessa School of Painting.

91. *Ondricek F.* Czech violinist and composer. Professor at the Prague Conservatoire. Toured Russia more than once.

92. *Eichmann G.* German painter and engraver. In 1903 he founded an art school in Berlin. His predilection was for portraiture and religious subjects.

93. *Ivanov S.V.* Historical artist and genre-painter. Member of the Wanderers and Union of Russian Artists. In 1900 he was in charge of the *eau-forte* studio at the Moscow School of Painting, Sculpture and Architecture.

94. *Gurevich L. Ya.* Writer, translator and theatre critic. She began her literary career in 1888. She edited *The Northern Herald,* not *The Contemporary* as the author states. Contributor to *Life, Education, Contemporary World, The Russian Idea* and *The Russian Gazette.*

95. *Rumyantzev* Founded in Petersburg in 1781 as a collection of ancient manuscripts, books, coins, minerals – bequeathed to the State by Chancellor N.P. Rumyantzev. In 1861 it was transferred to Moscow and joined to the Public Museum. Towards the end of the nineteenth century it was the biggest museum in Moscow after the Tretyakov. It also held a significant collection of Western art. After the revolution the artistic collections were transferred to the Tretyakov and the Pushkin Museum of Fine Arts in Moscow.

96. *Kivshenko A.D.* Painter (water-colour) and draughtsman. Painted hunting and battle scenes. Academician, director of the battle painting studio at the Academy of Arts. After 1880 he lived in Dusseldorf, Munich and Paris.

97. *Karazin* N.N. Battle-scene painter, draughtsman, water-colour painter, writer. Worked primarily in the field of illustrations.

98. *Solovyov* Pasternak has in mind V.S. Solovyov, the Idealist philosopher, theologian, poet and commentator on public affairs.

99. *Simplizissimus* Weekly satirical magazine founded by the artist T.T. Heine in 1896. Pasternak is evidently thinking here of *The Bugbear,* a magazine of political satire which first appeared on December 2 1905. The third and last issue came out on January 15 1906 after which it was banned.

100. *Rilke R.M.* Austrian neo-Romantic and Symbolist. His poetry is imbued with mysticism. He spent the years 1899–1900 in Russia and visited Tolstoy for the first time in April 1899.

101. *Andreas-Sâlomé Lou* German writer, daughter of a Russian general. Educated in Zurich. Wrote on women in the works of Ibsen, on Nietzsche's philosophy. The author of a book called *Rainer Maria*

Rilke, Leipzig, Insel-Verlag, 1928.

102. . . . *her husband.* Andreas F.K. Professor at Göttingen, Orientalist.

103. . . . *young wife* Westhof-Rilke, K. Rilke's wife, sculptor and artist. Studied in Germany and England. Pupil of Rodin (1900). Spent 1903–4 perfecting her craft in Rome.

104. *At the Rehearsal* According to Josephine Pasternak, the artist did a small number of off-prints from this lithograph. He stopped printing because he wanted to make several changes in the original, but unfortunately he did not return to it.

105. *Gennert A.I.* Chairman of the board of directors of the Moscow Commercial Bank. Moscow city councillor.

106. *Ettinger P.D.* Art critic and collector.

107. *Secession* The union of German artists formed around the turn of the century, opposed to official, academic art. Pasternak is referring here to the Berlin Secession founded in 1899 by Max Liebermann. A split occurred in 1906. The group was divided into 'The Free Secession' of which Liebermann remained leader, and 'The New Berlin Secession' led by Lovis Corinth.

108. *Renoir* The name of the Renoir picture which Pasternak has in mind has not been established.

109. *a friend of Tolstoy's, N.N. Gué* Nikolai Nikolaevich Gué – artist, close friend and follower of Tolstoy. During his brief stay in Rome in 1861 Tolstoy met up with a circle of Russian artists among whom was N.N. Gué. This acquaintance was renewed in 1882 when Gué went to see Tolstoy in Moscow after reading the article 'O Perepisi' (About the Census) which made a deep impression on him. From that time onwards, Gué was a frequent guest at Khamovniki and Yasnaya Polyana. Tolstoy had a great affection for Gué, who he knew shared many of his ideas; he read his works to him and corresponded with him. Tolstoy showed great sympathy for Gué's works and took particular interest in his picture entitled *What is Truth?* In the winter of 1884 Gué painted a portrait of Tolstoy at work in his study in Khamovniki; and in 1886 he illustrated his story *What Men Live By.*

110. *to settle on only four scenes* . . . In the album of illustrations to *War and Peace* published by the journal *The North* (1895), four of Pasternak's illustrations are reproduced: *Napoleon and Lavrushka, Natasha's First Ball, Natasha's Meeting with Prince Andrei at Mytishchi, The Execution of the Moscow Incendiaries by the French.*

111. *After a severe spiritual crisis* . . . Tolstoy's state of profound spiritual crisis coincided with his move from Yasnaya Polyana to Moscow in the early 1880s. The social contradictions of the large capitalist town shook Tolstoy and sharpened his awareness that life could no longer continue like that. He wrote of this in his *Confession* (1882): 'I have renounced the life of our circle recognizing that this is not real life but only an imitation of life; that the conditions of excess in which we live deprive us of the ability to understand life; and that in order to understand life, I must understand the life not of us parasites on life, but the life of the simple working people, those who make life, and the

meaning which they give to it' (*Poln. Sobr. Soch.* vol 23, p.47). From that moment Tolstoy went over completely to the side of the people.

112. *The regular exhibition of the Wanderers* . . . i.e. the twenty-first Exhibition of the Wanderers Fellowship which opened in Moscow on 29 March 1893.

113. *What is Art?* . . . Tolstoy began an article about art in 1893. He was increasingly absorbed by the work, and since the theme was a highly important one in early 1897, he began composing a large work which eventually became the tract entitled, 'What is Art?' In this essay, Tolstoy criticized the bourgeois aesthetic theories of 'pure art'; he expounded his views on the aim and purpose of art, maintaining the idea of a popular art serving lofty moral and religious ideals. The chief aim of art, according to Tolstoy, was to assist in the uniting of people. 'What is Art?' was first published in the journal *Questions of Philosophy and Psychology*, No. 5, 1897, and No. 1, 1898. The first separate edition was published by *Posrednik*, Moscow, 1898.

114. *to tell him about my illustrations* . . . Pasternak's illustrations were published in an edition entitled: 'Album of Water-Colours to Tolstoy's Novel *War and Peace*'. This publication also contained works by Repin, Karazin and Kivshenko.

115. *Fet A.A.* Poet friend of Tolstoy. For a quarter of a century, from the end of the 1850s to the early 1880s, Tolstoy and Fet maintained friendly relations. This extensive correspondence has been preserved and it contains reflections of Tolstoy's ideas during his period of work on the novel *War and Peace*, thoughts about art, philosophy and poetry. Fet was not only a first-class lyric poet, but also a fine connoisseur of art, and he was one of Tolstoy's few contemporaries who immediately realized the profound conception and the significance of the novel *Anna Karenina*. Tolstoy listened attentively to his friend's judgements about art, and it was no coincidence that he recalled Fet's words about the portrait in conversation with Pasternak.

116. . . . *Moscow's leading artists* . . . During almost twenty years many celebrated men of science, literature and art visited Tolstoy's Moscow residence, including professors M.M. Kovalevsky, I.I. Yanzhul, P.V. Preobrazhensky; the writers Anton Chekhov, Korolenko, Leskov; the artists Repin and Myasodeov and many others. Scriabin, Rachmaninov, Igumnov and Goldenveizer played and Chaliapin sang there. Many of those lucky enough to be present at Tolstoy's soirées have left memoir accounts of them.

117. *Koni A.F.* . . . lawyer and littérateur. Koni went to Yasnaya Polyana in the summer of 1897 at the invitation of A.M. Kuzminski who was living there with his family. During tea Koni was introduced to Tolstoy, an event later vividly described in Koni's memoirs. It was then that Koni told Tolstoy of a case from his legal practice about Rosalia, the ruined girl and her repentant seducer from the nobility. This story formed the basic subject-matter for a work which Tolstoy first called 'Konyevskaya Povyest'; in the process of composition, the story grew into the novel *Resurrection*, 1889–99.

118. *Biriukov P.I.* A friend and sympathizer of Tolstoy. Biriukov got to know Tolstoy in 1884 when the popular publishing house *Posrednik* was established. Biriukov became one of the active representatives of this publishing house. In 1892 he went with Tolstoy to Ryazan' *guberniya* province to help the starving peasants. It was at Birkiukov's request that Tolstoy in 1903 wrote his *Memoirs*. In the early 1900s Biriukov began work on his four-volume *Biography of L.N. Tolstoy*, the first edition of which appeared in 1906 (*Posrednik*).

119. *This was a fragment of a story* . . . Pasternak heard the reading of the unfinished story 'Who is right?' which Tolstoy worked on from March to November 1895. The story first appeared in print after Tolstoy's death with *Posrednik* Publishers in 1911. On the whole, Pasternak's retailing of the extract is correct apart from one slight inaccuracy: the story mentions not a 'Grand Duke' but 'an important prince'.

120. *Schmidt M.A.* Follower of Tolstoy. After acquainting herself with Tolstoy and his doctrine in 1884, she left her post of class teacher at the Nikolaevskye School in Moscow and settled in the village of Ovsyannikovo where she lived by peasant labour. Tolstoy corresponded with her and often visited her at Ovsyannikovo.

121. . . . *the most important was the French journal Illustration.* At the same time as the printing of *Resurrection* in *Niva*, Tolstoy's novel was also to appear abroad in English, French and German translations. It was proposed that in France, the translation of *Resurrection* would first be published in the journal *Illustration*. In connection with this Tolstoy wrote to V.G. Chertkov: 'I agree to release it to the French *Illustration* . . . and I am today writing to the editor of *Illustration* to tell him I am commissioning you to conclude the matter with him, and that Pasternak, our best illustrator has undertaken to do the illustrations.' (*Poln. Sobr. Soch.*, vol. 88, p.130)

However it was not possible to arrange the printing of *Resurrection* in the magazine, and the first publication of the French translation appeared in the newspaper *Illustration* in 1899.

122. *Tolstoy decided to depart from his principles of the last years* . . . On 16 September 1891, Tolstoy sent the editors of the newspapers *Ruskiye Vedomosti* and *Novoe Vremya* a letter renouncing his right to literary ownership. 'I leave to all who so wish the right to publish freely in Russia and abroad, in Russian and in translation, and also to produce on the stage all works of mine which have been written by me since 1881 . .' (*Poln. Sobr. Soch.* vol.66, p.47). This letter was printed in No. 523 of *Ruskiye Vedomosti* and No. 5588 of *Novoe Vremya*. Thereafter it was printed in several newspapers.

123. *Grünberg Yu. O.* Director of the Petersburg Office of the journal *Niva*, and a close friend of the Serov family. He was born in Hungary and lived in Russia from 1875.

124. *Marx A.F.* Publisher and bookseller, owner of *Niva*, the most popular magazine in pre-revolutionary Russia.

125. *Trubetskoi* . . . Pavel Petrovich Trubetskoi, sculptor. Born in Italy,

as a student he visited the studios of Milanese sculptors and in the late 1880s began exhibiting his works at Italian and French exhibitions. He came to Russia in 1897 and worked in Moscow. In spring of 1898 he made the acquaintance of Tolstoy and made a bust of the author at Khamovniki. The following year he worked on two statuettes of Tolstoy. One of them – 'Tolstoy on Horseback' – won the 'Grand Prix' at the World Exhibition of Paris in 1900. Tolstoy used to go to the sculptor's studio by the Myasnitsky Gates to pose for this statuette. Trubetskoi went to Yasnaya Polyana in 1899, 1903 and 1910, and during these visits he not only modelled but also drew Tolstoy (his drawings are in the State Tolstoy Museum). Tolstoy greatly appreciated Trubetskoi's original talent and referred to him as a 'man of original intelligence' (*Polnoe sobranie sochinenii*, vol.58, p.59). Concerning the relationship between Tolstoy and Trubetskoi, see: L.Shcherbukhina, 'Skul'ptor P. Trubetskoi i Lev Tolstoi', *Iskusstvo*, 1967, No. 9.

126. *Valentin Fyodorovich Bulgakov* . . . Littérateur and museum curator. In 1910 he was Tolstoy's secretary. From 1916 to 1923 he was assistant curator and head of the Tolstoy Museum in Moscow. From 1923 to 1948 he lived in Czechoslovakia where he founded the Russian Historical and Cultural Museum at Zbraslov. From 1948 onwards he was collaborator and afterwards curator of the Tolstoy Museum at Yasnaya Polyana. He is author of a series of research publications on Tolstoy.

127. *took it with me as a memento* . . . Tolstoy's pencil sketch of Pasternak's head and profile is dated '8 October 1898'. Below is Pasternak's signature. The drawing is preserved in the manuscript department of the State Tolstoy Museum.

128. *now in the Tolstoy Museum in Moscow* . . . Nothing is known of the whereabouts of these reproductions which carry Tolstoy's marks and were exhibited at the Tolstoy exhibition of 1911 in the Historical Museum.

129. *Musée Luxembourg* . . . Picture gallery in Paris in the Palais du Luxembourg, founded in 1750. From 1818 it was the repository for modern works of art; in 1939 this function was taken over by the Musée des Arts Modernes.

30. *Tolstoy Museum* Pasternak's drawing of the two Tolstoys is actually kept at Yasnaya Polyana.

131. *this 'Parisian'* . . . The sculptor who came to Yasnaya Polyana was Naum Lvovich Aronson. He made his bust of Tolstoy at Yasnaya Polyana in July 1901. See: N.N. Gusev, *Letopiszhizni i tvorchestva L.N. Tolstovo*, vol. II, Moscow 1960.

132. *list of them* . . . In 1904, Pasternak made six drawings to illustrate the story 'What Men Live By' entitled *The Village, Semyon's Meeting with Mikhailo, Mikhailo with Semyon and his Wife, Woman with the Two Little Girls, Semyon Measures his Client's Foot, Mikhailo*. The drawings were reproduced in a separate edition of the story published by the St Petersburg Society for Literacy (no date indicated). All the

illustrations listed above are preserved in the State Tolstoy Museum.

133. *S–* The man referred to is Vladimir Vasilyevich Stasov. Tolstoy first met Stasov in the public library of St Petersburg where the latter ws head of the Art Department. Stasov respected Tolstoy as an artist but was critical of the writer's religious and philosophical views. Stasov corresponded with Tolstoy, visited Khamovniki and also stayed at Yasnaya Polyana. Tolstoy turned to Stasov for assistance in obtaining books on the history of art for his work on the article 'What is Art?' and also books on the history of the Caucasian peoples and documents on the period of Nicholas I. In his critical articles on art, Stasov was in many ways a follower of Chernyshevsky, and it was he who introduced Tolstoy to Chernyshevsky's dissertation on 'The Aesthetic Relationship of Art to Reality'. Tolstoy willingly admitted the similarity of his views on art to those of Stasov. V. F. Lazursky quotes Tolstoy's comment on Stasov: 'These are my views also, harshly and crudely expressed, but essentially I agree with them.' (*Literaturnoe Nasledstvo*, No. 47–8, p.455.)

134. *Grigorovich* Dimitri Vasilyevich Grigorovich, writer, art critic and secretary of the St Petersbury Society for the Encouragement of the Arts.

135. *welcome and farewell . . . in the world today . . .* In autumn of 1909 Tolstoy was a guest of Chertkov at Krekshino on the Pashkov's estate in the Moscow *guberniya*. On 18 September he returned from Krekshino to Moscow, and the following day he left for Yasnaya Polyana. At the Kursk Station a huge crowd gathered to see the great writer off. This was Tolstoy's last visit to Moscow. For more information about the send–off given to Tolstoy on 19 September 1909, see: A.P. Sergeenko, 'Provody', in *L.N. Tolstoi v vospominaniyakh sovremennikov*, vol. II, Moscow 1955.